Las Vegas Lights

Mark P. Block & Robert Block

4880 Lower Valley Road, Atglen, PA 19310 USA

Dedication

To Marquerite, whose smile lit up the desert brighter than any neon sign ever could.

Copyright © 2002 by Mark Block & Robert Block
Library of Congress Control Number: 2002103534

All rights reserved. No part of this work may be reproduced or used in any form or by any means—graphic, electronic, or mechanical, including photocopying or information storage and retrieval systems—without written permission from the copyright holder.
"Schiffer," "Schiffer Publishing Ltd. & Design," and the "Design of pen and ink well" are registered trademarks of Schiffer Publishing Ltd.

Cover and Book Designed by Bruce Waters
Type set in Humanist 521 BT/Humanist 521 BT

ISBN: 0-7643-1632-X
Printed in China

Published by Schiffer Publishing Ltd.
4880 Lower Valley Road
Atglen, PA 19310
Phone: (610) 593-1777; Fax: (610) 593-2002
E-mail: Schifferbk@aol.com
Please visit our web site catalog at www.schifferbooks.com
We are always looking for people to write books on new and related subjects. If you have an idea for a book please contact us at the above address.

This book may be purchased from the publisher.
Include $3.95 for shipping.
Please try your bookstore first.
You may write for a free catalog.

In Europe, Schiffer books are distributed by
Bushwood Books
6 Marksbury Ave.
Kew Gardens
Surrey TW9 4JF England
Phone: 44 (0)20-8392-8585
Fax: 44 (0)20-8392-9876
E-mail: Bushwd@aol.com
Free postage in the UK. Europe: air mail at cost

All trademarked materials illustrated and discussed in the book are the properties of the corporations that own them. No attempt to infringe on any copyrights has been made in this text. The research for this book is solely the work of the authors, materials were neither provided nor approved by any of the corporations found herein. This book is presented for the education and entertainment of the readership and is not authorized by any of the aforementioned corporations.

Contents

Acknowledgment	4
Introduction	5
Chapter 1. Neon and Gaseous Lighting	6
Chapter 2. Las Vegas: A History of Discovery	10
Chapter 3. Gaming Grows	12
Chapter 4. From Fremont Street to Las Vegas Boulevard	14
Chapter 5. That's Entertainment	18
Chapter 6. From Gaming to Resort Capital of the World	19
Chapter 7. Neon Radiates from the Desert	26
Chapter 8. Las Vegas Lights	28
Selected Bibliography	160

Acknowledgment

Without the encouragement and professionalism of Peter Schiffer, Jeff Snyder, and the staff of Schiffer Publishing, this book would be merely a dream. Thank you for making the dream a reality.

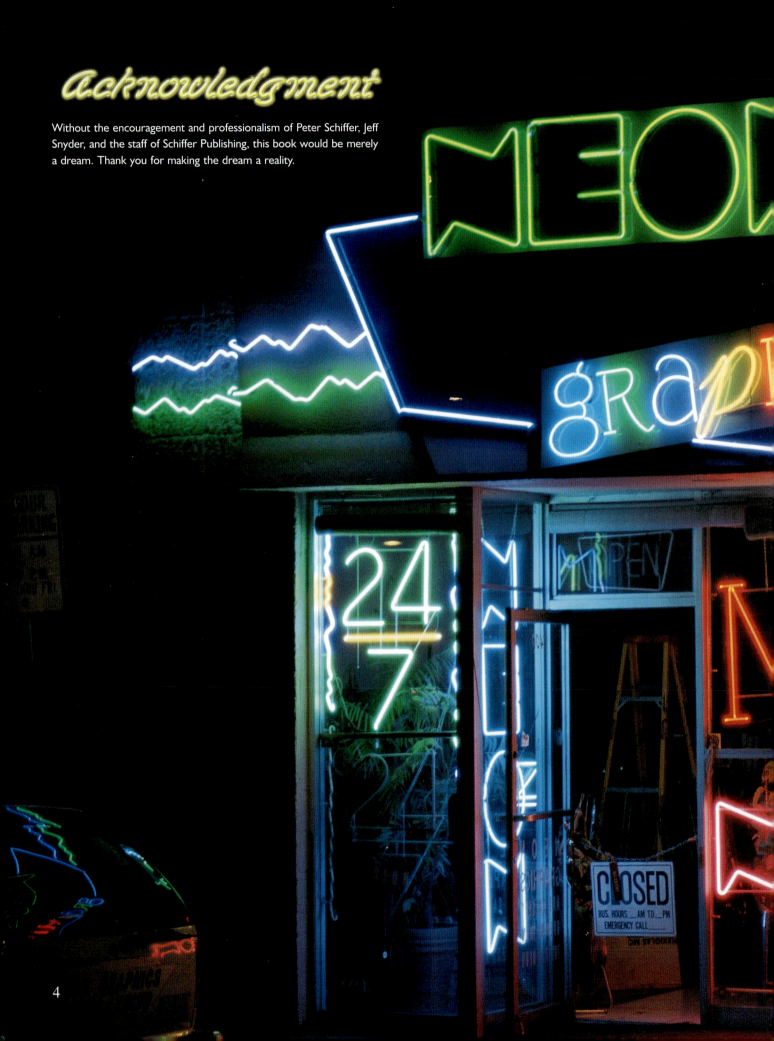

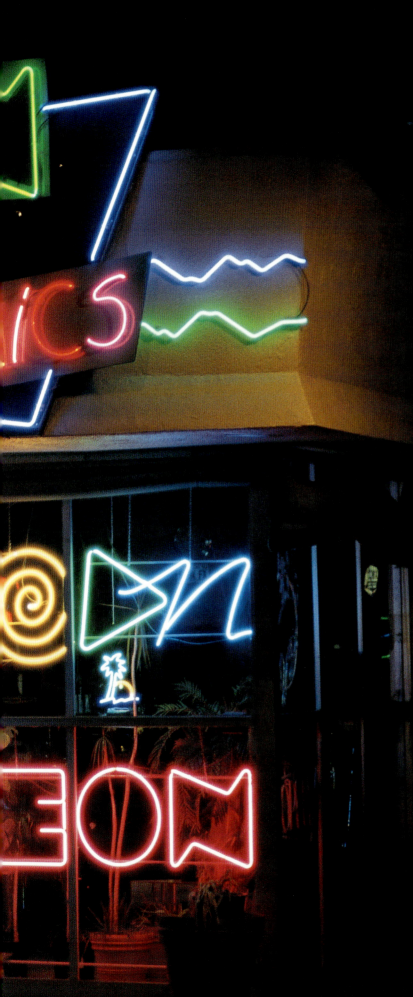

Introduction

When you approach Las Vegas for the first time at night by air, or head into the city by car, you will find yourself amazed by an oasis of light that beckons you to try your luck at one of the many games of chance Las Vegas has to offer.

My first trip into Las Vegas, nearly thirty years ago, came during one of the city's reincarnations. The mid-1970s saw the showrooms of such famed hotels as Caesar's Palace, the Sands, Desert Inn, Hilton, and Sahara, and others filled with the brightest stars to shine anywhere on Earth. Included among these were Frank Sinatra, Dean Martin, Sammy Davis Jr., Jerry Lewis, Liberace, Elvis, and many others. One could spend a week and see them all, each playing to packed houses of dinner-jacket-clad gentlemen and bejeweled women in evening dresses.

But, times and tastes change, and Las Vegas is no different. On the contrary, the Las Vegas valley has been able to grow into one of America's leading destination resorts. Because of its uncanny ability to read the public's changing tastes, and market and alter its concepts of entertainment to the trends of the day, Las Vegas appears not so much to grow as it does evolve. From country-western singing sensations, to female impersonators, magic and Broadway show extravaganzas, Las Vegas has drawn in successive generations through change. However, one thing remains constant, the sound of coins dropping into slot machine trays and the dealing of cards, rolling of dice, and ever present bright lights—both neon and incandescent.

Families have now made Las Vegas a vacation destination resort. Retirees spend their golden years at luxurious retirement resorts with all the amenities of the "good life," and hotel casino workers have turned this once small railroad stop into America's fastest growing city. With neighborhoods of valley dwellers expanding, malls and banks, schools and services have seemingly popped up on every street corner.

For those who remember the "old" Las Vegas, the images illustrated in this book will provide fond reminiscences of days-gone-by, and for those having discovered the "new" Las Vegas, it remains a city of dreams, a destination of luck, and a Strip and Downtown of neon and incandescent light to deprive one of their senses, if only for a brief time. Luck-Be-A-Lady has reigned over this desert oasis for decades and shows no sign of leaving!

— Mark Block
January 2002

Neon and Gaseous Lighting

Neon lighting arose from the numerous failed attempts to create a usable and economical artificial source of light. The story of neon lighting is really the story of the development of electricity, artificial phosphorescence and luminescence itself, as well as the power of marketing.

Neon lighting can be traced back to the French astronomer and scientist, Jean Picard. While much definitive information on this man is unknown, according to the Galileo Project (a hypertext source of information on the life and work of Galileo Galilei (1564-1642) and the science of his time. Information on the project may be found at http://es.rice.edu/ES/humsoc/Galileo/), Picard was born in La Flèche, France, on July 21, 1620. His father is believed to have been a local bookseller. Picard likely did his early studies at the Jesuit college at La Flèche. His later schooling is unknown, though he did earn an Master of Arts degree from Paris in 1650. Picard was ordained a Catholic priest that same year and is known to have held more than four benefices. It was around this time Picard became serious about astronomy. He worked to develop instruments and equipment to aid in observations. For example, with Auzout he perfected the movable-wire micrometer, utilizing it to measure the diameter of the sun, moon, and planets. He is known to have made a number of other innovations in instrumentation as well.

Picard became an important member of the group of academicians carrying out cartographic measurements in France. He was placed in charge of mapping the region of Paris, and then worked to remeasure an arc of the meridian, utilizing Snell's method of triangulation. The resulting method and measurements were then published in his *Mesure de la terre* (1671). Picard was also a leader in the development of scientific cartography and was an important member of the team that began to compile a map of France based on these concepts. In addition, he aided in surveys at Marly and Versailles, and was a key figure in creating a water supply to Versailles. Other interests of Picard's were barometric experiments, hydraulics, and optics. He made several improvements to the workings of telescopes before dying on October 12, 1682 in Paris.

It was Picard's experiments with barometric pressure that form the basis for neon lighting. The barometer was invented by Evangelista Torricelli and was also known as "Torricelli's tube." Evangelista Torricelli was born October 15, 1608, in Faenza, Italy, and died October 22, 1647 in Florence. He was a physicist and mathematician, and became the first scientist to create a sustained vacuum and discover the principle of a barometer. In 1641, Torricelli moved to Florence to assist Galileo. It was at this time that Galileo suggested Torricelli use mercury in the vacuum experiments he was then conducting. Taking his mentor's advice, Torricelli filled a four-foot long glass tube with mercury and inverted the tube into a dish. Some of the mercury did not escape from the tube and Torricelli observed that a vacuum had been created. He discovered the variation of the height of the mercury from day to day was caused by changes in atmospheric pressure. It was around 1675 Jean Picard began studying the variation in air pressure at different altitudes. One evening, Picard took a mercury barometer up a mountain to measure the pressure. He observed that the tube glowed faintly for some reason and by shaking the mercury he could even cause it to glow more.

Another scientist of the time, Otto von Guericke (born: Magdeburg, 20 Nov. 1602, died: Hamburg, 11 May 1686), later became involved with barometric experiments in Germany. As a convinced Copernican, von Guericke philosophized on the nature of space. By applying the concept of vacuum to space, he considered the possibility that space was, in fact, empty, and therefore, considered the physics of moving across empty space. Von Guericke constructed a model, based on empty space across which magnetic action controls the movements of the planets. He postulated that each celestial body has its own finite sphere of activity. Von Guericke's experiments with models of this concept led him to recognize the elasticity of air, which he went on to further investigate. When he learned of Torricelli's experiments on atmospheric pressure, he repeated them and made barometric forecasts of the weather based on systematic observations over a period of years. He then proposed a network of stations to make systematic reports of the barometer and weather.

Von Guericke created a specialized barometer in which the column of mercury moved the arm of a man, which thus pointed out rising and falling pressure. This device was referred to as the "Wettermännchen." He experimented with what is now called static electricity, although he himself did not recognize it as such. His first suction pump was created in 1647 and he continued in the following years to work at improving it into a real air pump. He was able to produce barometric light, demonstrating in 1683 that applying an externally generated static electric charge to the barometer could produce barometric light. This experiment was used to create the first static electric machine, a sulfur globe mounted on an axle. Von Guericke's experiments thus demonstrated that electricity could be converted to light in a controlled manner.

The first researcher able to replicate light's glow was Francis Hauksbee, an English scientist. Hauksbee was born in Colchester around 1666, and died in London in the spring of 1713. It is generally recognized that sustained experimentation with electricity began with Hauksbee. He also

performed important experiments on capillary phenomena, the propagation of sound in compressed and rarified air, on the freezing of water, and elastic rebound. Further, Hauksbee investigated the law of magnetic attraction and the time of fall through air.

In early 1704, Hauksbee became the Royal Society's paid performer of experiments, a role he continued until his death, though he had already made himself known to people outside the Royal Society as an experimenter by the time of his appointment. It is reported that he gave demonstrations in his shop in 1704, and by 1710 was offering public lectures. He also made and sold instruments—amongst them, air pumps, barometers, and cupping glasses used in surgery. Hauksbee was well known for his scientific instruments for physical experiments. He improved the air pump, made improvements on von Guericke's static electric machine (the glass globe mounted on an axle), and also developed a primitive electroscope to detect electric charges.

Hauksbee's contribution to the development of gaseous lighting was his adding of an air valve to the barometer, allowing him to demonstrate that the glow was best when a barometer was half-filled with air. He presented an explanation for the glowing mercury to the Royal Society in 1705, hypothesizing that the friction between glass and mercury was responsible. Hauksbee continued his research, and the next year demonstrated his improvement on von Guericke's machine. This was a device consisting of a glass globe in which a partial vacuum was created. It was then spun, and when a hand was pressed lightly against the spinning glass, there resulted a mysterious luminescence.

Even though barometric light was not understood, it continued to be investigated. When the principles of electricity were discovered, scientists moved forward toward the invention of various forms of lighting. Friction machines were the only means of artificially producing electricity early in the eighteenth century, and although several men had suspected that the sparks and flashes of the friction machines were similar to lightning, no one had demonstrated the relation. Dutch, English, and German scientists, like others of the time, had produced electricity by friction but, like the others, were unable to collect and retain it to be used at will. Nor had they been able to create any form of sustained electric light.

Earlier historical sources of neon lighting indicate that in 1734 Johann Heinrich Winkler, continuing Hauksbee's research, sealed mercury in evacuated glass tubes and achieved a sort of portable glow light. However, no listings for a scientist by this name have been found to this date.

It is known that in France in the mid-1700s, a scientist named Abbe Nollet reportedly created vacuum tubes that glowed when an electric charge was passed through them by means of wires embedded in such tubes. These were referred to as "electric eggs." Experiments with electricity and lighting continued through the 1700s and early 1800s in England, France, and Germany. Eventually it was discovered that when a high enough voltage is applied to electrodes in a partially evacuated glass tube, a colorful glow is often produced.

The Geissler Tube is the predecessor for the modern neon tube, invented by Heinrich Geissler in the 1850s. A Geissler is a high-voltage discharge tube in which traces of gas ionize and conduct electricity. The electrified gas takes on a luminous color that is characteristic of the gas used in the tube. Geissler was born in the village of Igelshieb, in Germany. His father Georg was an innovative glass blower and maker of instruments such as barometers and thermometers.

Heinrich Geissler grew up during a time when experimental natural sciences were leading to a greater demand for laboratory apparatus, particularly hollow glassware. This demand would aid in catapulting the craft of the glassblower from a cottage industry to a profession. This same period of time saw a flourishing of the use of glass in decorative items (i.e., paperweights) and toys (i.e., marbles). During the 1840s, Geissler earned his living as a traveling instrument maker before settling and establishing a workshop in Bonn, a young university town with a demand for laboratory apparatus. It was here Geissler worked closely with various scientists and built up an international client list. He invented the mercury vacuum pump, which greatly improved the efficiency of evacuating air from glass tubes and beginning in 1855 Geissler participated regularly in world exhibitions, winning several medals for his scientific apparatus. Geissler began experimenting with what were later to become known as "Geissler tubes" in 1857, and full-scale production of these was well underway in the 1880s. He died in 1879 and is buried in Bonn.

Occurring around the same time, in the 1850s, Alexander Edmond Becquerel (the father of Antoine Henri Becquerel, an early pioneer in the study of radiation) was studying phosphorescence. He described making tubes containing luminescent materials and rarified air. These tubes are among the first examples of fluorescent light production, which is used today for phosphor coated neon tubes. It has been reported that in 1893, Nicola Tesla produced the first phosphor coating, although others place the same claim having been attributed to Becquerel. The sign Tesla made, which read "LIGHT," only worked for a short time.

In 1898, an American, D. McFarlan

Moore, invented discharge lamps that were gas filled tubes measuring up to 250 feet long. His solution was to fill these long tubes with a mixture of carbon dioxide and nitrogen to produce fairly efficient electric light. Unfortunately, the chemical reactions and the electrodes absorbed the gases. Moore then created a simple valve that admitted additional gas when needed. Sadly, his lights were expensive and difficult to operate and maintain. Research at the time did indicate that higher efficiencies might be attainable with discharge lamps, so work continued.

A French engineer, chemist, and inventor, Georges Claudé (b. Sept. 24, 1870, d. May 23, 1960), was the first to apply an electrical discharge to a sealed tube of neon gas to create a neon lamp. Building on Moore's work, Georges Claudé developed neon filled tubes in 1910. Neon, being inert, did not combine with other tube elements, so the gas valve wasn't necessary with this new gas. He showed that a discharge lamp was capable of producing 15 lumens per watt of light. Unfortunately, the light was red, which was unsuitable for general lighting requirements. Claudé's second contribution to neon lighting was that he developed the process of extracting neon from the atmosphere by liquefying air, yielding extremely pure neon in useful quantities. His third contribution to neon technology was the invention of noncreative electrodes, ones large enough to handle the ion bombardment without heating or sputtering, thus, opening the way to long life, maintenance free tubes.

As a practical matter, the bright red tubes weren't very useful as a general-purpose light source, but the eye-catching color and its ability to be seen through rain and fog made it a natural for advertising signs. Claude patented the inventions and incorporated a company named *Claude Neon*.

Georges Claudé displayed the first neon lamp to the public on December 11, 1910, at the Grand Palais in Paris. In 1912, a more capitalistic colleague of his, Jacques Fonseque, designed the first neon advertising sign for a Paris barbershop. Neon advertising signs remained a purely French phenomenon until 1922, when it is reported that two brothers named Haaxman brought the first neon signs to Holland.

The United States, in an uncharacteristic lapse of marketing judgment, was late entering the neon advertising trade. However, by 1923, Georges Claudé and his company Claude Neon had introduced neon gas signs to the United States, by selling two to a Packard car dealership in Los Angeles. Earle C. Anthony purchased the two signs reading "Packard" for $24,000. Neon lighting quickly became a popular fixture in outdoor advertising. Visible even in daylight, neon signs were dubbed "liquid fire."

Today there are more than 150 neon color possibilities created by combining different gases. However, two favorites remain: a fiery orange-red neon gas called Ruby Red and a soft lavender argon gas that turns a brilliant blue when enhanced with a drop or two of mercury.

In the early years of usage, neon signs would stop traffic as people stared in fascination. This "Liquid Fire" captured the public's senses. As with all good marketing techniques, everyone had to have it. So, it wasn't long before neon was everywhere. Soon all manner of signage, from theater marquees to restaurant and gas station signs, became a part of the American landscape. Neon came to represent the progress of America.

Unfortunately, because the 1960s saw the development of bright plastic signs backlit by fluorescent lighting, neon's fiery colors suddenly appeared tacky, and faded away in the name of progress. During the next decade neon sign making nearly became a lost art, but in the early 1970s a new breed of neon craftspeople emerged. These artists and craftsmen not only produced neon-advertising signs, but also neon as an art form.

For almost a hundred years, neon has been a part of the urban and rural landscape. In some instances, it is the landscape. Many images come to mind when we hear the word "neon." For some it is the tawdry or tacky glare of the overdone, while others see and enjoy neon as "kitsch."

The Gases

In 1868, helium was first observed through spectrographic analyses of the sun. It was the first of the "noble" gases to be discovered, and obtained its name from the Greek word *Helios* for 'sun'. The next to be discovered was Argon, which was isolated and identified by Lord Rayleigh and Sir William Ramsay in 1894. It took its name from the Greek word *Argos* meaning 'inactive'. Then in 1897, William Ramsay predicted the existence of the element neon. He and Morris Travers discovered it in the atmosphere in 1898, and they named it after the Greek word for 'new': the new gas. Neon is a rare gaseous element present in the atmosphere to the extent of 1 part in 65,000 of air. It is obtained by liquefaction of air and separated from other gases by fractional distillation. Argon, Helium, Neon, Xenon, Krypton, and Radon are the "noble" gases, so called because they are inert and do not form compounds like other elements. This was shown not to be strictly true in 1962, when researchers managed to combine xenon and fluorine into xenon tetra fluoride.

The noble gases are the elements in the last column of the periodic table of chemicals: Helium (He), Neon (Ne), Argon (Ar), Krypton (Kr), Xenon (Xe), and Radon (Rn, which has no stable isotopes). Because of their specific "saturated" electron configuration, the noble gases are practically non-chemically reactive. This is the reason they are called noble and why they are almost always found in gaseous form. Furthermore, it is also the reason they were not efficiently held back when the Earth formed, and hence are very rare on Earth. Because of this fact, they are also refered to as rare gases, they don't react, they are the perfect element to use in electric discharge lighting.

Each noble gas is interesting in its own right. Helium is the second lightest and second most abundant gas in the known universe (hydrogen being number one). Because of its scarcity in our atmosphere, helium's existence was not suspected until spectroscopic measurements revealed an unknown element present in the sun. The discovery of helium is generally credited to Sir William Ramsay in 1895. As no helium compounds are known, this family of gases was

once thought to be inert. In 1962 the first noble gas compound was prepared with xenon. Still, helium only occurs in uncombined form and must either be extracted from the atmosphere by liquefaction of air or separated from deposits of natural gas. It is thought that some terrestrial helium is the product of the alpha decay of radioactive isotopes beneath the Earth's crust. Helium is the only known element that cannot be converted to a solid simply by cooling. It has 98% the lifting power of hydrogen with none of the Hindenburg-type drawbacks, and is still used today in airships.

Neon is the fourth most abundant element in the known universe, and was discovered in 1898 by Ramsay and Travers. This is perhaps the best-known noble gas because of its use in so-called neon lights (many of which actually contain other gases) and is relatively plentiful in the earth's atmosphere (fifth in abundance, following carbon dioxide). No stable compounds of neon are known to date, and the gas is extracted from air by liquefaction.

Argon is third in abundance in the Earth's atmosphere (about 1% by volume). Rayleigh and Ramsay isolated and identified the gas in 1894. Like the rest of the noble gases, Argon is colorless, tasteless, and odorless. For years argon has been used in ordinary incandescent light bulbs to replace the oxygen that would otherwise shorten the life of the filament. It is used in some types of welding where active atmospheric gases would interfere with the process. Argon is also used in various types of "black lights" or ultraviolet lamps since excitation of the gas produces a significant amount of ultraviolet radiation. A few curious compounds have been made with argon but they are not regarded as being very stable.

Krypton is a name derived from the Greek *Kryptos* or 'hidden'. Krypton is neither green nor a solid material that can defeat Superman. Rather it is another noble gas discovered in 1898 by Ramsay and Travers. It ranks sixth in abundance in the atmosphere. Krypton gas is used in various kinds of lights, from small bright flashlight bulbs to special strobe lights for airport runways. As with other noble gases, krypton is isolated from the air by liquefaction. One of the naturally occurring non-radioactive isotopes of Krypton, Kr-86 (17.3%) is used as the basis for the current international definition of the *meter*. One meter is 1,650,762.73 wavelengths of the red-orange spectral line of Krypton-86.

Xenon, also discovered by Ramsay and Travers in 1898 (its name taken from the Greek *Xenos* for 'strange'), is the rarest of the stable noble gases in the air. It is still recovered by liquefaction techniques and is widely used in strobe lamps. In 1962 Neil Bartlett, combining xenon, platinum, and fluorine, produced the first noble gas compound.

Friedrich Dorn discovered radon in 1900. It is a radioactive noble gas now regarded as a potential health hazard in some homes. It also has medical applications for cancer treatment. Its original name was to be *Niton* for 'shining' but it was eventually named as a derivative of radium. Radon is found in underground deposits where it is produced by uranium and radium decay. Lastly, radon fluoride (RnF) has been produced and the element glows with a yellow light in its solid state.

Making Neon Signs

Hollow glass tubes used to make neon lighting come in four, five, and eight foot lengths. The glass tubes can be either "soft" glass or "hard" glass. "Soft" glass has compositions that include lead glass, soda-lime glass, and barium glass. "Hard" glass is from the borosilicate family, commonly known by the trade name Pyrex.

The glass tubes are scored (partial cut) while cold with a file and then snapped apart while hot. The artisan then creates the angle and curve combinations. To shape the tubes, the glass is heated by lit gas and forced air, and depending on the glass composition, the working range of glass range from 1600° Fahrenheit to over 2200° F. The temperature of the air-gas flame, depending on the fuel and ratio, is approximately 3000° F using propane gas. The artisan creates right angles, double-backs, and combination bends upon a reversed-pattern paper to form the design. All work on a neon lamp/sign must be in reverse because all plugs and electrical connections are in the back.

When the shaping is finished, the tube must be processed to achieve stability of form. This process varies depending on country. In the United States the procedure is called "bombarding." The tube is partially evacuated of air. Next, it is short circuited with a high voltage current until the tube reaches a temperature of 550° F. The tube is then evacuated again until it reaches a vacuum of 10-3 torr. The gas is back filled to a specific pressure depending on the diameter of the tube. Additional elements are injected, depending on the color desired, and the tube is sealed off.

Red is the color neon gas produces; neon gas glows with its characteristic red light even at atmospheric pressure. Today there are now more than 150 neon colors possible; almost every color other than red is produced using argon, mercury, and phosphor. Neon tubes actually refer to all positive-column discharge lamps, regardless of the gas filling. The colors in order of discovery were blue (Mercury), white (Co2), gold (Helium), red (Neon), and following the different colors from phosphor-coated tubes. The mercury spectrum is rich in ultraviolet light which in turn excites a phosphor coating on the inside of the tube to glow. Phosphors are available in most any pastel color.

One of the biggest differences between old and new neon is the manner in which each is illuminated. Old neons use heavy transformers made from wrapped copper wire coiled around an iron core, all of which weighs several pounds. The good part about the weight is that the signs or designs stay right where you put them, on table or shelf. New neon signs, however, use lightweight transistorized transformers that weigh mere ounces in comparison. Therefore, the new signs have to be weighted down somehow or bracketed against the wall so they won't fall over and break. Throughout this book, you will see many examples of both types of neon signage, and the multitude of colors used.

Chapter 2

Las Vegas: A History of Discovery

Going back in time millions of years, and far removed from the abundance of water and vegetation today's Las Vegas is an outgrowth that has its own natural history—better described as one that has been aided by mankind in the parched desert of the American Southwest since the discovery of the Las Vegas Valley in the early 1800s. From the once teeming wetlands, marshes and rivers, the desert landscape arose as the rivers receded underground in a geological formation that became known as the Las Vegas Valley. These underground waters, or aquifers, give life to only the hardiest of plants, those that can survive on less than three inches of rainwater a year. Yet only a short distance from the Colorado River, giant fountains, manmade lakes, and pools by the score make the Las Vegas Valley one of the most exotic oases of contemporary manmade water attractions in the world.

It is generally acknowledged that over 150 years ago, Rafael Rivera, a Mexican scout, traveling with the Mexican trader Antonio Armijo along the Spanish Trail to California, discovered what became known as Las Vegas Springs.

Armijo's sixty-man party was camped out around Christmas of 1829, nearly one hundred miles to the northeast of today's Las Vegas. Rivera, well-known as an experienced scout, wandered from the main party to explore the virgin desert. That desert had been inhabited by mammoths, first discovered in the early-1990s by paleontologists, who estimated their bones to be up to 15,000 years old. With the exception of the Native American population whose home had been the desert valley for generations, Rivera became the first non-Indian to view the beauty of the Las Vegas Valley with its oasis-like landscape.

The discovery of artesian spring water served to shorten the Spanish Trail to Los Angeles, and hence eased the travels of the Spanish traders. Later, the gold rush in California saw an even greater number of adventurers move through what was referred to on early maps as "Vegas," on their way to California in search of fortunes. Little did many of these men know that in their quest for gold they were nearly tripping over the greatest concentration of silver in North America. Maps after about 1848 were changed, referring to the place as *Las Vegas*, which in Spanish means 'The Meadows'.

Only a decade and a half after Rivera's discovery of the Las Vegas Valley, Mormon leader John C. Fremont had his expedition camping at Las Vegas Springs in 1844. Fremont's name is synonymous with today's Las Vegas. The Fremont name is lit up in neon at the Fremont Hotel Casino and has been given to the main thoroughfare downtown, the famed Fremont Street, running from east to west right through the heart of the casino crunched "Glitter Gulch."

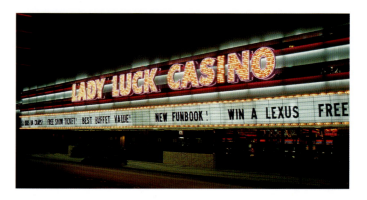

While traveling to Las Vegas Springs from Salt Lake City, Mormon settlers sought to protect the Los Angeles-Salt Lake City mail route. They built the first established fort in the Nevada territory in 1855. Constructed from sun-dried bricks of clay, soil, and grass, this adobe was the first true structure upon which today's Las Vegas can trace its history of modern inhabitants.

A small part of this Mormon fort still survives, having withstood time and harsh desert winds. It can be seen at the intersection of Las Vegas Boulevard North and Washington Avenue. It was here that the Mormons cultivated vegetables and planted fruit trees, though they reluctantly abandoned the site in 1858 because of constant Indian raids.

As time comes full circle, a beautiful Mormon Temple was dedicated in the late 1980s, and is visible in the foothills of one of the most stunning and well-known natural landmarks in the Valley—Sunrise Mountain, to the east of the present day Las Vegas.

As with much of the late-1800s West, it wasn't long before the developers of Americas railroads recognized the water rich Las Vegas Valley would make an ideal location for a railroad stop. And, since Nevada had been entered in to the Union as a free state in 1864 during the Civil War, a government was now in place to accept the railroad's proposals and personal financial incentives.

A short decade after first proposing Las Vegas Valley as a rail stop to California, work began on the first tracks, and the small tent town called Las Vegas was born. Complete with saloons, boarding houses, stores, and all the excitement of Western living that went with these establishments, Las Vegas' future was cast.

In 1905, the first run of the San Pedro, Los Angeles, and Salt Lake Railroad was made from California east. The Union Pacific Railroad, which still operates today, later absorbed these rail lines, and the rail yards are still located at what became the birthplace of Las Vegas' downtown, the

western end of Fremont Street. Today, Jackie Gaughan's Plaza Hotel Casino, located at Main and Fremont streets, stands on the site of the original Union Pacific Railroad depot. And today, the depot site at the hotel is used as a passenger terminal, the only railroad station having the distinction of being located inside a hotel/casino.

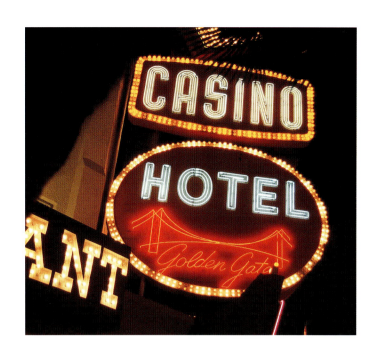

Modern Las Vegas can be recorded as being founded on May 15, 1905, when the Union Pacific auctioned 1,200 lots in a single day in the area that today is lined with casino's and hotels and known the world over as "Glitter Gulch."

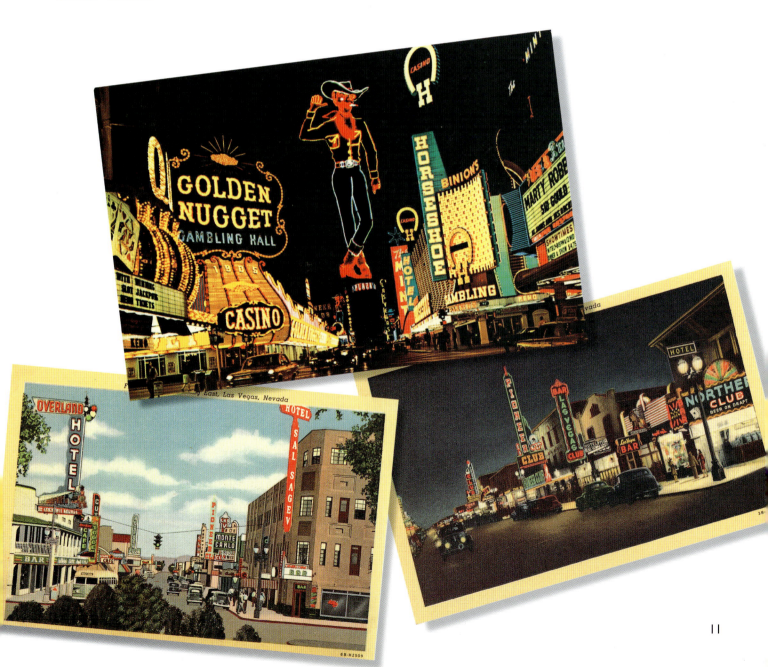

Chapter 3

Gaming Grows

Being the first state in the nation to legalize gambling in 1931, Las Vegas took a circuitous route to doing so, having first been the last western state to outlaw gaming in the 1910s. On October 1, 1910, at the stroke of midnight, Nevada forbid by law any form of gaming, including the custom of flipping a coin for the price of a drink!

As was reported at the time in *The Nevada State Journal*, "Stilled forever is the click of the roulette wheel, the rattle of dice and the swish of cards." Of course, as became second nature in Las Vegas in the latter part of the 20th century, forever didn't last long. In this case, forever meant less than three weeks in Las Vegas, and by today's Las Vegas standards, three weeks can be an eternity.

Gaming behind closed doors, where patrons knew the proper password meant a day and/or night of excitement. That was, until 1931, when state legislator Philip Tobin, a Northern Nevadan who had never even visited Las Vegas or expressed an interest in gambling, proposed legislation to legalize gaming. Tobin believed that this would be the simplest and least offensive way for Westerners to raise the needed taxes for pubic schooling. The West was being tamed just as Las Vegas was going to explode and redefine industry in the Southwest during the Great Depression of the 1930s. Though a small industry, gambling and Las Vegas received the boost that would propel it through the remainder of the 20th century—the construction of Boulder Dam. The Boulder Dam federal project, later renamed Hoover Dam, began in 1931, employing over 5,000 workers and support staff at its height. Many of these men began looking for diversion from the heat and desolation of desert life. They found it in Las Vegas.

Awash with jobs and money from the dam project only thirty-four miles away in the Black Canyon on the Colorado River, and the Union Pacific Railroad, Las Vegas, still a young town in the later 1930s, was spared the hardships that befell most communities during the Depression years. Though development slowed during the years of World War II, the basis for expansion and growth were sown in 1941 by the building of the famed El Rancho Vegas Hotel Casino. Tommy Hull, an early visionary in resort hotels, believed that even in the desert, if you built a quality property, people would move from the gambling halls of Fremont Street to the two lane highway to the south of downtown, away from the crowds. The El Rancho Vegas stood on the land now owned by the Hughes Corporation that remains vacant at the south end of today's Strip across from the Sahara Hotel.

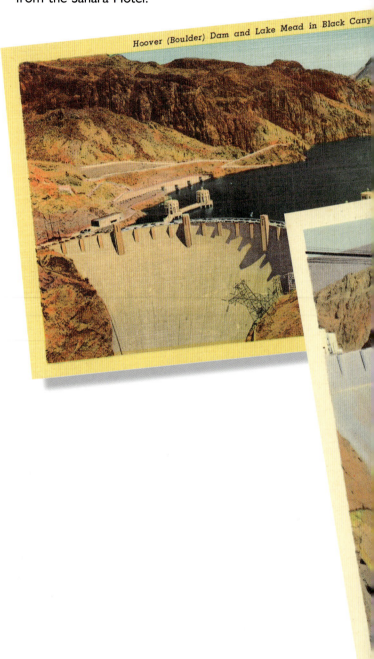

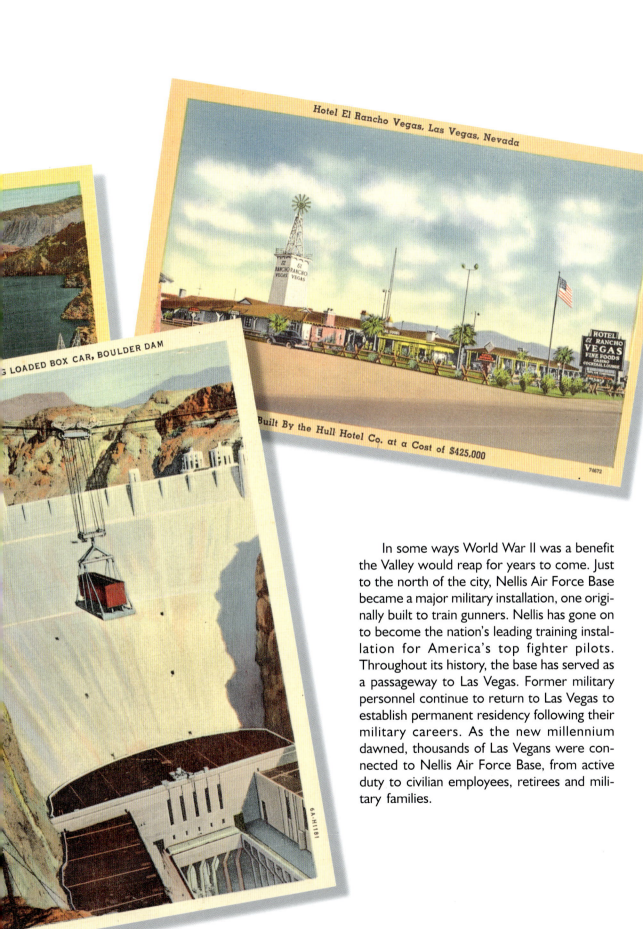

In some ways World War II was a benefit the Valley would reap for years to come. Just to the north of the city, Nellis Air Force Base became a major military installation, one originally built to train gunners. Nellis has gone on to become the nation's leading training installation for America's top fighter pilots. Throughout its history, the base has served as a passageway to Las Vegas. Former military personnel continue to return to Las Vegas to establish permanent residency following their military careers. As the new millennium dawned, thousands of Las Vegans were connected to Nellis Air Force Base, from active duty to civilian employees, retirees and military families.

Chapter 4

From Fremont Street to Las Vegas Boulevard

While the El Rancho Vegas suffered the worst fate imaginable to a resort hotel—a fire which burned the wooden structure to the ground in mid-1960, the hotel's history as the first true resort remains legendary. For it was the success of the El Rancho Vegas that led to the encouragement of others to build on the stretch of highway, Interstate 15, throughout the late 1940s. These hotel/casinos were spread on both sides of the road leading to Los Angeles, and included such long-gone establishments as the Last Frontier, Club Bingo, and the Thunderbird. Through renovations, name changes, and demolitions, the floors of these early hotels, with acres of desert between them, gave a welcome respite to drivers from the desert heat, and a playground for some of Hollywood's most famous celebrities. It didn't hurt business either that Nevada boasted the most liberal divorce laws in the country. A simple six week residency was all that was required to finalize the end of a marriage, and this law was taken advantage of by many . . . as are the liberalized marriage requirements, or lack of them!

Of all the early hotels, none provided more press and interest in Las Vegas than the structure that was the vision of Benjamin (Bugsy) Siegel, a member of the Meyer Lansky crime organization, who in the mid-1940s vowed to build a playground in the desert. With funding provided by organized crime, Siegel built the "Fabulous Flamingo," a hotel/casino resort unlike any other in the desert. With its large neon flamingo sign visible for miles on the highway leading to town, the Flamingo was a playground for the stars and well-to-do. From its poolside to the pink flamingos on the lawn, the Flamingo was built well over budget and was believed by the Lansky organization to be their boondoggle in the desert.

With Sophie Tucker opening on stage on New Year's Eve 1946, the Flamingo drew in less than the expected crowds Siegel had envisioned when he first began his project. A mere six months later, Siegel was found murdered at the home of his girlfriend, actress Virginia Hill, in the living room of her Beverly Hills home. His death was widely attributed to his failure to generate the income from casino gambling necessary to recoup the "family's" major desert investment. A few short years later, the building boom that was to follow in the 1950s confirmed Siegel's vision.

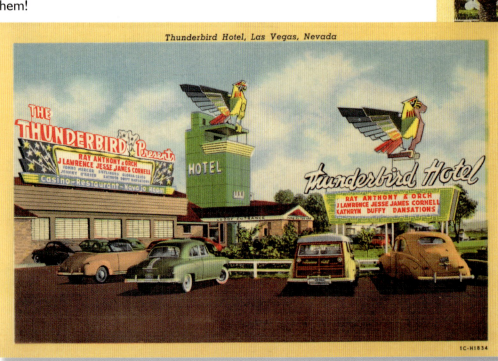

One of the major changes seen by the building of the Flamingo was its departure from the western-style resorts of hotels like the El Rancho Vegas. Siegel referred to his Flamingo as a "carpet joint" and not a gambling hall. Taking its cues from hotel resorts in Miami, Florida, the Flamingo Hilton is the only hotel from the early modern era of hotel casinos to retain its name. The hotel added Hilton to the name when Conrad Hilton purchased it in the 1970s. To see the hotel today, you would not recognize it from its original design. From the addition of six towers to the bulldozing of the last portion of the original hotel, including the Bugsy Siegel Suite, it is nearly impossible to imagine this two-story resort sitting in the desert with nothing surrounding it but sagebrush and dust.

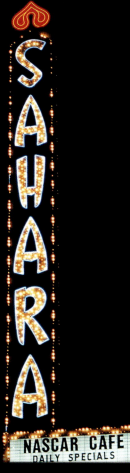

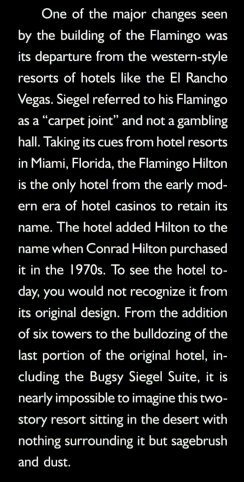

The 1950s saw the first wave of building that was to transform Las Vegas from a mere downtown of gambling and outlying strip of resorts to a destination that would generate the type of excitement for which the Las Vegas valley continues to be known for today.

From Wilbur Clark's Desert Inn—offering guests unobstructed views of the Las Vegas Valley from the hotel/casino's Skyroom high atop the third floor—to the Riviera Hotel—which boasted rooms at nine stories above the Strip, resorts were built throughout the 1950s, each trying to outdo the other, a trend that has continued in cycles for decades.

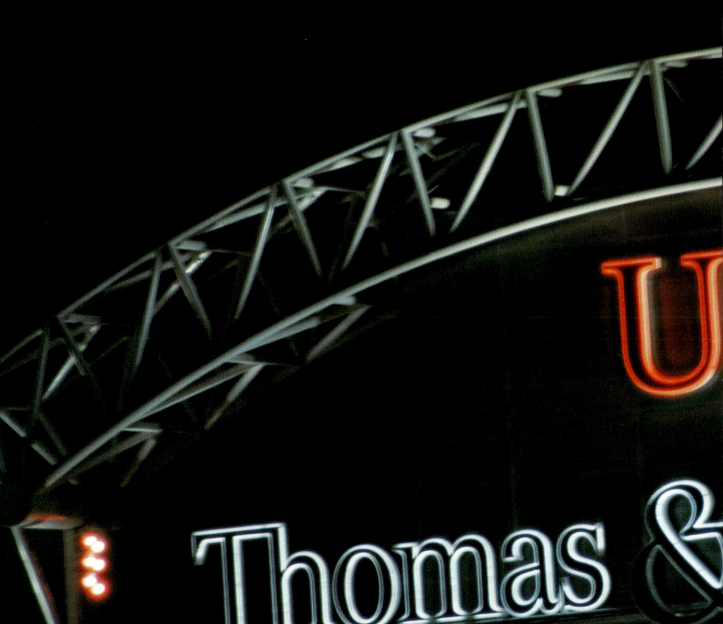

Hundreds of conventions and meetings are held throughout Las Vegas in the hotel casinos and convention center each year. Whether it's the world's largest electronics convention or the largest computer technology convention, Las Vegas relies on price, service, and the allure of the casinos to attract conventioneers and maintain its status as the convention capital of the world.

The building boom of the 1950s brought hotel/casinos to the Strip, including the Dunes, Hacienda (the furthest hotel from Downtown and the first one would come upon when arriving from California), the Tropicana, and Stardust. Downtown saw its own expansion with the addition of the Fremont Hotel Casino, as well as additions to other well-known spots from one end of Fremont Street to the other.

Of interest and in keeping with the times, the Moulin Rouge opened in 1955, a time when blacks were unwelcome guests at the hotels on the Strip. Black entertainers of Strip hotels were required to live off premises. And while the Moulin Rouge was a popular spot with whites and blacks, it was built off the Strip to accommodate the black population of Las Vegas. So well known was this hotel that heavyweight-boxing champion Joe Louis served as an owner and host for many years. The hotel closed and reopened many times over the years, and the building was declared a national historical site in 1992.

It became apparent to civic leaders in the 1950s that in order for Las Vegas to grow and continue to fill hotel rooms during slow tourist times, a convention center would be needed. Set one block east off the Las Vegas Strip, a state of the art 6,000+ seat silver-domed rotunda and 90,000 square foot exhibition hall opened in 1959. While the convention center still sits on its original site, its hallmark silver-dome was demolished in 1990 to allow for a major expansion of exhibitor space to 1.3 million square feet, making it one of the world's largest single story convention halls.

Chapter 5

That's Entertainment

Self-proclaimed the "Entertainment Capital of the World," Las Vegas has grown and evolved in more ways than just gaming. Entertainment for all ages has been nearly as important in maintaining and enhancing Las Vegas' allure for travelers since the 1940s when the El Rancho Vegas was the only resort on the Las Vegas Strip. Singers, dancers, comedians, strippers, and an array of performers were booked into the small, intimate showroom of the El Rancho Vegas.

Sophie Tucker, Jimmy Durante, Milton Berle, and Liberace were just a few of the stars you would see on the hotel's marquee. Each subsequent hotel would copy their predecessors by adding stars of stage, radio, and television, performing twice daily for a week or more. Although Elvis Presley's first foray into Las Vegas in the 1950s was considered a flop and he would not return until 1969, he then began a run as the most popular entertainer in Las Vegas, staging his shows from the International Hotel, later renamed the Las Vegas Hilton, off the Las Vegas Strip near the convention center. It was not uncommon to have every showroom filled twice nightly with names like Joe E. Lewis, Dean Martin and Jerry Lewis, Benny Goodman, Jack Benny, Frank Sinatra, Sammy Davis Jr., and many others.

One hotel broke with what was becoming an early Strip tradition by bringing a stage spectacular to audiences as its feature entertainment. The Stardust Hotel Casino staged the French import, *Lido de Paris,* and the show was quickly acclaimed a greater spectacle than the original overseas performance had ever been.

And, as with everything in Las Vegas, it seems that success brings on more success. The Tropicana brought the *Folies Bergere*, the longest running stage show, to its showroom not long after the Stardust experienced success with its *Lido* show. And though the Dunes, one of the first major hotels of the "golden era" of Las Vegas, was imploded to make way for the Mirage Resort in 1993, Minsky's *Follies*, opening in 1957, was the first topless show to make its debut on the Las Vegas Strip.

Besides the hotels main showrooms, their lounges became wonderful training grounds for future stars and served as an effective means to keep customers in the casino. Providing continuous entertainment from dawn till dusk and back to dawn again, lounges offered free drinks and major celebrity attractions such as Buddy Hackett, Don Rickles, Alan King, Louis Prima and Keely Smith, and the man who became synonymous with the Las Vegas lounge, Shecky Greene.

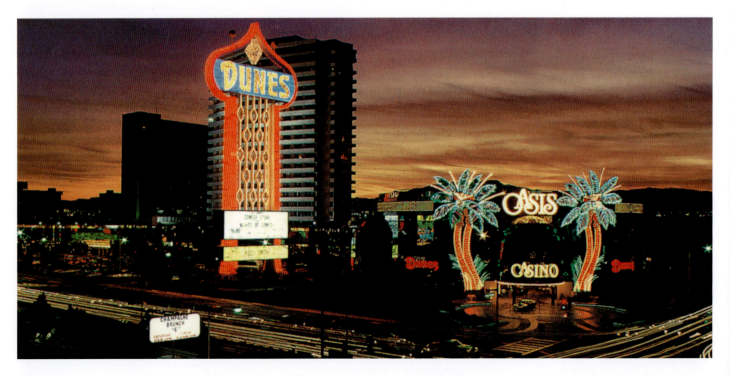

Chapter 6

From Gaming to Resort Capital of the World

As Las Vegas grew in stature, its hotels and casino space became legendary throughout the late 1950s and early 1960s. A change began to occur that became more noticeable around 1960. During the filming of the movie *Oceans Eleven*, which starred Frank Sinatra, Dean Martin, Sammy Davis Jr., Peter Lawford, and Joey Bishop, the antics of what became known as "The Rat Pack" transformed Las Vegas stage shows. After filming, it was not uncommon for these stars to perform at the Sands Hotel Casino in the famed Copa Room to a packed house. Between their ad-libbing, singing, and dancing, the Rat Pack brought playfulness to the Strip for the entire world to see. And after hearing what others had seen, many wanted to experience this excitement themselves. Las Vegas was well on its way to another resurgence and transformation, one that would propel the oasis in the desert through the turbulent 1960s and 1970s and establish the mega resorts of the late 1980s and 1990s, leading Las Vegas into the 21st century.

This transformation began with the first truly acknowledged modern 'mega resort' established mid-way on the Strip and the dream of developer Jay Sarno. From its patrons clad in black dress and dinner jackets, Caesar's Palace Hotel Casino has long epitomized the modern style of Las Vegas. Its intimate, low ceiling casino and large boothed Circus Maximus Showroom featured some of the brightest stars on the Las Vegas Strip. Caesar's Palace has also been used as the setting for numerous movies and television shows. Even with the newest mega resorts built since the early 1990s, "Caesar's" continues to shine brightly on the Strip with its fountains and tall eucalyptus trees set back from the bustle of the Strip.

Contrast the elegance of Caesar's Palace on one end of the then late 1960s Strip with the north end's family oriented Circus Circus Hotel Casino, and the transformation can be seen quite visually, though, in part external forces brought about this transformation. With legalized casino gaming having been passed by the New Jersey State Legislature in the mid-1970s, Resorts International became the first casino/hotel to open on the famed Atlantic City Boardwalk in 1979. Las Vegas could no longer claim exclusive rights to casino gambling. But as Las Vegas has proven time and time again, it is a city that thrives on challenges. Accepting challenges is one of the city's hallmarks, and Las Vegas would do it once more. Critics who decried the demise of Las Vegas did not take into account the ability and willingness of the newest Vegas visionaries, men like Steve Wynn, Kirk Kerkorian, and Bob Stupak, to transform Las Vegas into a true vacation destination resort. Their ambition was to give the public a Las Vegas geared to luring families, the wave of the valley's future, while maintaining a steady stream of conventioneers, gamblers, and vacationers.

Circus Circus, the innovative indoor circus tent casino, with its free overhead aerial acts, was the first of the resorts to market its property specifically to families. With an arcade for the kids on the level overlooking the casino floor, families could safely leave their children to play games of chance for prizes, while the adults spent their monies on games of chance on the casino floor just below. With the opening of its hotel in 1972, Circus Circus became as well known for its large bright neon clown out front as for its giant pink tent casino roof.

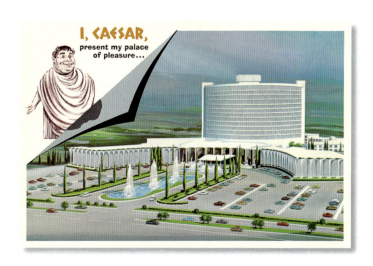

The current Las Vegas incarnation can be traced back to 1989 and the visionary leadership of Steve Wynn. Having bought the old downtown casino, Golden Nugget, Wynn renovated the property to make it an established and luxurious site amongst the gaming halls and hotels of Fremont Street. Wynn showed Las Vegas he had the ability to look beyond the façade of neon and establish resorts that were upscale, elaborate, imposing, and unique in every way . . . every way except one, of course. Casino gaming would still be the draw to keep customers inside and coming back for more, time and time again.

Wynn's Mirage Resort Hotel Casino arose from the desert Strip with some of the most unique sites ever set upon the desert landscape. A living rainforest leads you to the front desk, along with a dolphin pool, waterfalls, a white tiger habitat, and an outdoor man-made volcano belching fire and steam along the Strip every fifteen minutes after dusk. The Mirage set a standard for all others to follow in the decades to come. It also became home to the magical wonders of Siegfried and Roy, whose shows fifteen years earlier at the Frontier brought a new form of entertainment to a city accustomed to celebrities like Paul Anka, Wayne Newton, Ann Margaret, and Juliet Prowse.

Following close behind the Mirage, Circus Circus Enterprises was not to be outdone in the family market. In 1990 an imaginative medieval castle opened across from the Tropicana and what would later become known as the "Four Corners" of Las Vegas. The Excalibur Hotel Casino became a family favorite, with floors devoted to children and non-gaming entertainment, a showroom featuring jousting knights on horseback and food eaten without utensils. William Bennett, Circus Circus chairman, added the most striking design on the Las Vegas Strip.

That is of course until just a few short years later, when Bennett and the world saw the pyramid-shaped Luxor arise from the desert floor. With its mirrored exterior, its beam of light shining brightly into the night sky directly above the hotel—visible to planes nearly 250 miles away, the Luxor is pure spectacle. Its vast inner atrium is large enough to hold nine 747 airplanes stacked one on top of another. All of this, plus a full-scale replica of King Tut's Tomb and the complete renovation of the entrance not more than a year after opening at a cost of millions, was produced in an effort to lure customers from other properties.

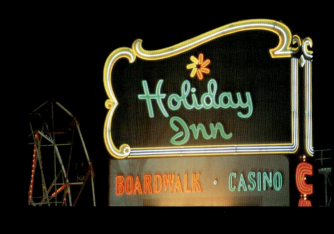

As the decade of the 1990s unfolded, the massive MGM Grand Hotel Casino emerged as one of the most ambitious hotels to be developed in the world. Kirk Kerkorian, a Vegas visionary, who had previously owned the MGM Grand that later was sold to become Bally's after a devastating fire in the mid-1980s, retained the rights to the MGM name. The retention of those rights was an important issue for Kerkorian, for he had intentions of returning to Las Vegas in a grand way. And that is just what he did. Boasting over 5,000 rooms, the world's largest valet parking service, a theme park, showroom, theater, and special events arena for concerts, fights, and other exhibitions, the MGM Grand opened in its entire Wizard of Oz emerald green splendor in 1993. With Barbara Streisand headlining a concert, her first in twenty-seven years, the opening was ensured worldwide coverage, and Kerkorian succeeded with the MGM Grand in a way that forced Steve Wynn to do him one better.

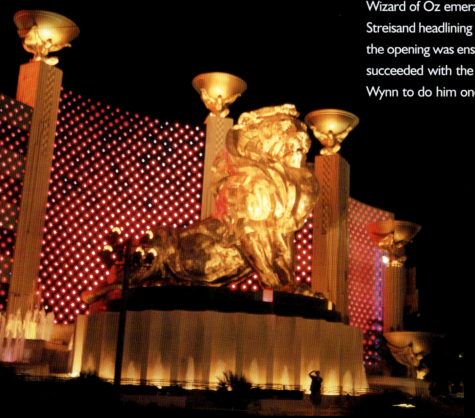

Before Kerkorian could open his New York New York Hotel Casino across the Strip from the MGM Grand, Wynn opened his Treasure Island Resort. With an outdoor British frigate and pirate ship putting on a realistic cannon fight display multiple times each night, the Strip was beginning to find properties expanding from one end to the other. Moving forward from frontage parking lots to mammoth parking garages, hotels had to spend millions to keep up with the new mega resorts built with their entrances right at the Strip's edge. Old venerable establishments like the Sahara, Stardust, Imperial Palace, Harrah's, and the Flamingo are just some of the hotel casinos doing their best with available land to compete with these much larger properties. As hotels and gaming halls come and go, the continued building appears to go on unabated.

In typical Las Vegas fashion, Steve Wynn brought even more class to Las Vegas with his much anticipated Bellagio Resort Hotel Casino. Modeled after a small town in Northern Italy he fell in love with, the Bellagio epitomizes the "new" Las Vegas, one which seeks to lure the middle to upper income gambler, along with their families, to a true destination resort. The Bellagio garden conservatory is a must see for all Las Vegas visitors, and the Bellagio Gallery of Fine Arts broke new barriers by bringing fine art to the Strip and patrons in to view their collections and showings. Not to be outdone by the MGM Lion, which stands guard in all its golden splendor, or the Sphinx of the Luxor, the Bellagio has an outdoor fountain extravaganza that thrills visitors with Wynn's tribute to "Mr. Showmanship" himself, Liberace, with a show of dancing fountains choreographed to the music of Las Vegas: Frank Sinatra, Shirley McLaine, Luciano Pavarotti, and others.

As the Monte Carlo, Mandalay Bay, Paris, Venetian, and Aladdin Hotel Casinos became the latest mega resorts, there seems no end to what Las Vegas will see in the next decade, especially with the selling of Wynn's Mirage Resorts to Kerkorian. Wynn successfully transformed Las Vegas with his singular vision of making what was once a dusty railroad stop on the way to Los Angeles into the most traveled to resort destination in the United States. And even after doing that he is left unsatisfied. To keep himself occupied and others guessing what is in store for the Strip next, Wynn purchased the storied Desert Inn Hotel and Casino. Though the historic PGA championship golf course will remain, much like the implosion of the Dunes, Sands, Landmark, and Aladdin, the older Desert Inn will disappear into Las Vegas lore, only to be replaced by an as yet unnamed resort that will no doubt be as spectacular as any built to date in Las Vegas.

From the top of the Stratosphere Hotel Casino, Bob Stupak has made an indelible impression on Las Vegas and its skyline. From its highest-in-the-world roller coaster you see a valley awash in light. Along what was once a lonely stretch of road, a fascinating transformation from desert oasis to thriving metropolitan city has taken place.

This can be seen up close by spending time back where it all began, Fremont Street. First in the forefront of the gaming industry in Las Vegas, Fremont Street became the city's first paved road in 1925, the first with an electric traffic light, and the site of the first high-rise to grace the downtown scene when, in 1956, the Fremont Hotel was built. Other downtown notables include the Apache Hotel, which in 1932 became the first hotel to have an elevator, and the Horseshoe, which became the first to install carpeting in its casino. While the Strip is known by today's public, Downtown Las Vegas already had thirty-six years of gaming history to its credit when the El Rancho Vegas opened its doors on what would later become known as the Las Vegas Strip in 1941.

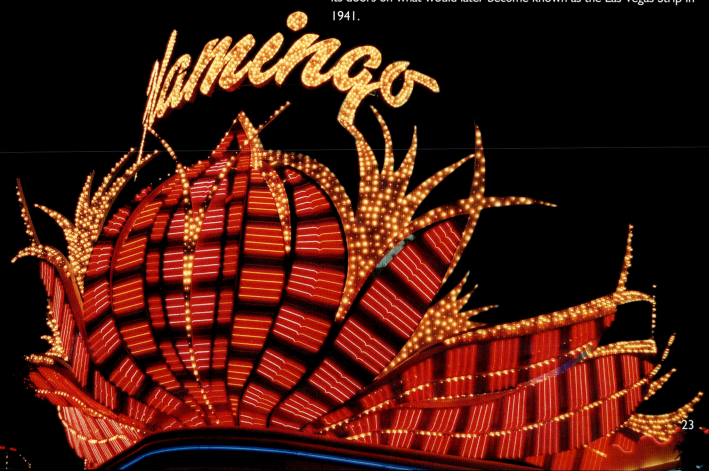

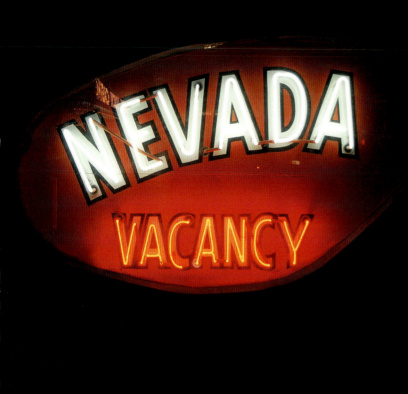

What was once just blocks of gaming halls and hotels has been transformed in a way unlike the Strip, but not dissimilar in purpose, to draw gamblers and families to play and pay. The Fremont Street Experience has become a successful cooperative effort on the part of the downtown hotel casinos to launch an extravagant project that has wrapped a four block section of the downtown area in light and sound. Where once cars traveled back and forth and teenagers showed off their "souped-up" hot rods, Fremont Street has been turned into a pedestrian mall, complete with roving musicians, clowns, and souvenir kiosks. Young ladies with enticing smiles and coupons sure to lead you to riches can continue to lure you into the casino though. You can also still have your picture taken at Benny Binion's Horseshoe Million Dollar window—though it doesn't seem as if a million goes as far as it once did when Binion first came up with this gimmick to lure people into his establishment decades ago. The 1.5 million lights of the Fremont Street Experience provide a multi-sensory show that combines the theatrical experiences of light, sound, and movement.

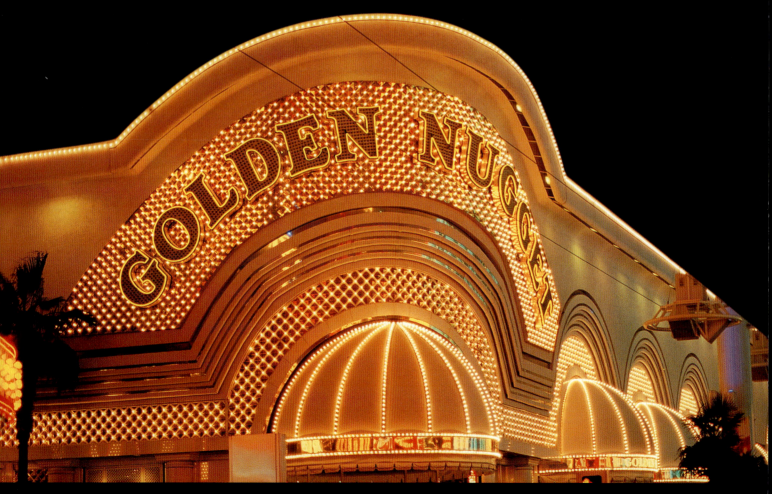

From the Hard Rock Hotel/Casino to Lake Las Vegas, from Sunset Station and the Rio to Sam's Town and Boulder Station, much continues to grow in Las Vegas. Boulder Highway runs from East to West into Fremont Street, and as the twenty-first century progresses is fast becoming the latest growth area in Las Vegas, thus being dubbed, "Boulder Strip."

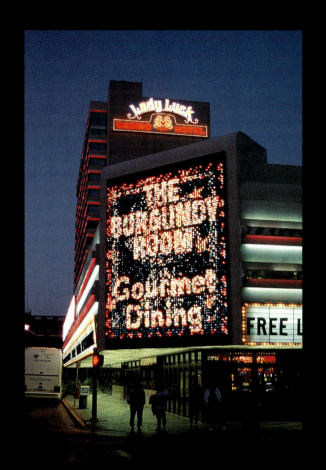

Where it will end is anyone's guess. The nay sayers have been proven wrong again and again over the decades. Las Vegas proves that behind the cascading lights and incandescent radiating bulbs, the stationary neon of the old motels, the jumbo signs, and moveable computer imaging of the mega resorts, the city will continue to grow and expand to the foothills of the mountains that surround the Las Vegas Valley.

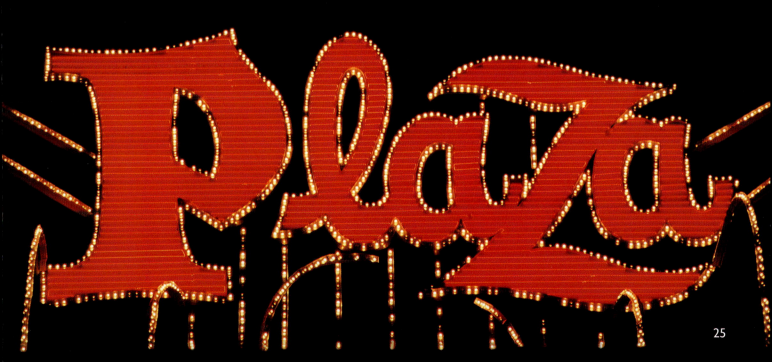

Chapter 7

Neon Radiates from the Desert

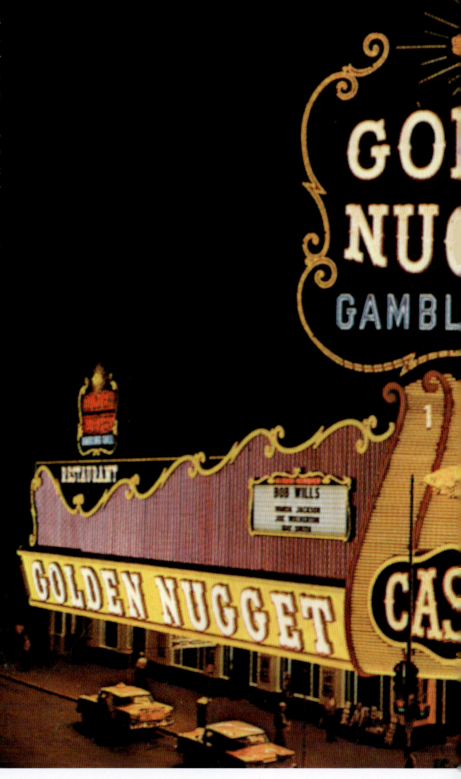

A discussion of the history of Las Vegas lights would be incomplete without acknowledging the works of Thomas Young, founder of the Young Electric Sign Company (YESCO) in Las Vegas. YESCO is the acknowledged founder of Las Vegas neon. In 1929, Young, a lighting businessman from Utah, installed a neon sign in the Fremont Street Oasis Club gaming hall and sparked a revolution of light that would grow to emblazon the desert for generations to come.

Because of its unique properties and decorative effects, neon became the choice of light throughout Las Vegas, invading the expanding town in the 1940s and 1950s. Every hotel tried to outdo the other, a Las Vegas tradition that still goes on today. From the first freestanding 40-foot sign of the Boulder Club Downtown, with its vertical letters, to the Frontier Club, and most importantly in establishing Las Vegas' identity to the world at large, the Pioneer Club—where Vegas Vic has become an endearing presence greeting visitors for decades, neon signs became ever more extravagant. The grand prize for neon in its earlier days goes to the Golden Nugget with its 100-foot high golden-yellow lit sign that was a hallmark of light for nearly 50 years until the late 1980s.

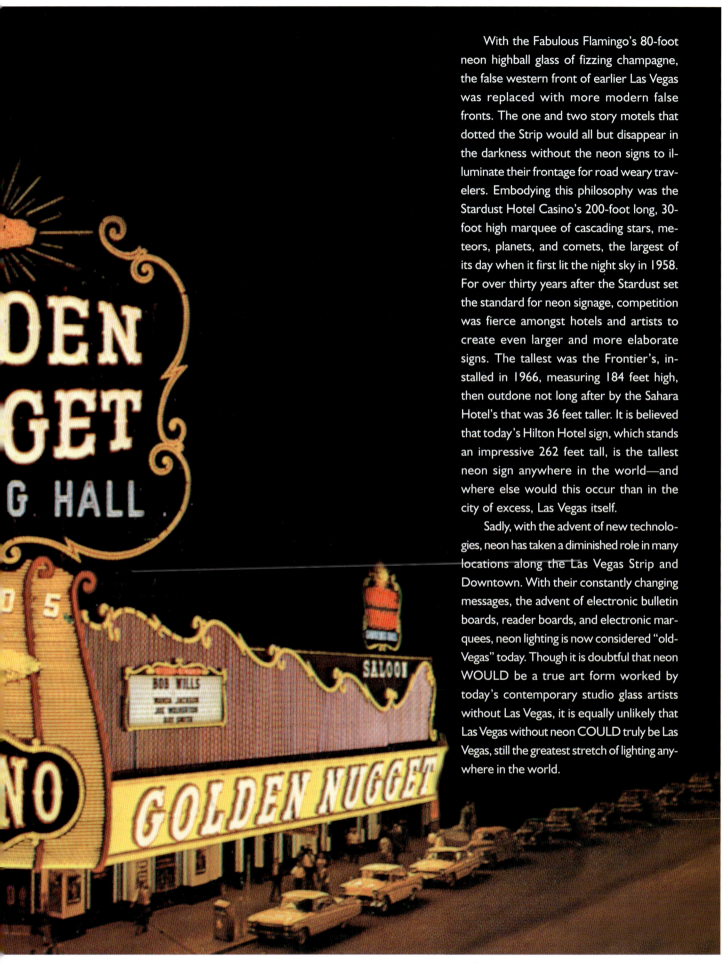

With the Fabulous Flamingo's 80-foot neon highball glass of fizzing champagne, the false western front of earlier Las Vegas was replaced with more modern false fronts. The one and two story motels that dotted the Strip would all but disappear in the darkness without the neon signs to illuminate their frontage for road weary travelers. Embodying this philosophy was the Stardust Hotel Casino's 200-foot long, 30-foot high marquee of cascading stars, meteors, planets, and comets, the largest of its day when it first lit the night sky in 1958. For over thirty years after the Stardust set the standard for neon signage, competition was fierce amongst hotels and artists to create even larger and more elaborate signs. The tallest was the Frontier's, installed in 1966, measuring 184 feet high, then outdone not long after by the Sahara Hotel's that was 36 feet taller. It is believed that today's Hilton Hotel sign, which stands an impressive 262 feet tall, is the tallest neon sign anywhere in the world—and where else would this occur than in the city of excess, Las Vegas itself.

Sadly, with the advent of new technologies, neon has taken a diminished role in many locations along the Las Vegas Strip and Downtown. With their constantly changing messages, the advent of electronic bulletin boards, reader boards, and electronic marquees, neon lighting is now considered "old-Vegas" today. Though it is doubtful that neon WOULD be a true art form worked by today's contemporary studio glass artists without Las Vegas, it is equally unlikely that Las Vegas without neon COULD truly be Las Vegas, still the greatest stretch of lighting anywhere in the world.

Chapter 8

Las Vegas Lights
Downtown

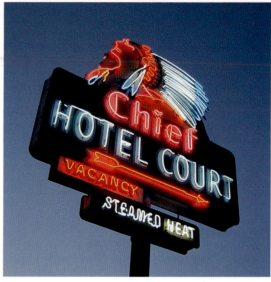

Figure 1. Downtown. Neon Museum. Chief Hotel Court. Stationary neon.

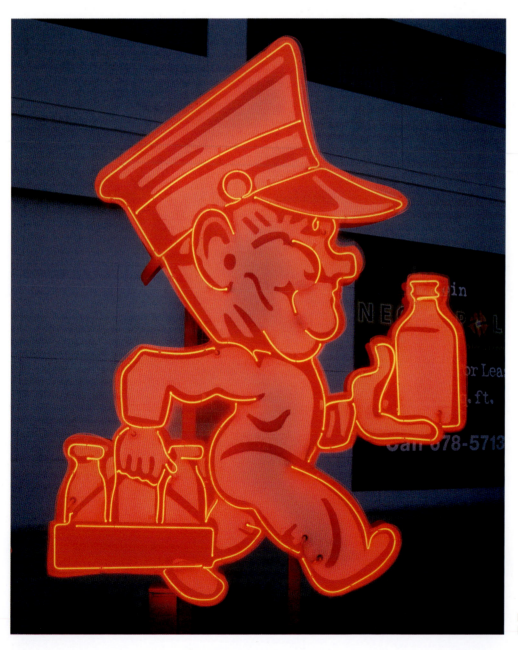

Figure 2. Downtown. Neon Museum. Milk Man sign. Stationary neon.

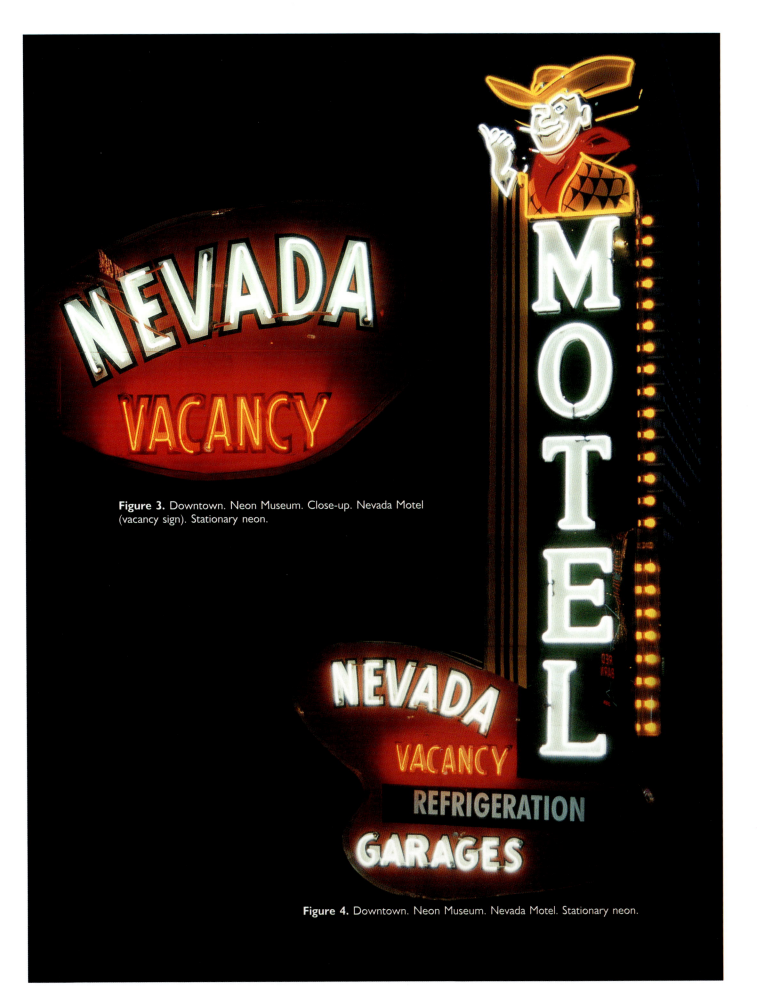

Figure 3. Downtown. Neon Museum. Close-up. Nevada Motel (vacancy sign). Stationary neon.

Figure 4. Downtown. Neon Museum. Nevada Motel. Stationary neon.

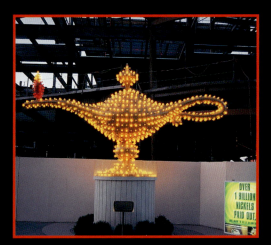

Figure 6. Downtown. Neon Museum. Original Aladdin Hotel Casino lamp. Incandescent bulbs.

Figure 5. Downtown. Neon Museum. Close-up. Nevada Motel

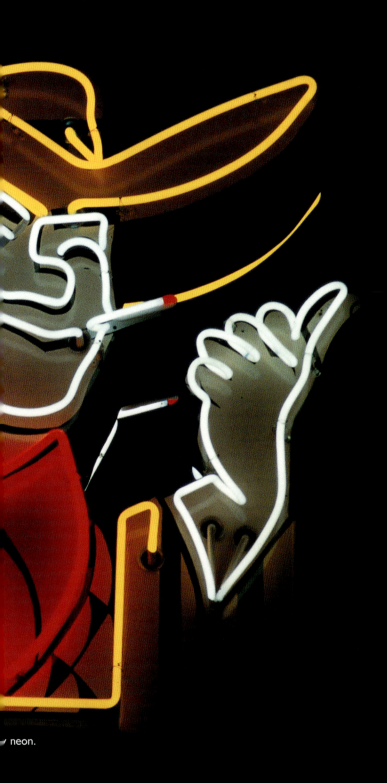

neon.

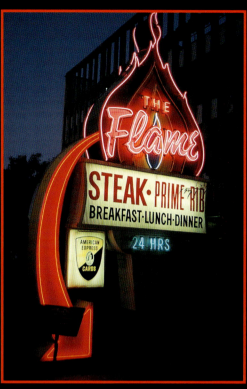

Figure 7. Downtown. Neon Museum. The Flame Steak House. Stationary neon.

31

Figure 8. Downtown. Neon Museum. Rider on horse in daylight. Stationary neon and flickering incandescent bulbs.

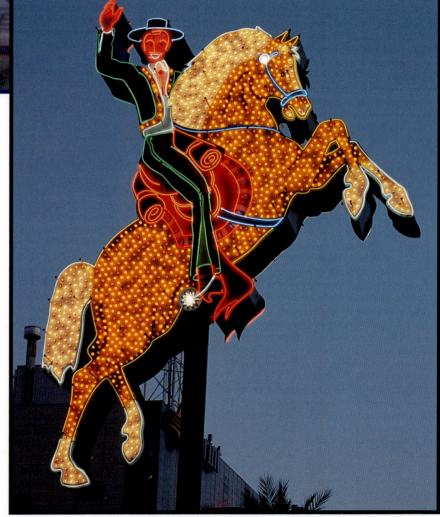

Figure 9. Downtown. Neon Museum. Sign in Figure 8, at dusk. Stationary neon and flickering incandescent bulbs.

32

Figure 11. Downtown. Neon Museum. Wedding Information. Neon with incandescent bulbs.

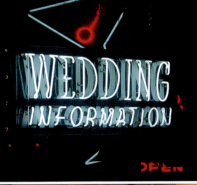

Figure 10. Downtown. Neon Museum. Red Barn Cocktail Lounge. Stationary neon.

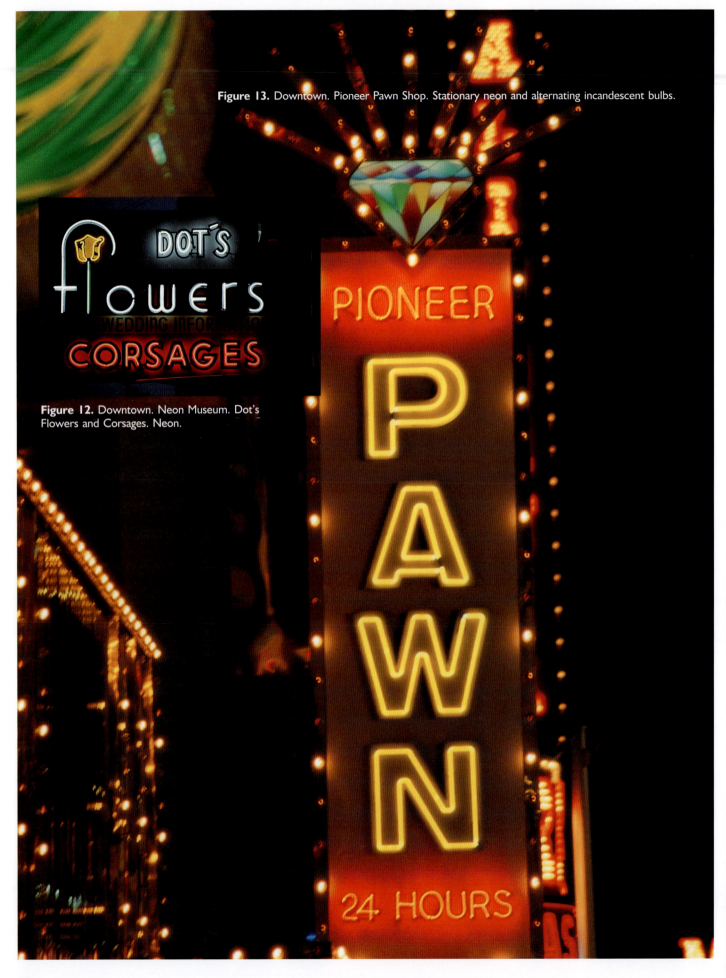

Figure 13. Downtown. Pioneer Pawn Shop. Stationary neon and alternating incandescent bulbs.

Figure 12. Downtown. Neon Museum. Dot's Flowers and Corsages. Neon.

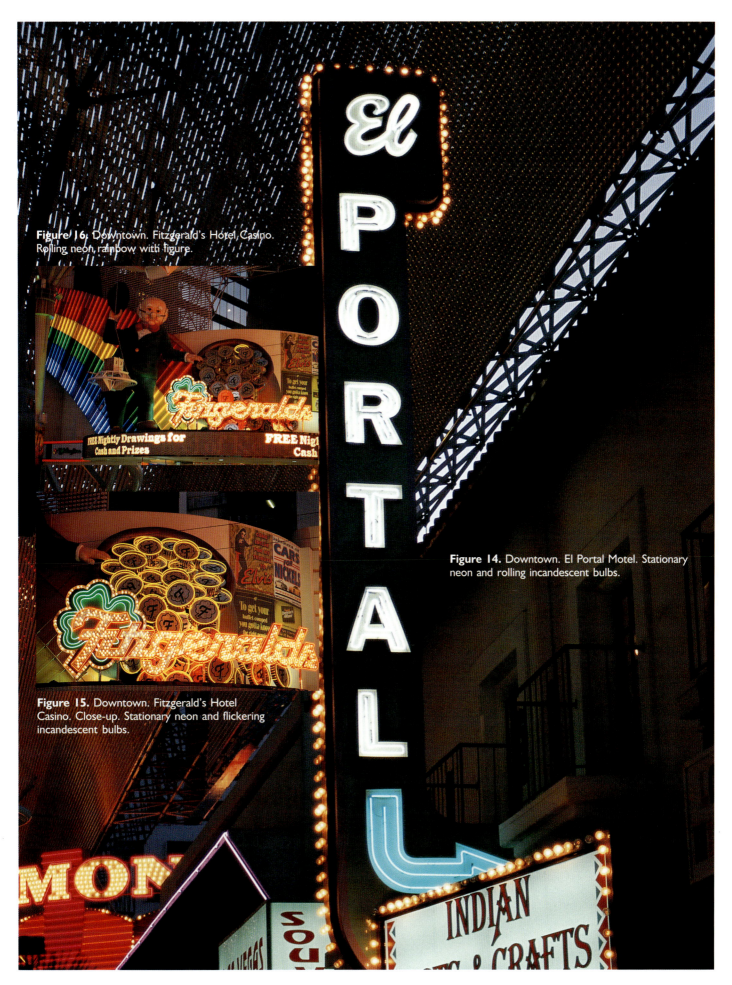

Figure 16. Downtown. Fitzgerald's Hotel Casino. Rolling neon, rainbow with figure.

Figure 15. Downtown. Fitzgerald's Hotel Casino. Close-up. Stationary neon and flickering incandescent bulbs.

Figure 14. Downtown. El Portal Motel. Stationary neon and rolling incandescent bulbs.

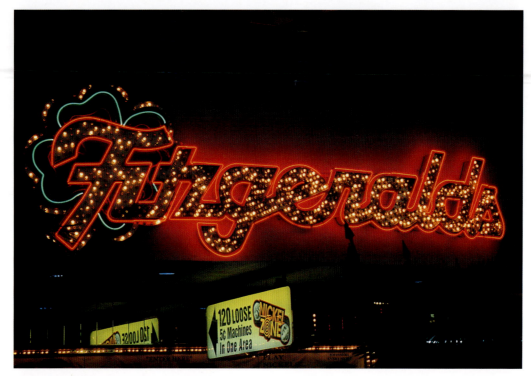

Figure 17. Downtown. Fitzgerald's Hotel Casino. Close-up. Neon outline with flickering incandescent bulbs.

Figure 18. Downtown. Golden Nugget Hotel Casino. Stationary neon with stationary incandescent bulbs.

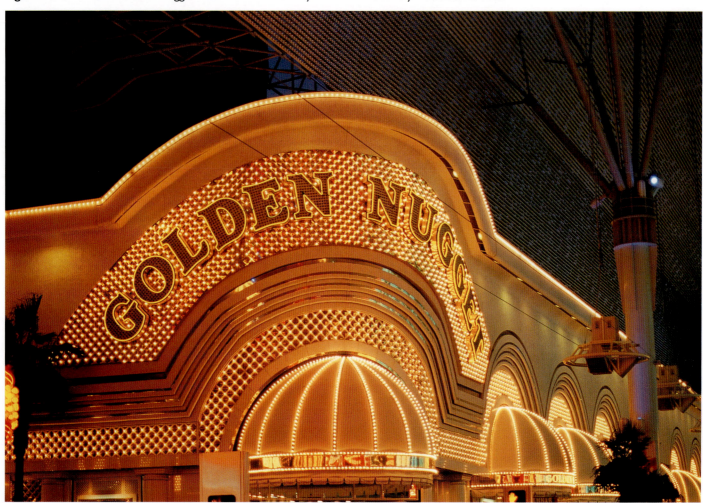

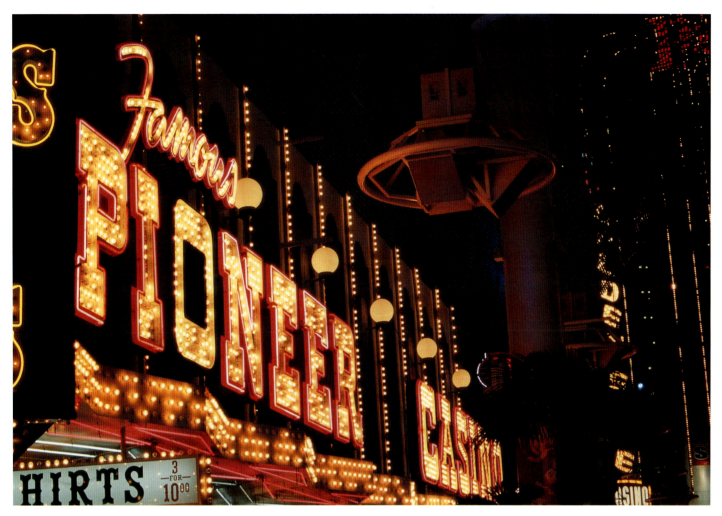

Figure 20. Downtown. Famous Pioneer Club Casino. Neon outline with flickering incandescent bulbs.

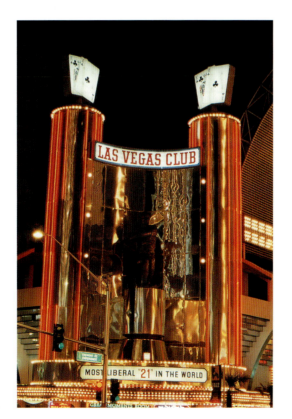

Figure 19. Downtown. Las Vegas Club Hotel Casino. Stationary neon with mirror.

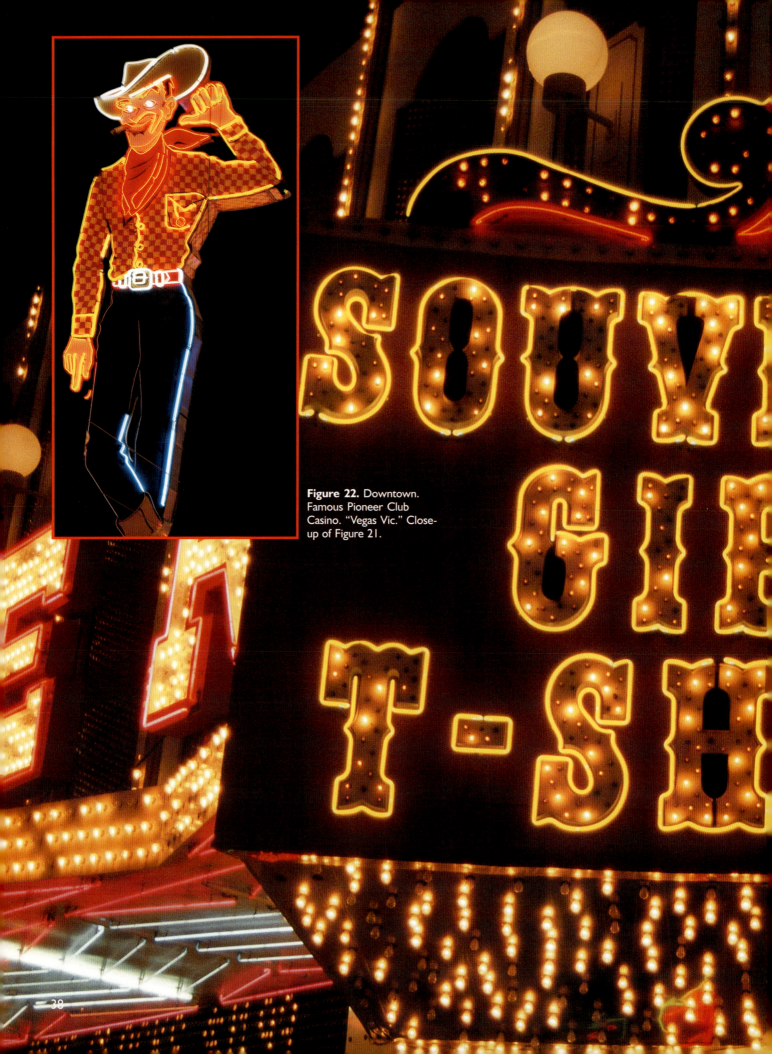

Figure 22. Downtown. Famous Pioneer Club Casino. "Vegas Vic." Close-up of Figure 21.

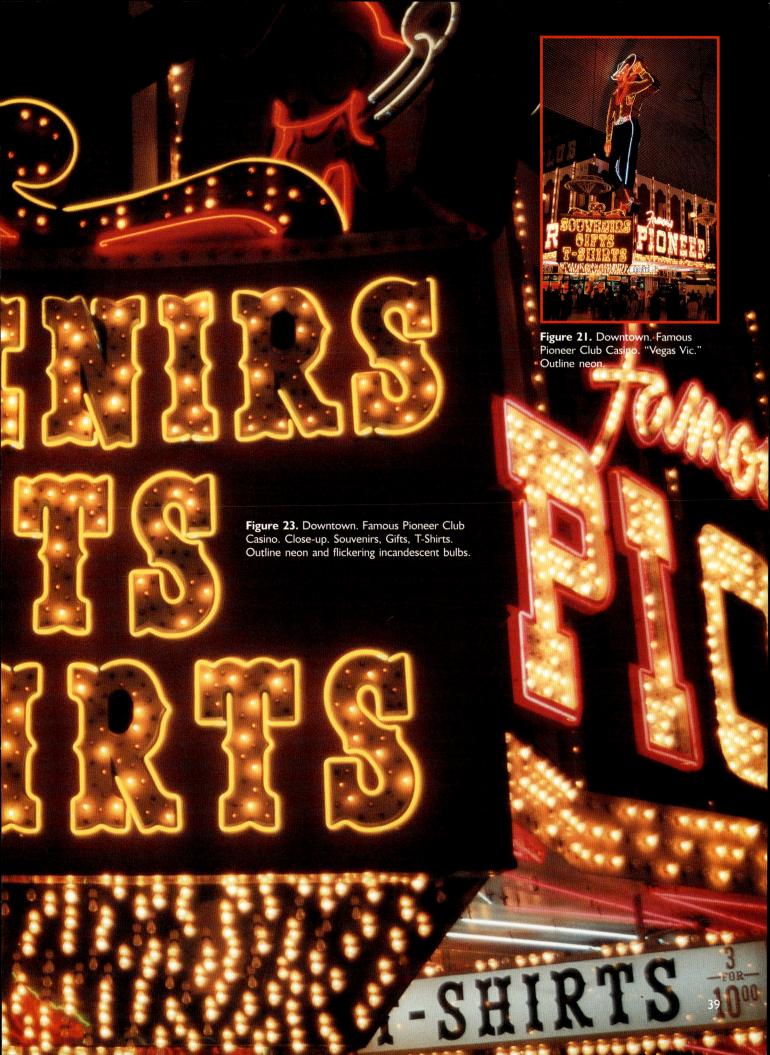

Figure 21. Downtown. Famous Pioneer Club Casino. "Vegas Vic." Outline neon.

Figure 23. Downtown. Famous Pioneer Club Casino. Close-up. Souvenirs, Gifts, T-Shirts. Outline neon and flickering incandescent bulbs.

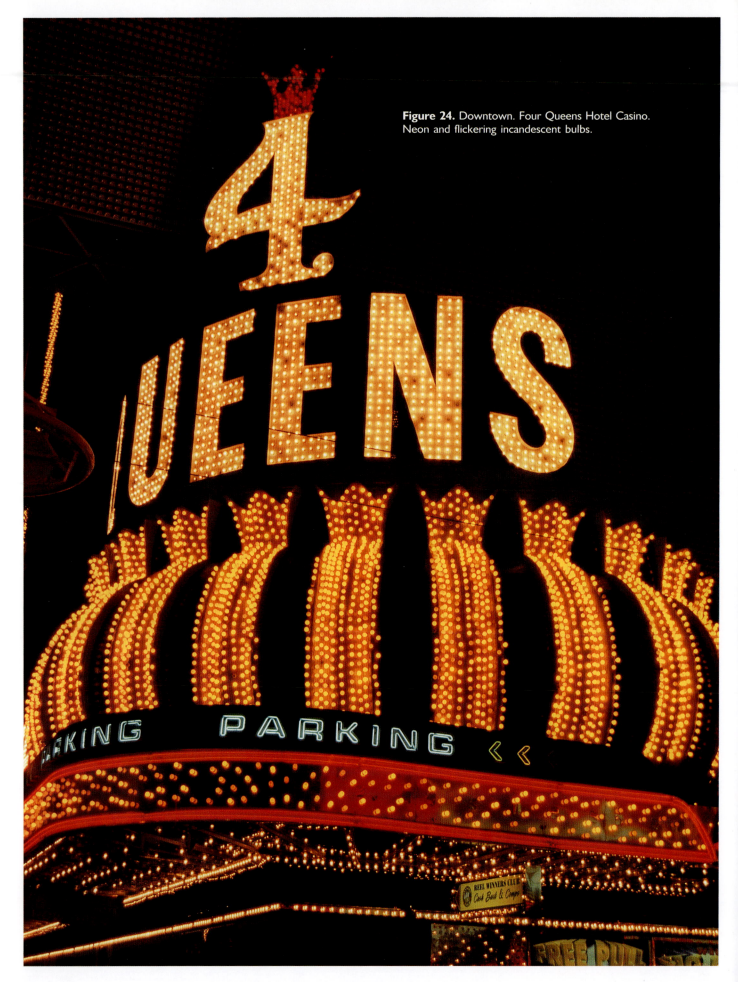

Figure 24. Downtown. Four Queens Hotel Casino. Neon and flickering incandescent bulbs.

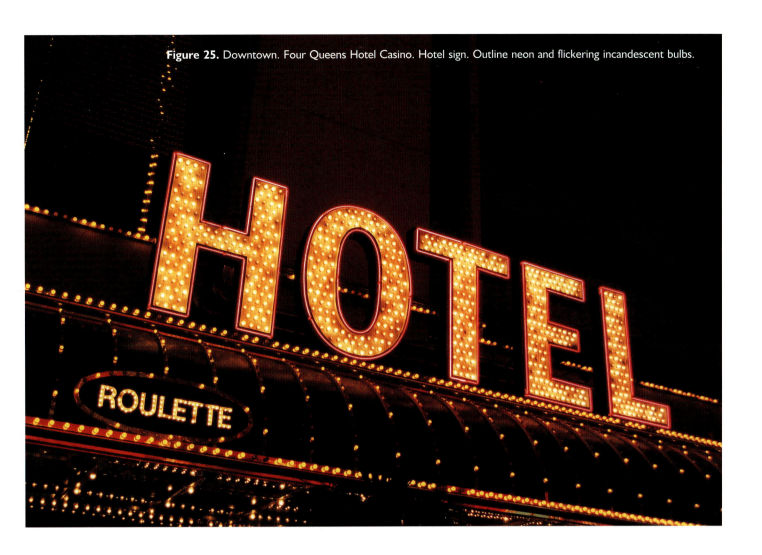

Figure 25. Downtown. Four Queens Hotel Casino. Hotel sign. Outline neon and flickering incandescent bulbs.

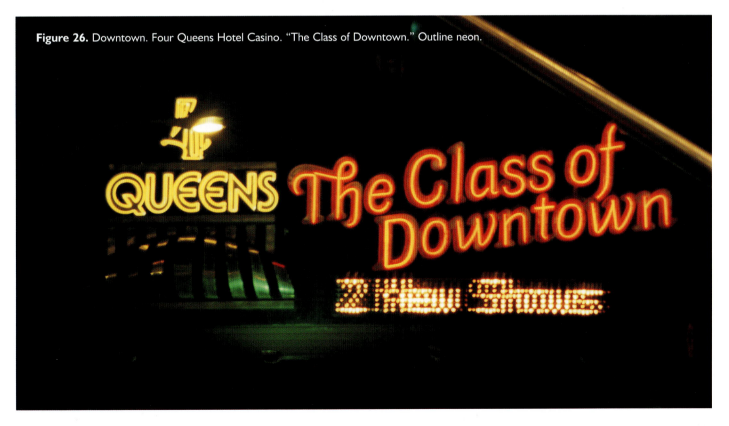

Figure 26. Downtown. Four Queens Hotel Casino. "The Class of Downtown." Outline neon.

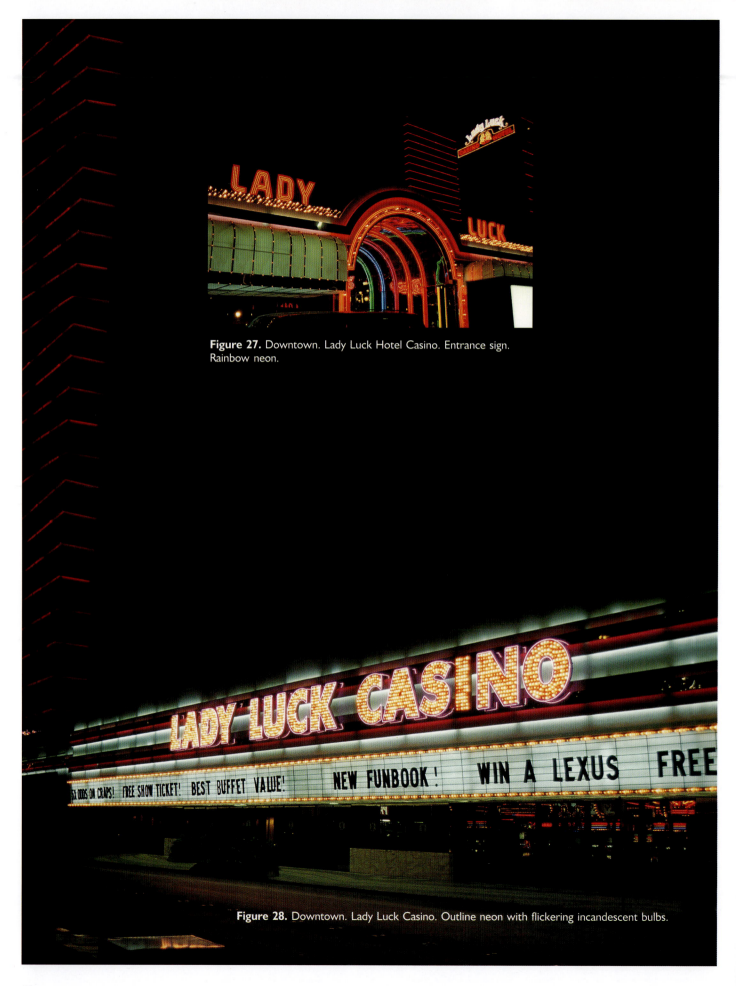

Figure 27. Downtown. Lady Luck Hotel Casino. Entrance sign. Rainbow neon.

Figure 28. Downtown. Lady Luck Casino. Outline neon with flickering incandescent bulbs.

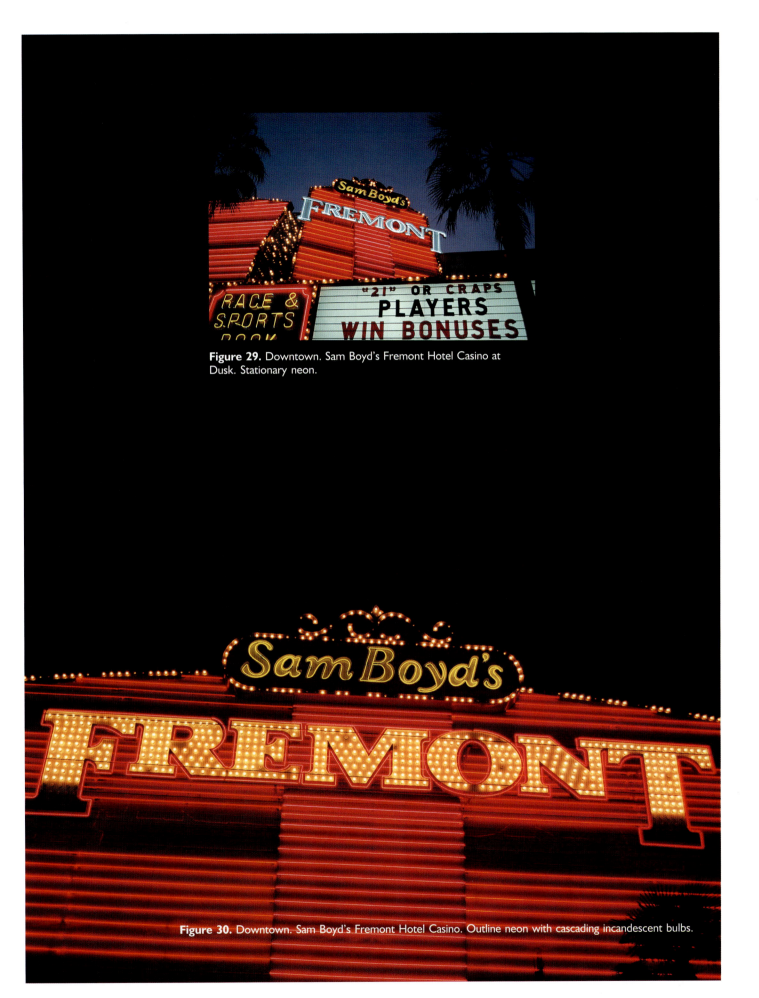

Figure 29. Downtown. Sam Boyd's Fremont Hotel Casino at Dusk. Stationary neon.

Figure 30. Downtown. Sam Boyd's Fremont Hotel Casino. Outline neon with cascading incandescent bulbs.

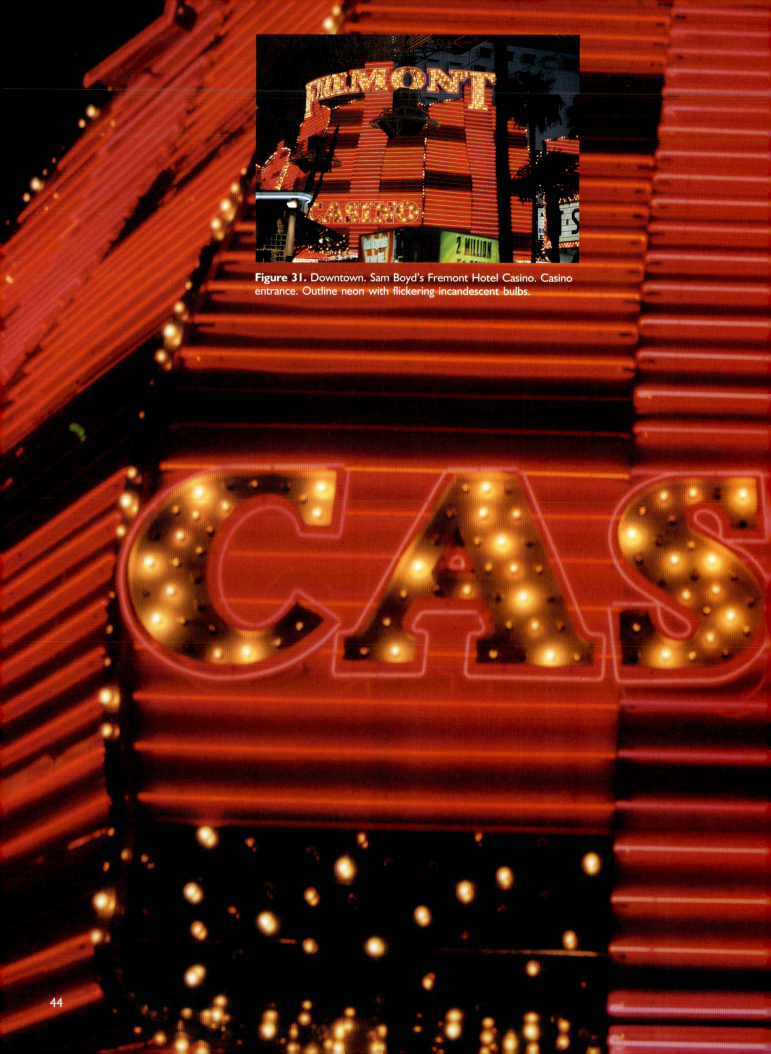

Figure 31. Downtown. Sam Boyd's Fremont Hotel Casino. Casino entrance. Outline neon with flickering incandescent bulbs.

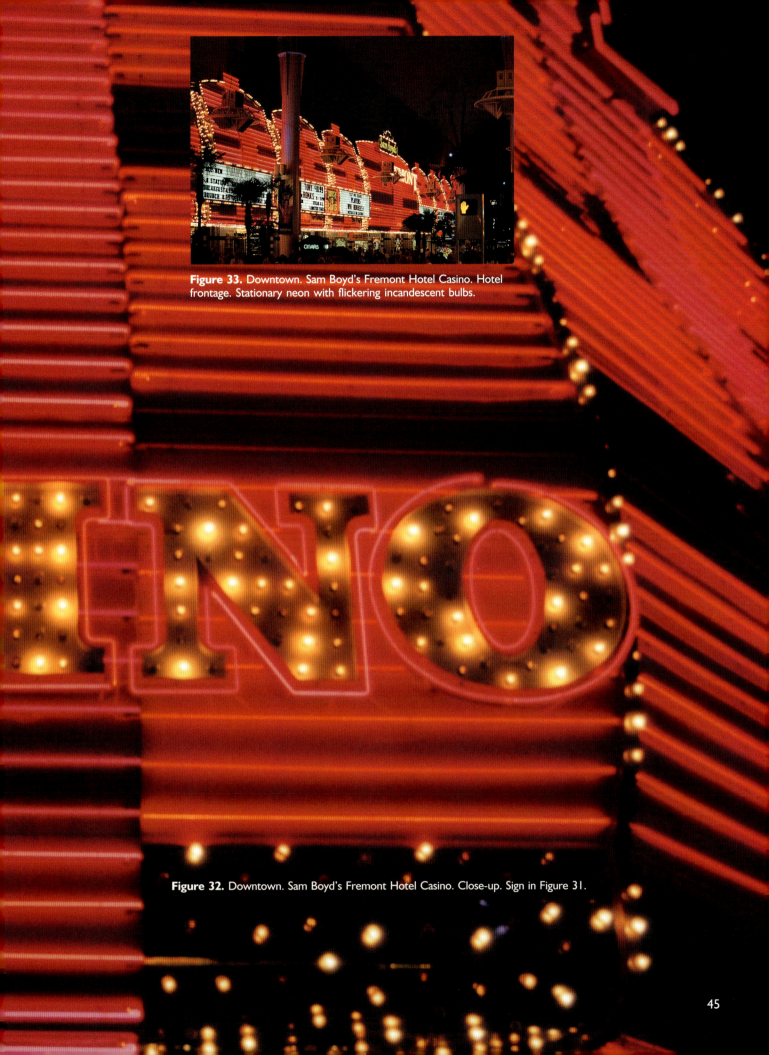

Figure 33. Downtown. Sam Boyd's Fremont Hotel Casino. Hotel frontage. Stationary neon with flickering incandescent bulbs.

Figure 32. Downtown. Sam Boyd's Fremont Hotel Casino. Close-up. Sign in Figure 31.

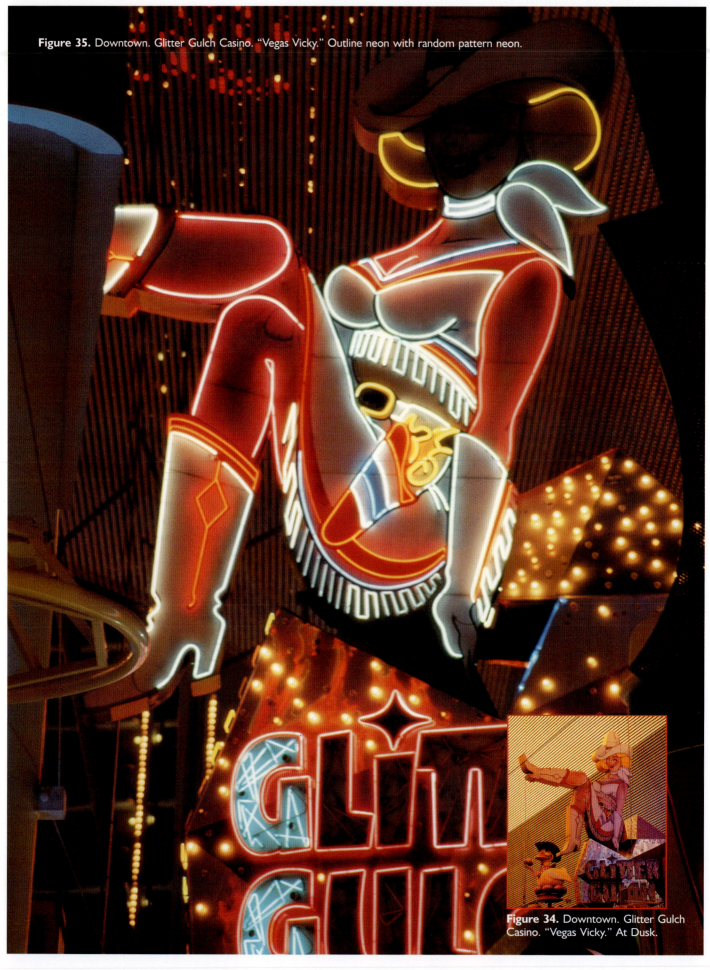

Figure 35. Downtown. Glitter Gulch Casino. "Vegas Vicky." Outline neon with random pattern neon.

Figure 34. Downtown. Glitter Gulch Casino. "Vegas Vicky." At Dusk.

Figure 37. Downtown. Glitter Gulch Casino and Golden Goose Casino. Assorted neon and incandescent bulbs.

Figure 36. Downtown. Glitter Gulch Casino. Close-up of Figure 35. Outline neon, random pattern neon, cascading neon, and flickering incandescent bulbs.

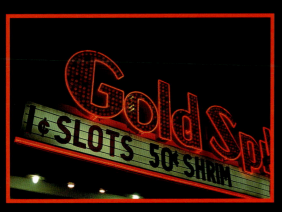

Figure 38. Downtown. Gold Spike Casino. Close-up. Outline neon and flickering incandescent bulbs.

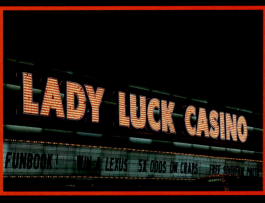

Figure 39. Downtown. Lady Luck Casino Hotel. Stationary neon and flickering incandescent bulbs.

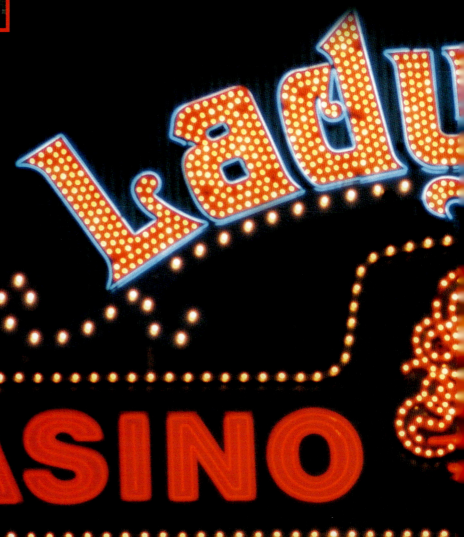

Figure 40. Downtown. Lady Luck Casino. Casino frontage. Outline neon, incandescent, and fluorescent lights.

Figure 41. Downtown. Lady Luck Casino Hotel. Marquee sign. Stationary neon, alternating incandescent bulbs.

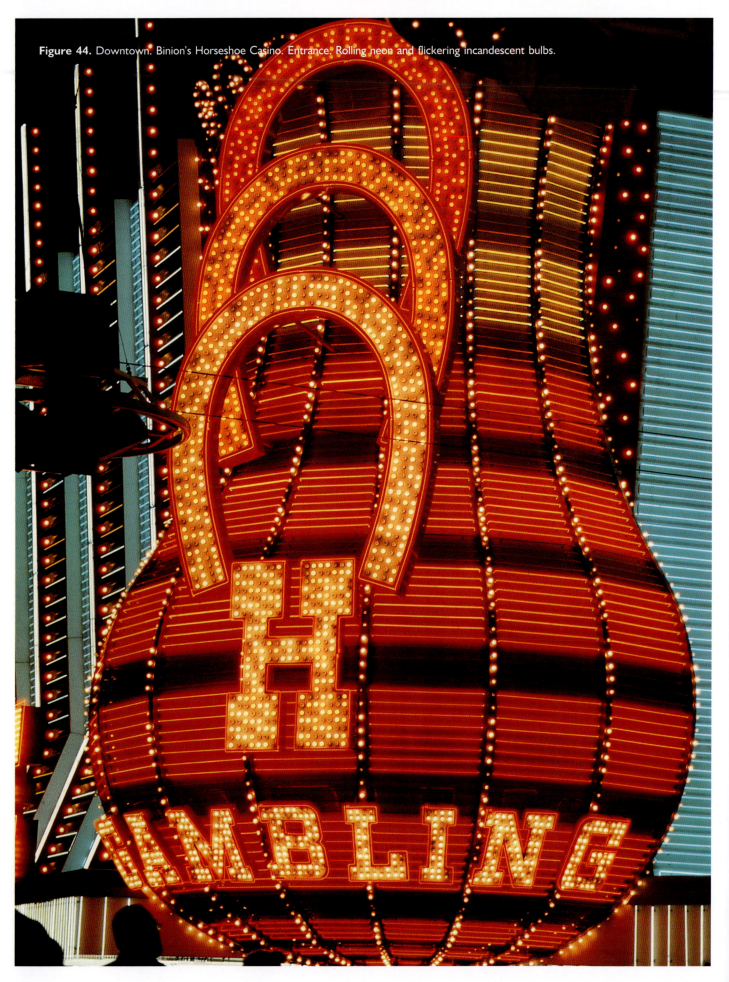

Figure 44. Downtown. Binion's Horseshoe Casino. Entrance. Rolling neon and flickering incandescent bulbs.

Figure 43. Downtown. Binion's Horseshoe Hotel Casino. Stationary neon and flickering incandescent bulbs.

Figure 42. Downtown. Binion's Horseshoe Casino. Entrance. Outline neon, stationary incandescent, and flickering incandescent bulbs.

Figure 45. Downtown. Binion's Horseshoe Casino. Close-up of Figure 44.

Figure 48. Downtown. Binion's Horseshoe Casino. Parking. Stationary neon and rolling incandescent bulbs.

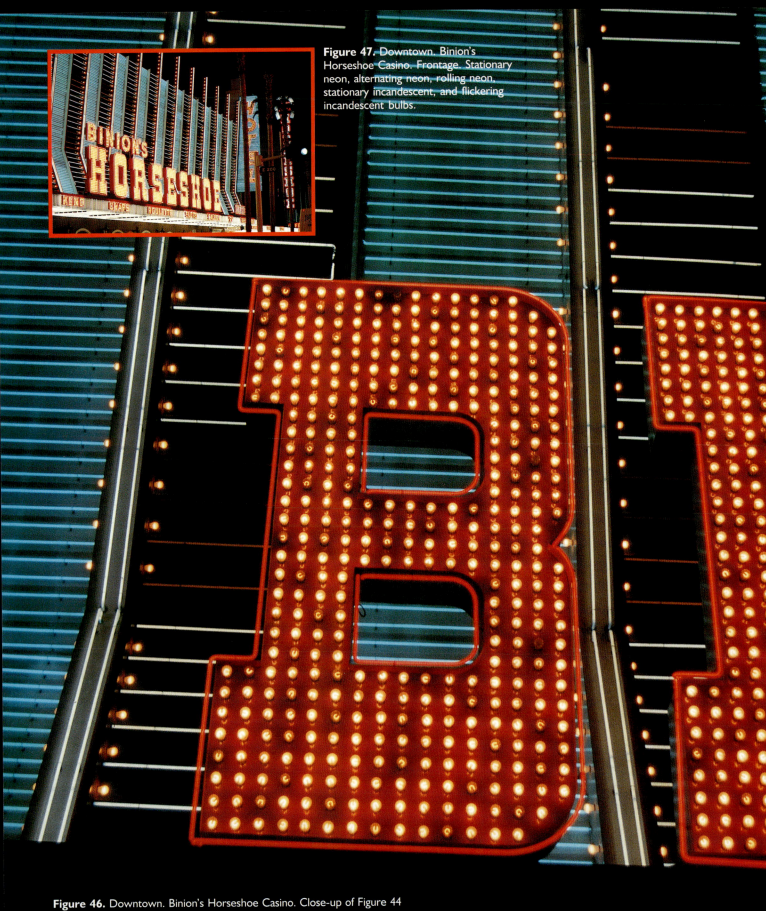

Figure 47. Downtown. Binion's Horseshoe Casino. Frontage. Stationary neon, alternating neon, rolling neon, stationary incandescent, and flickering incandescent bulbs.

Figure 46. Downtown. Binion's Horseshoe Casino. Close-up of Figure 44

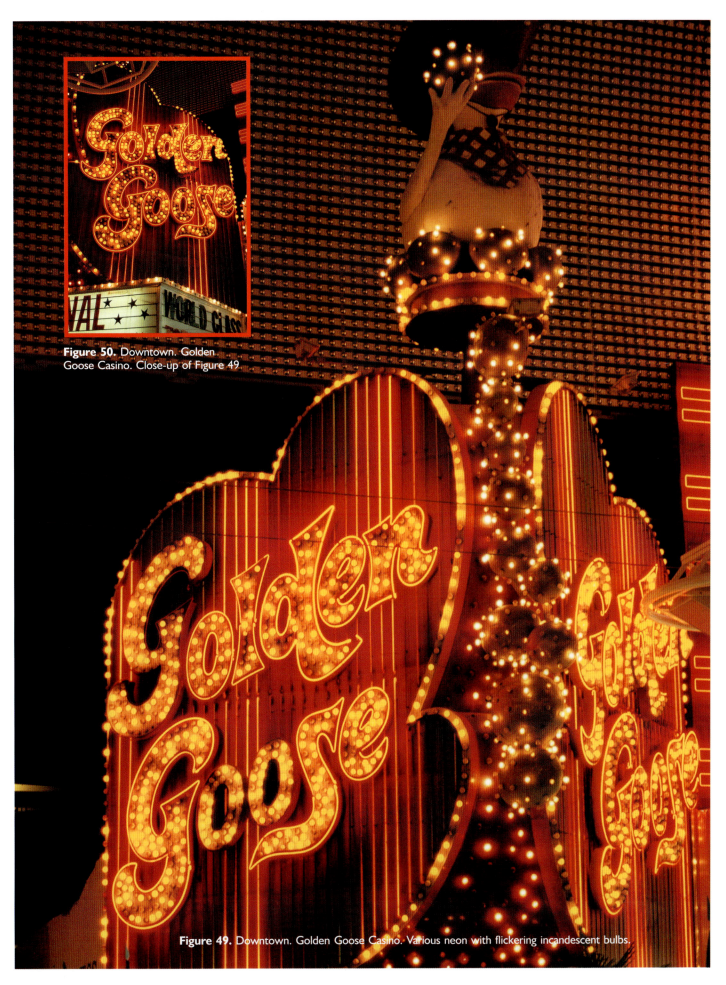

Figure 50. Downtown. Golden Goose Casino. Close-up of Figure 49

Figure 49. Downtown. Golden Goose Casino. Various neon with flickering incandescent bulbs.

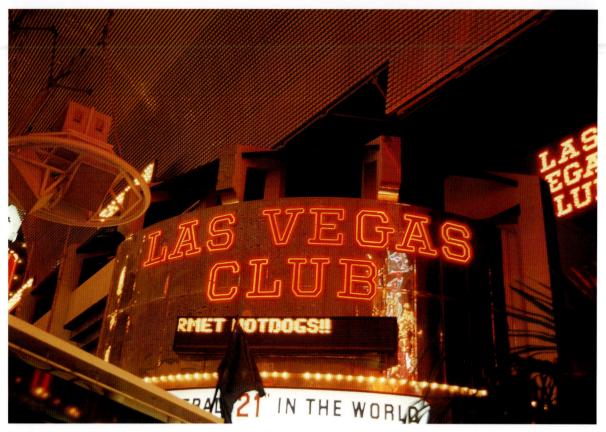

Figure 51. Downtown. Famous Las Vegas Club. Hotel entrance. Various neon.

Figure 52. Downtown. Famous Las Vegas Club. "Famous." Outline neon with flickering incandescent bulbs.

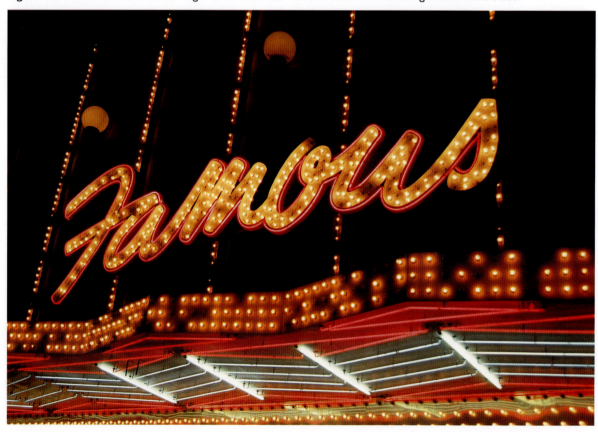

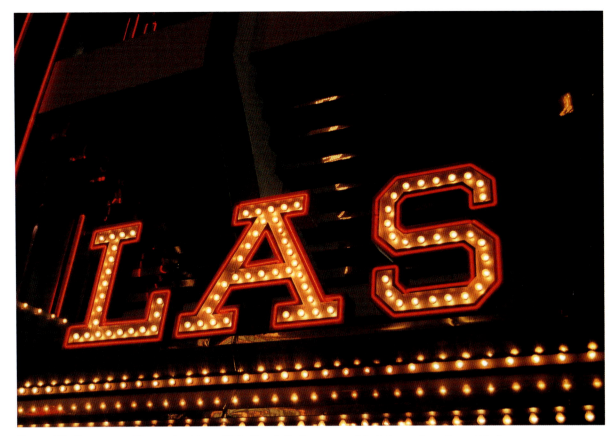

Figure 53. Downtown. Famous Las Vegas Club. "Las." Outline neon with stationary incandescent bulbs.

Figure 54. Downtown. Famous Las Vegas Club. "Vegas." Outline neon with stationary incandescent bulbs.

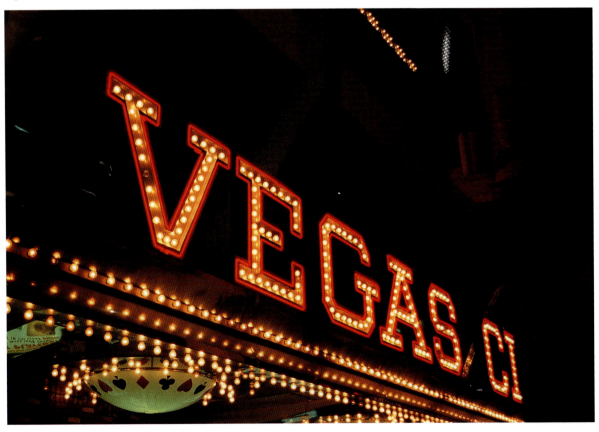

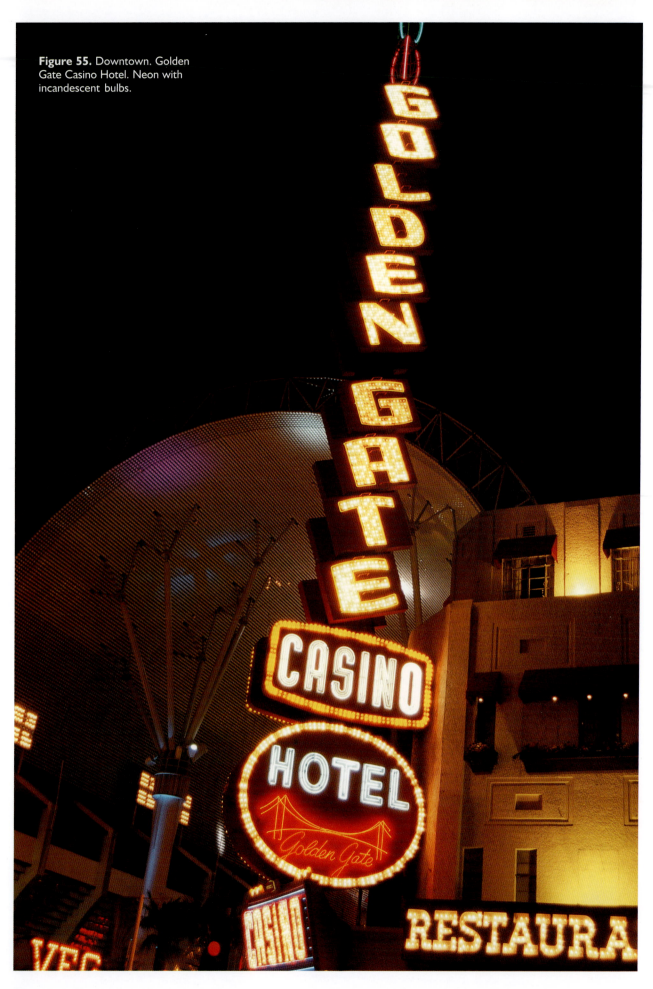

Figure 55. Downtown. Golden Gate Casino Hotel. Neon with incandescent bulbs.

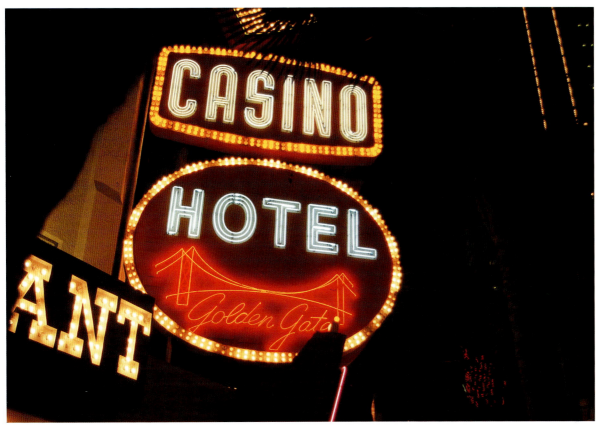

Figure 56. Downtown. Golden Gate Casino Hotel. Close-up of Figure 55.

Figure 57. Downtown. Golden Gate Casino. Entrance sign. Outline neon with flickering incandescent bulbs.

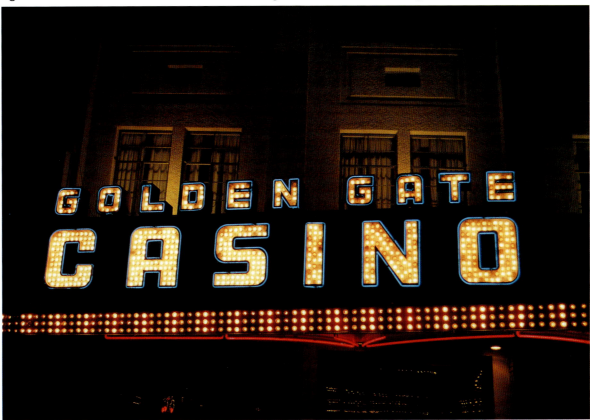

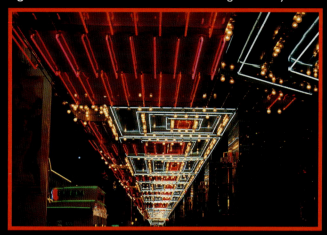

Figure 59. Downtown. Underside of overhang. Stationary neon.

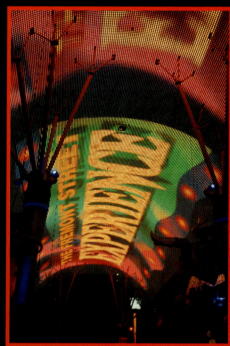

Figure 60. Downtown. Fremont Street Experience. Overhead canopy. Bulbs provide computer generated rolling light show.

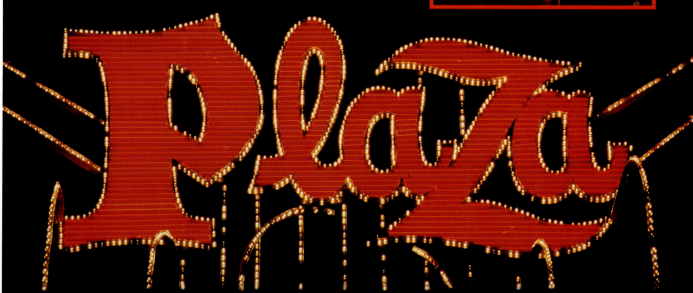

Figure 58. Downtown. Plaza Hotel Casino. Rooftop sign. Outline incandescent bulbs with stationary neon.

North Las Vegas Boulevard

Figure 62. North Las Vegas Boulevard (The Strip). TOD Motor Motel. Outline neon.

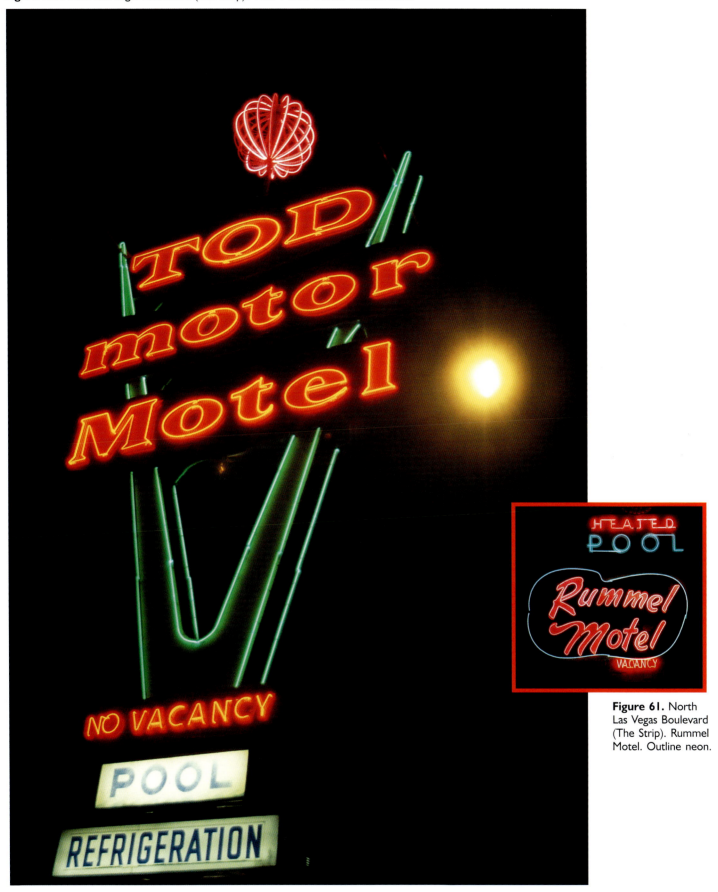

Figure 61. North Las Vegas Boulevard (The Strip). Rummel Motel. Outline neon.

Figure 64. North Las Vegas Boulevard (The Strip). Holiday Motel and Hollywood Wedding Chapel.

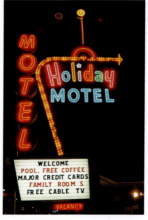

Figure 63. North Las Vegas Boulevard (The Strip). Holiday Motel. Outline neon and traveling incandescent bulbs.

Figure 66. North Las Vegas Boulevard (The Strip). Oasis Motel. Outline neon.

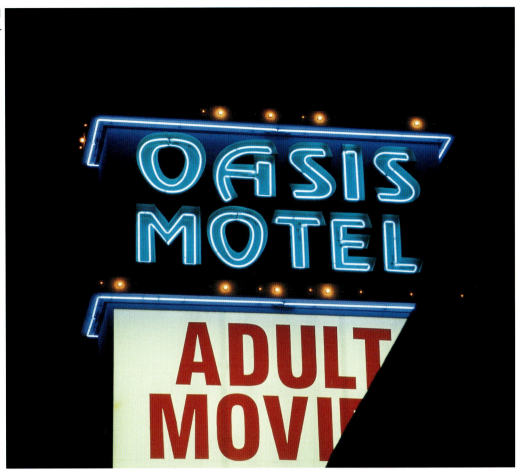

Figure 65. North Las Vegas Boulevard (The Strip). Holiday House Motel. Outline neon and flickering incandescent bulbs.

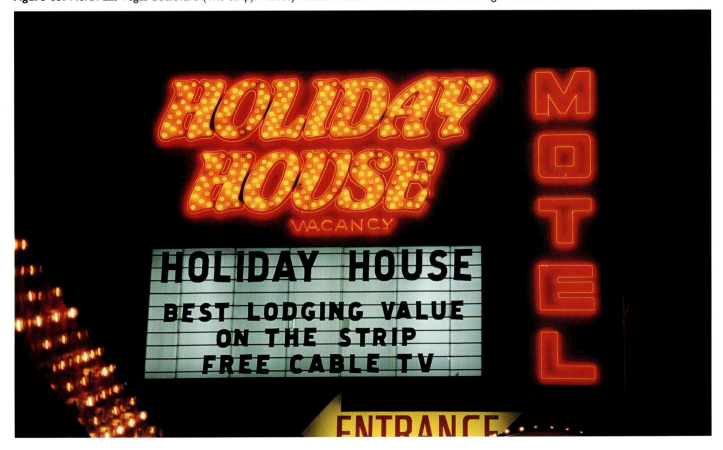

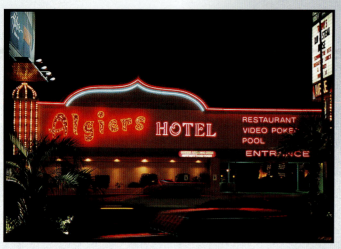

Figure 68. North Las Vegas Boulevard (The Strip). Algiers Hotel. Frontage. Neon with flickering incandescent bulbs.

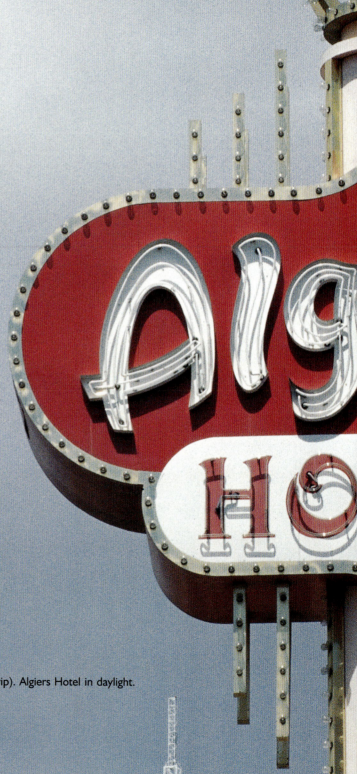

Figure 67. North Las Vegas Boulevard (The Strip). Algiers Hotel in daylight.

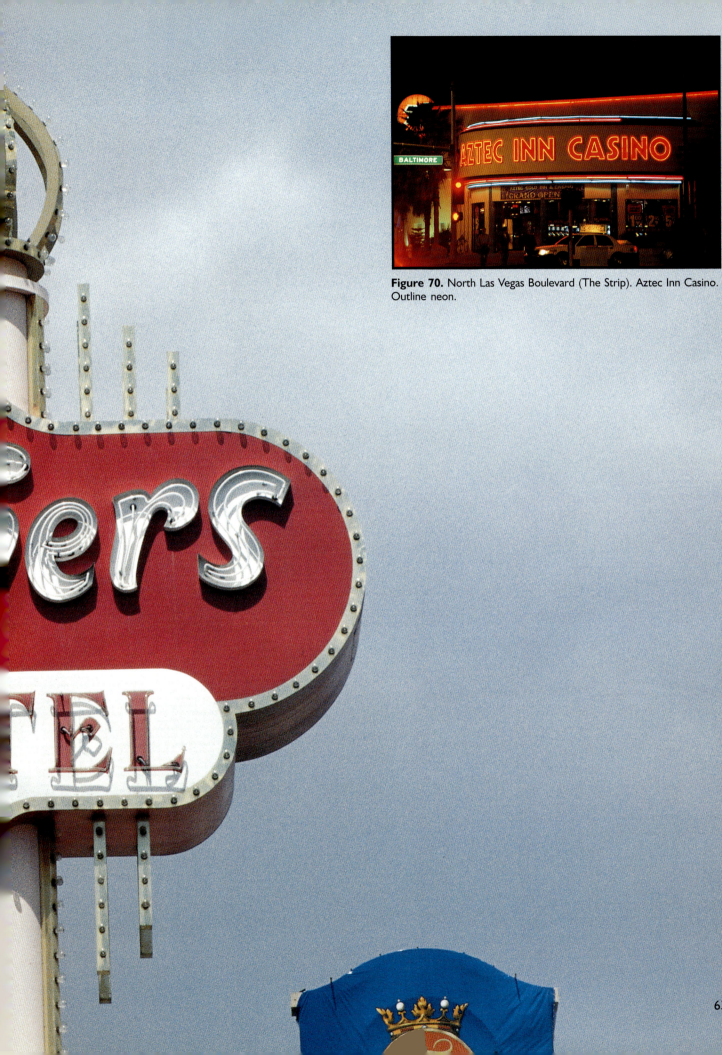

Figure 70. North Las Vegas Boulevard (The Strip). Aztec Inn Casino. Outline neon.

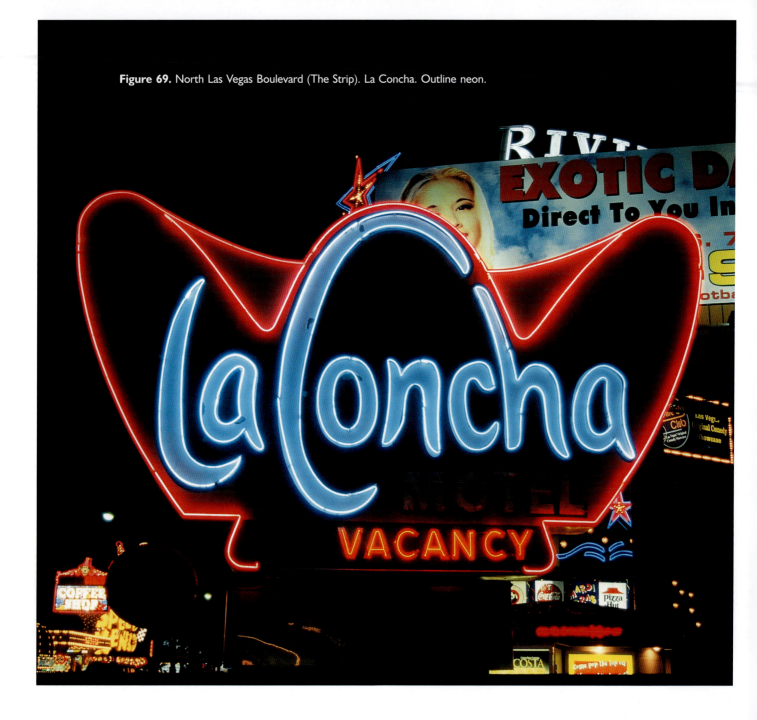

Figure 69. North Las Vegas Boulevard (The Strip). La Concha. Outline neon.

Figure 71. North Las Vegas Boulevard (The Strip). Key Largo Casino. Outline neon.

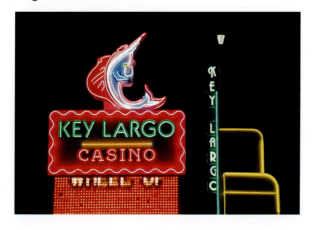

Figure 72. North Las Vegas Boulevard (The Strip). Key Largo Casino. Frontage. Neon with flickering incandescent bulbs.

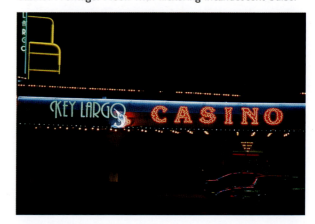

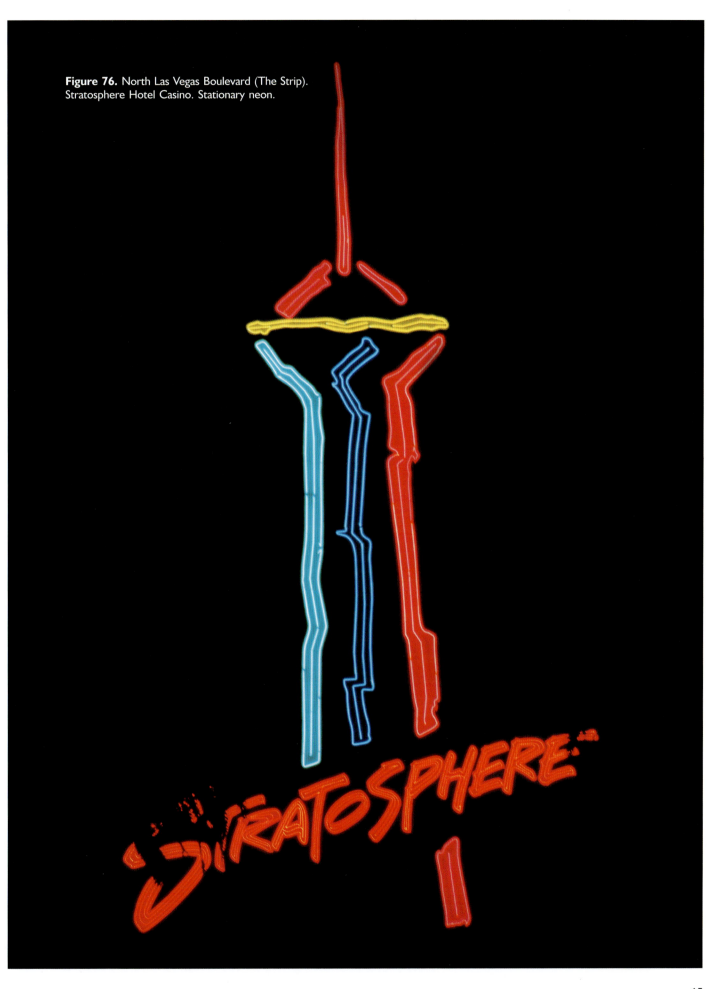

Figure 76. North Las Vegas Boulevard (The Strip). Stratosphere Hotel Casino. Stationary neon.

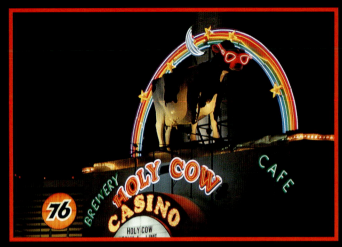

Figure 73. North Las Vegas Boulevard (The Strip). Holy Cow Casino Brewery Café. Stationary neon.

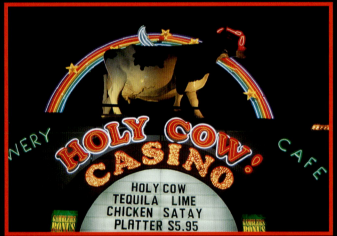

Figure 74. North Las Vegas Boulevard (The Strip). Holy Cow Casino Brewery Café. Close-up of Figure 73

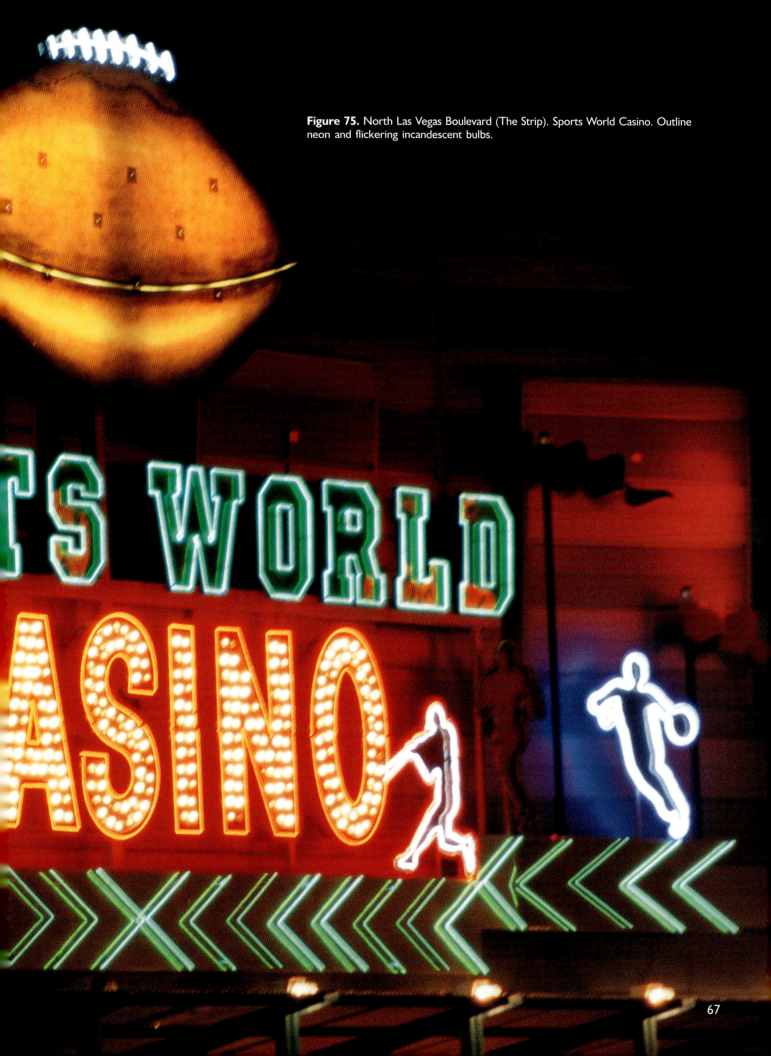

Figure 75. North Las Vegas Boulevard (The Strip). Sports World Casino. Outline neon and flickering incandescent bulbs.

The Las Vegas Strip

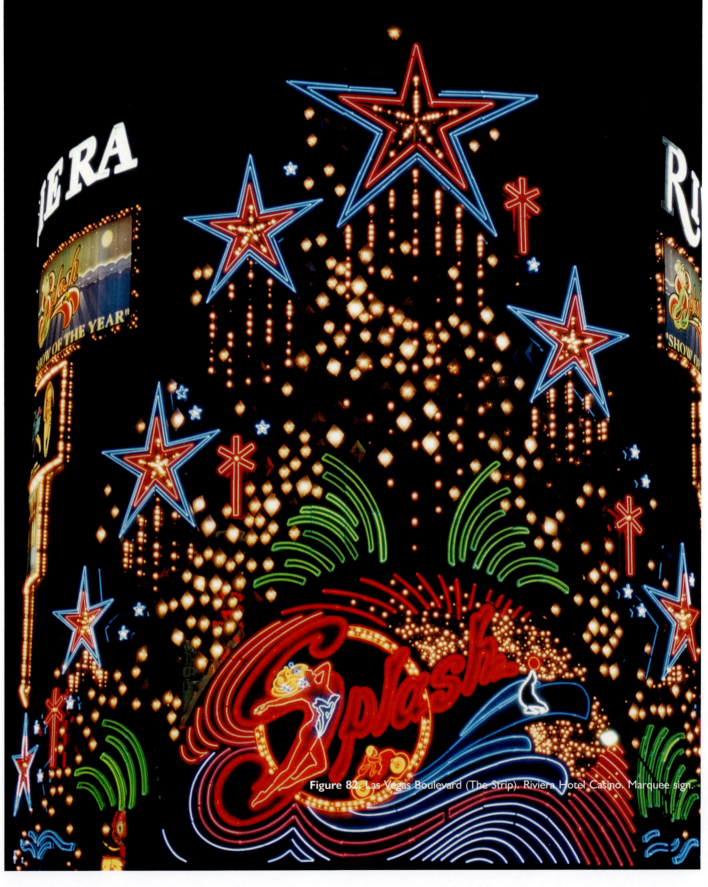

Figure 82. Las Vegas Boulevard (The Strip). Riviera Hotel Casino. Marquee sign.

Figure 77. Las Vegas Boulevard (The Strip). Riviera Hotel Casino. Outline neon, glittering incandescent, and fluorescent bulbs.

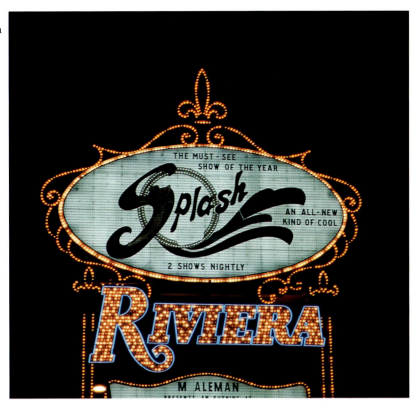

Figure 78. Las Vegas Boulevard (The Strip). Riviera Hotel Casino. Marquee sign.

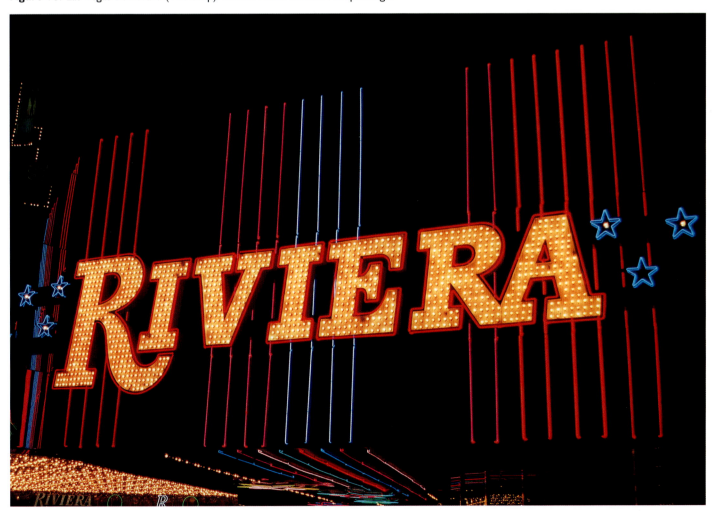

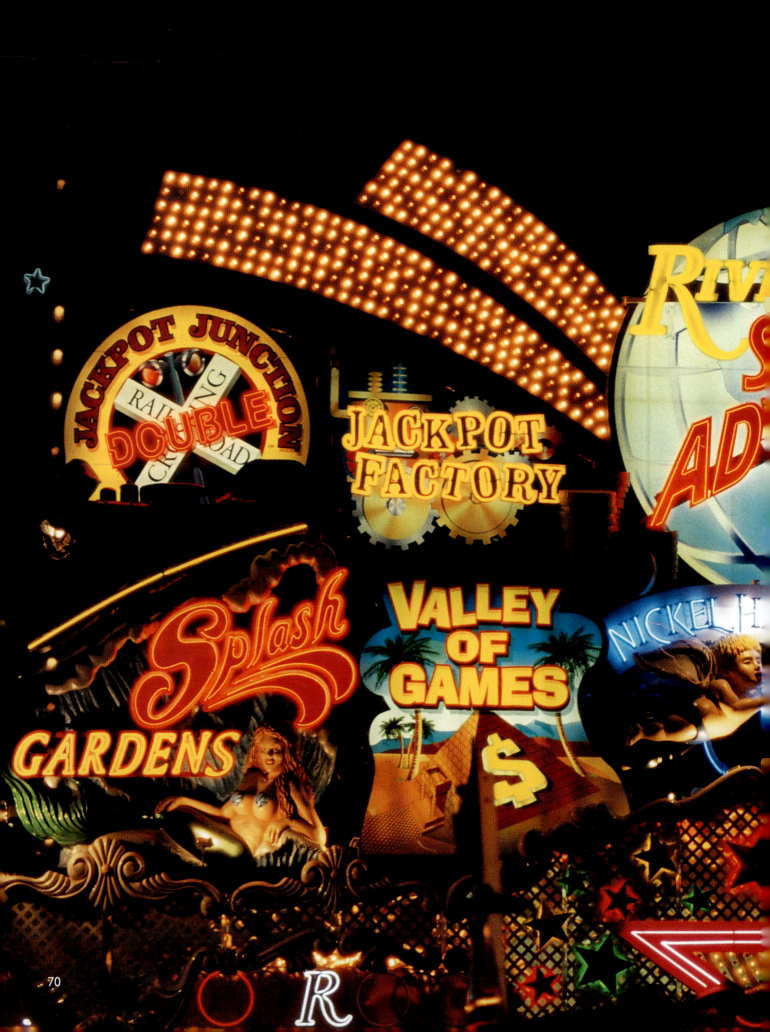

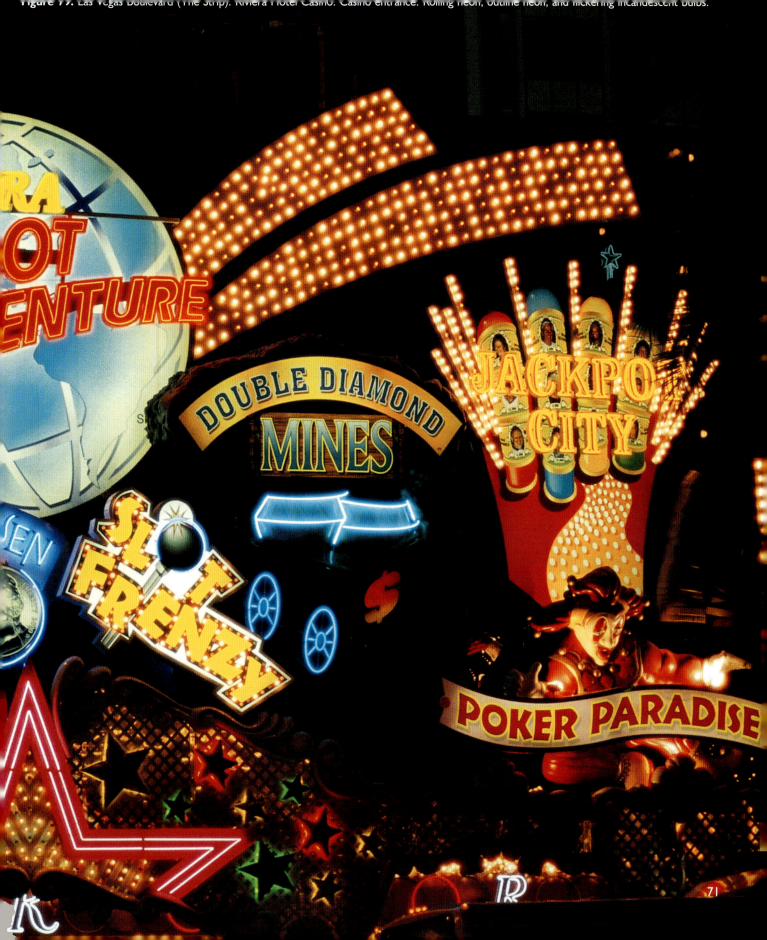

Figure 79. Las Vegas Boulevard (The Strip). Riviera Hotel Casino. Casino entrance. Rolling neon, outline neon, and flickering incandescent bulbs.

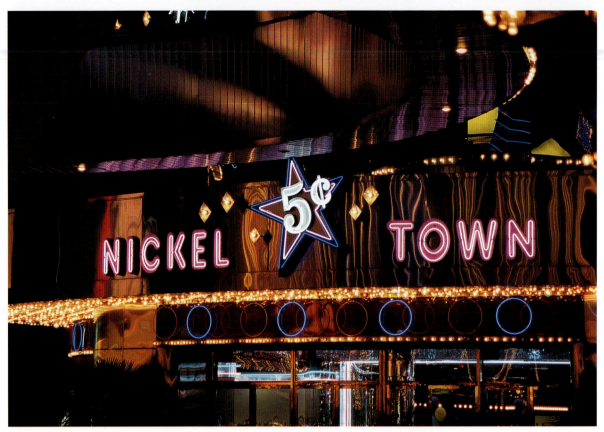

Figure 80. Las Vegas Boulevard (The Strip). Riviera Hotel Casino. Nickel Town. Rolling neon.

Figure 81. Las Vegas Boulevard (The Strip). Riviera Hotel Casino. Nickel Town. Rolling neon.

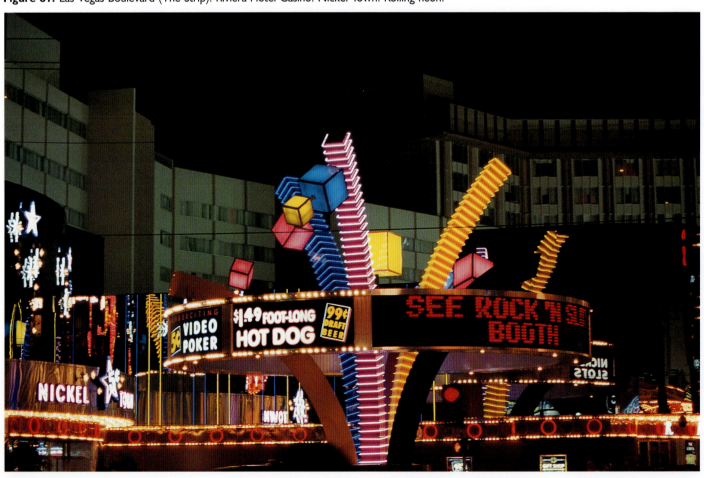

Figure 84. Las Vegas Boulevard (The Strip). Sahara Hotel Casino. Outline neon, glittering and rolling incandescent bulbs.

Figure 83. Las Vegas Boulevard (The Strip). Riviera Hotel Casino. Casino entrance. Stationary neon and incandescent bulbs.

Figure 85. Las Vegas Boulevard (The Strip). Sahara Hotel Casino. Outline neon and incandescent bulbs.

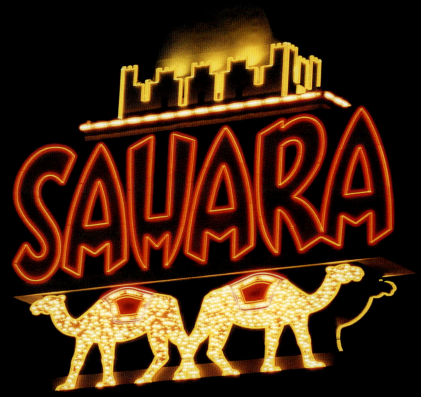

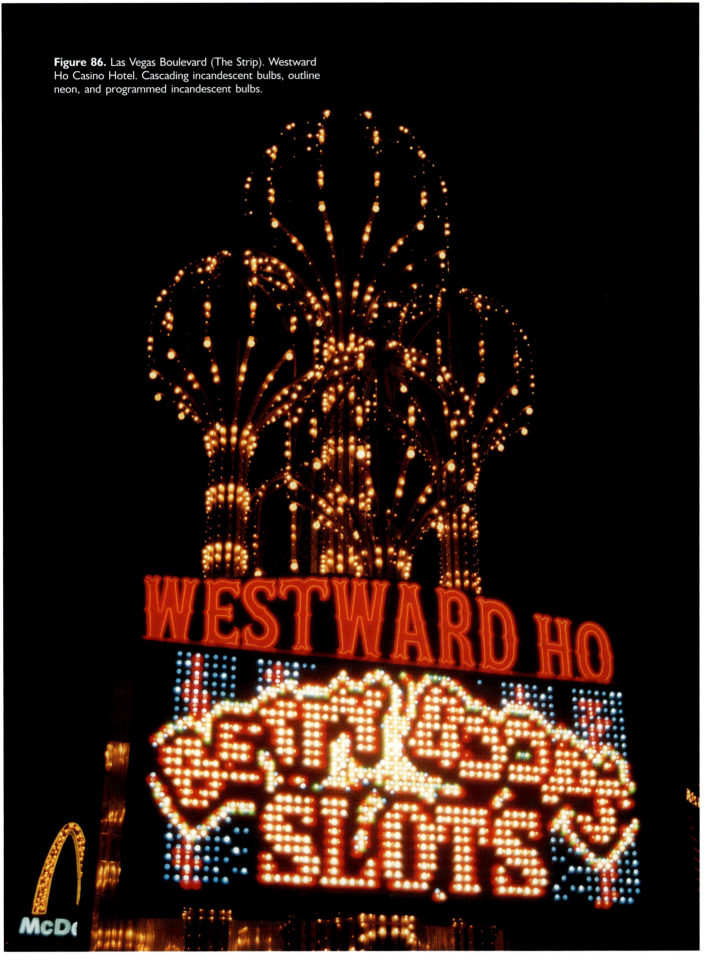

Figure 86. Las Vegas Boulevard (The Strip). Westward Ho Casino Hotel. Cascading incandescent bulbs, outline neon, and programmed incandescent bulbs.

South Las Vegas Boulevard

Figure 87. Las Vegas Boulevard (The Strip). Stardust Hotel Casino. Building side. Stationary neon.

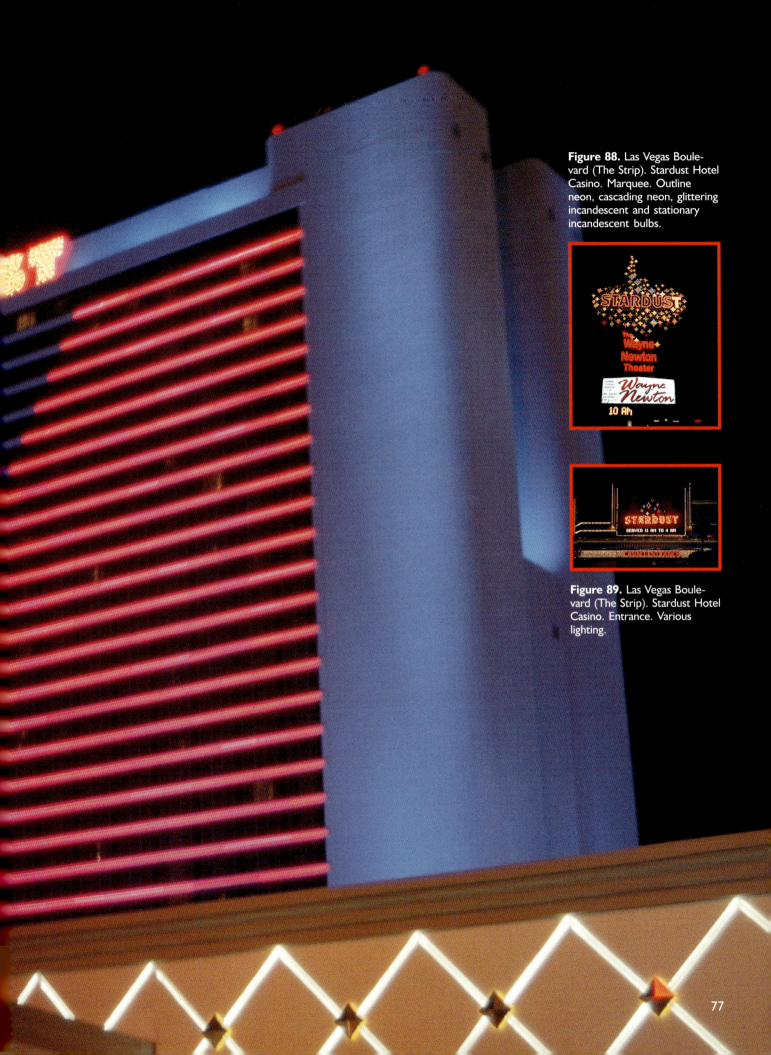

Figure 88. Las Vegas Boulevard (The Strip). Stardust Hotel Casino. Marquee. Outline neon, cascading neon, glittering incandescent and stationary incandescent bulbs.

Figure 89. Las Vegas Boulevard (The Strip). Stardust Hotel Casino. Entrance. Various lighting.

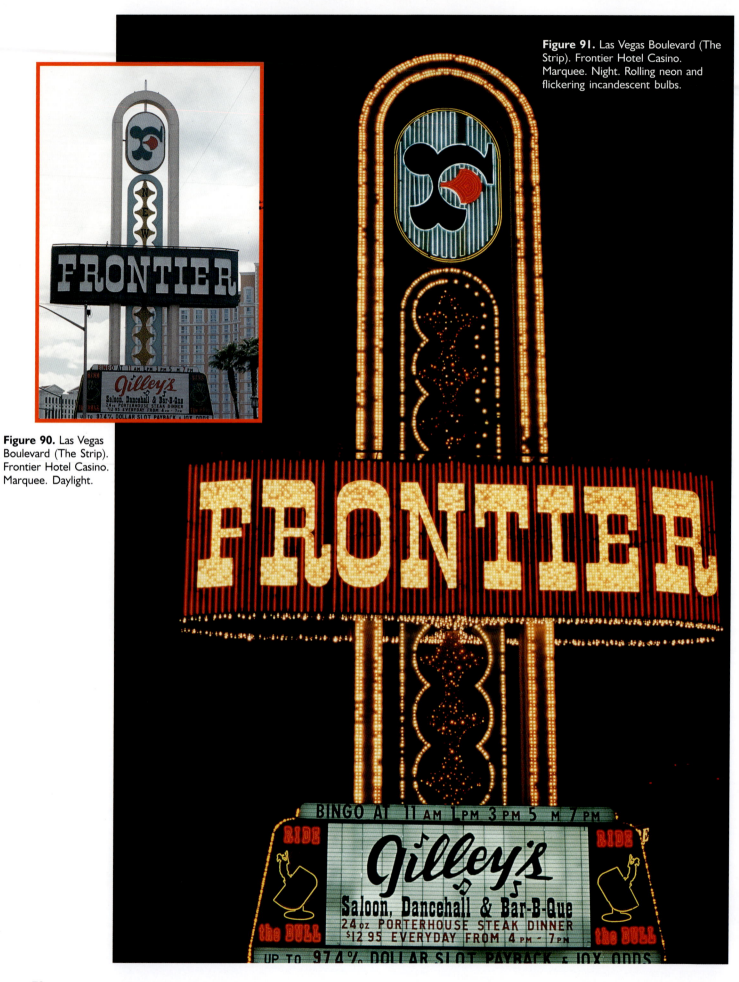

Figure 91. Las Vegas Boulevard (The Strip). Frontier Hotel Casino. Marquee. Night. Rolling neon and flickering incandescent bulbs.

Figure 90. Las Vegas Boulevard (The Strip). Frontier Hotel Casino. Marquee. Daylight.

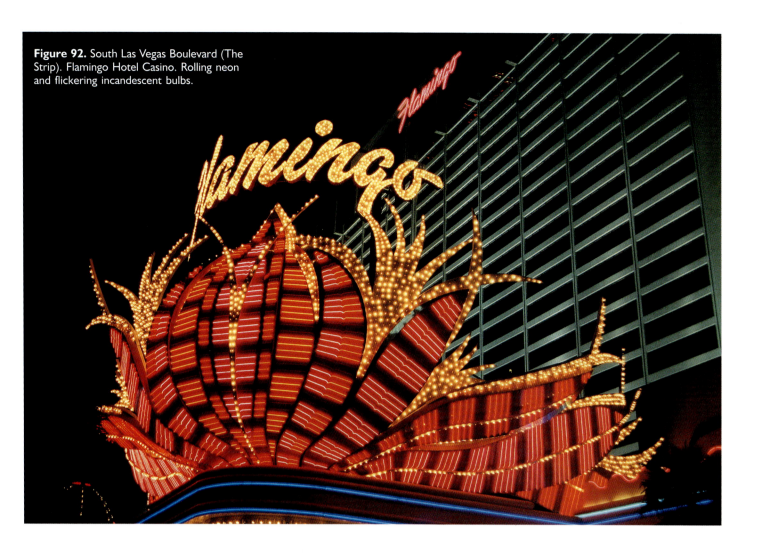

Figure 92. South Las Vegas Boulevard (The Strip). Flamingo Hotel Casino. Rolling neon and flickering incandescent bulbs.

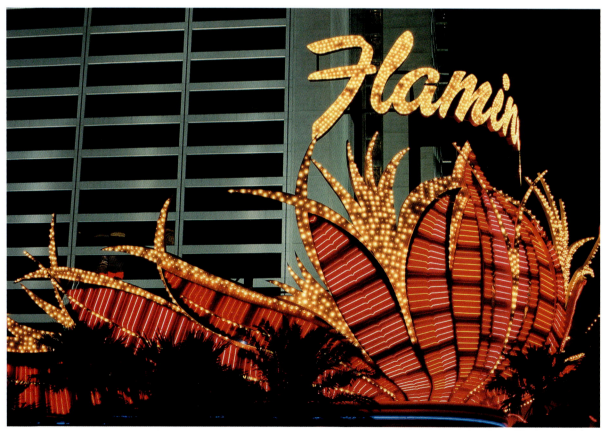

Figure 93. South Las Vegas Boulevard (The Strip). Flamingo Hotel Casino. Rolling neon and flickering incandescent bulbs.

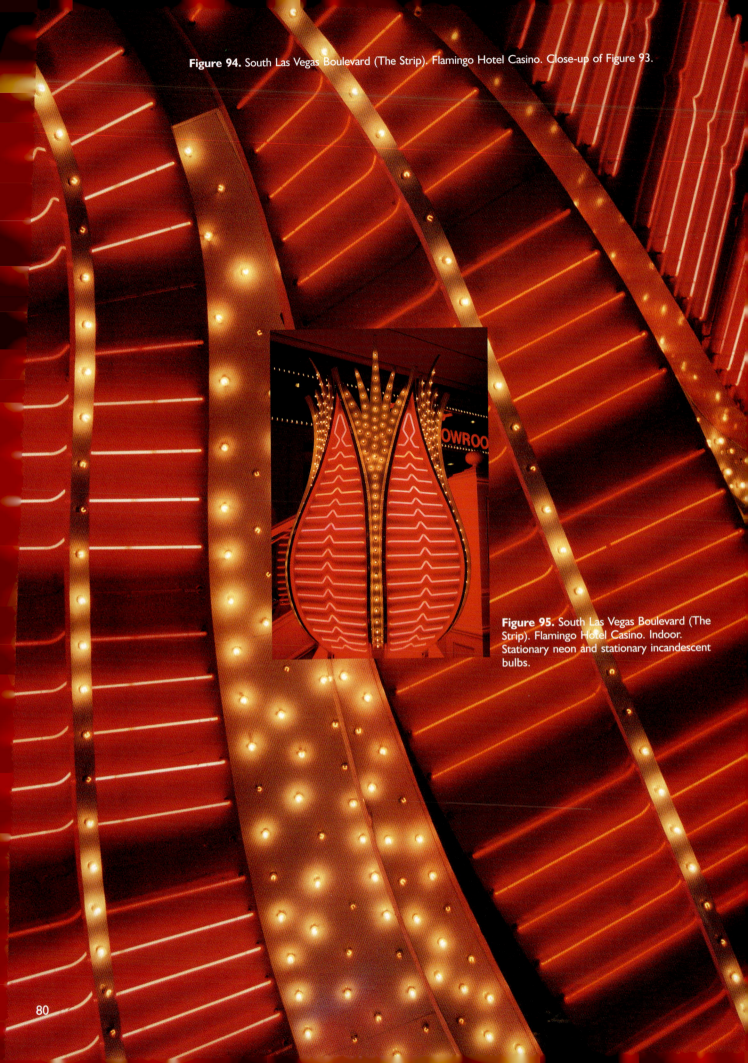

Figure 94. South Las Vegas Boulevard (The Strip). Flamingo Hotel Casino. Close-up of Figure 93.

Figure 95. South Las Vegas Boulevard (The Strip). Flamingo Hotel Casino. Indoor. Stationary neon and stationary incandescent bulbs.

Figure 97. South Las Vegas Boulevard (The Strip). Flamingo Hotel Casino. Stationary neon.

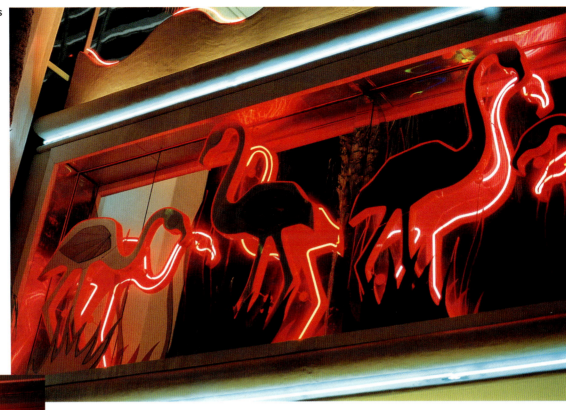

Figure 96. South Las Vegas Boulevard (The Strip). Flamingo Hotel Casino. Stationary neon.

Figure 98. South Las Vegas Boulevard (The Strip). Flamingo Hotel Casino. Background neon.

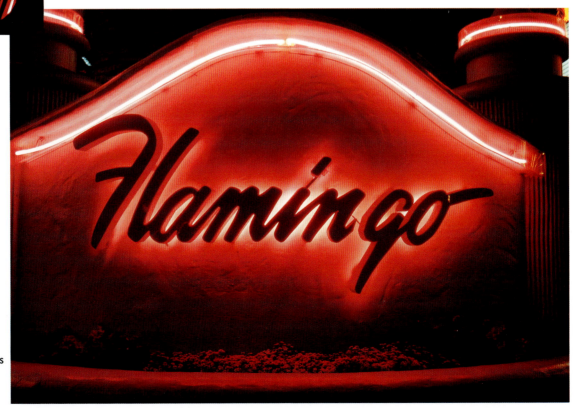

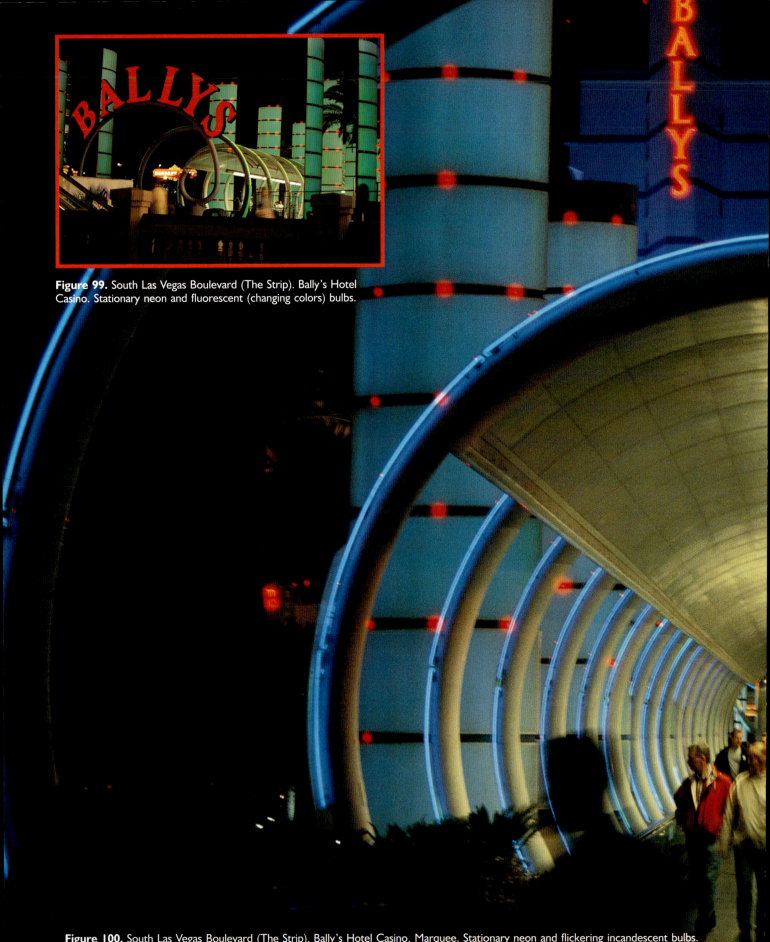

Figure 99. South Las Vegas Boulevard (The Strip). Bally's Hotel Casino. Stationary neon and fluorescent (changing colors) bulbs.

Figure 100. South Las Vegas Boulevard (The Strip). Bally's Hotel Casino. Marquee. Stationary neon and flickering incandescent bulbs.

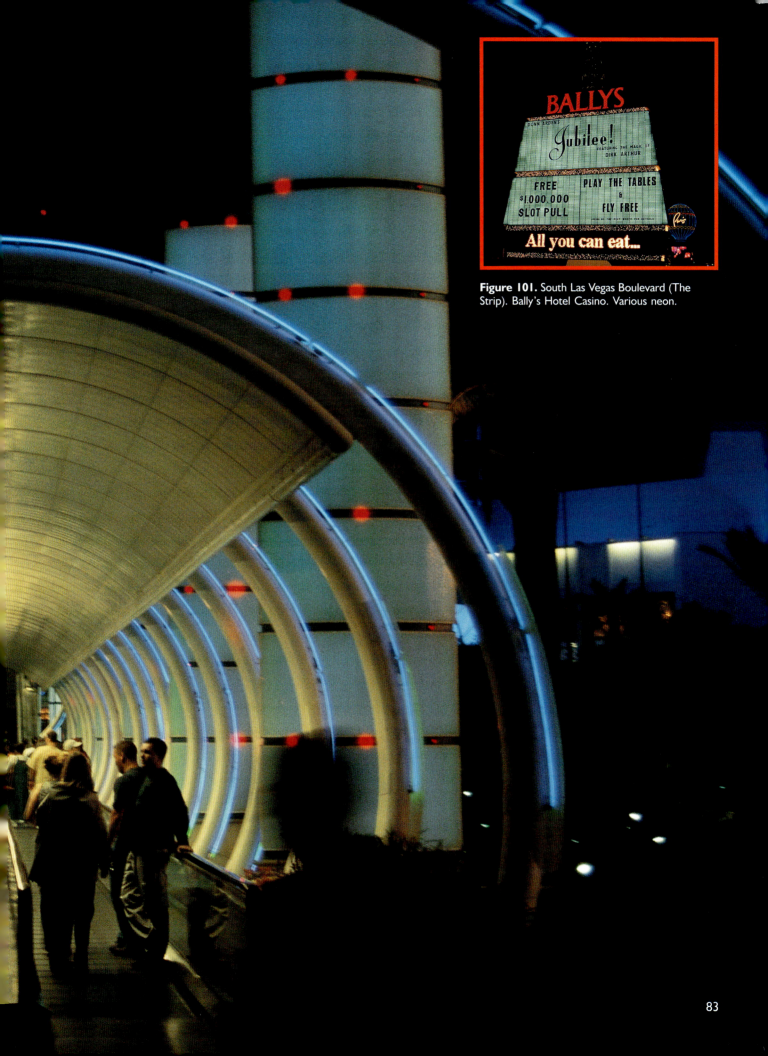

Figure 101. South Las Vegas Boulevard (The Strip). Bally's Hotel Casino. Various neon.

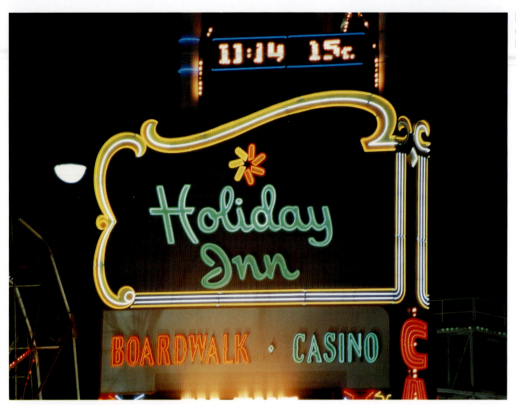

Figure 102. South Las Vegas Boulevard (The Strip). Holiday Inn Boardwalk Hotel Casino. Stationary neon.

Figure 103. South Las Vegas Boulevard (The Strip). Bally's Hotel Casino, Barbary Coast Hotel Casino, Flamingo Hotel Casino. Reflections off crosswalk protective glass. Various neon.

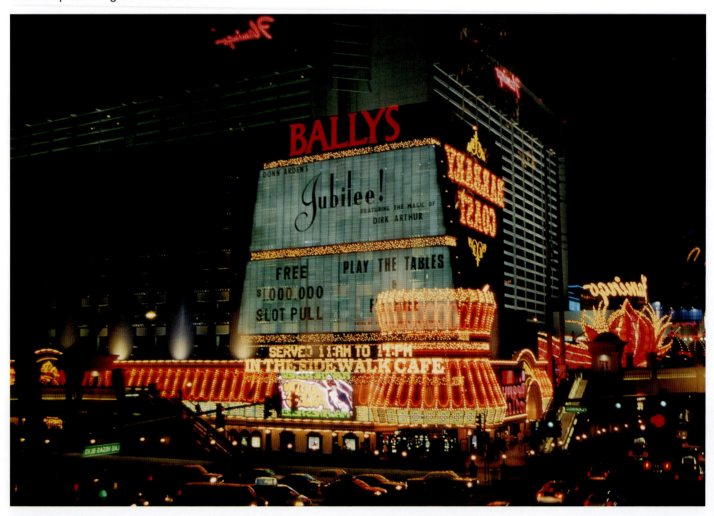

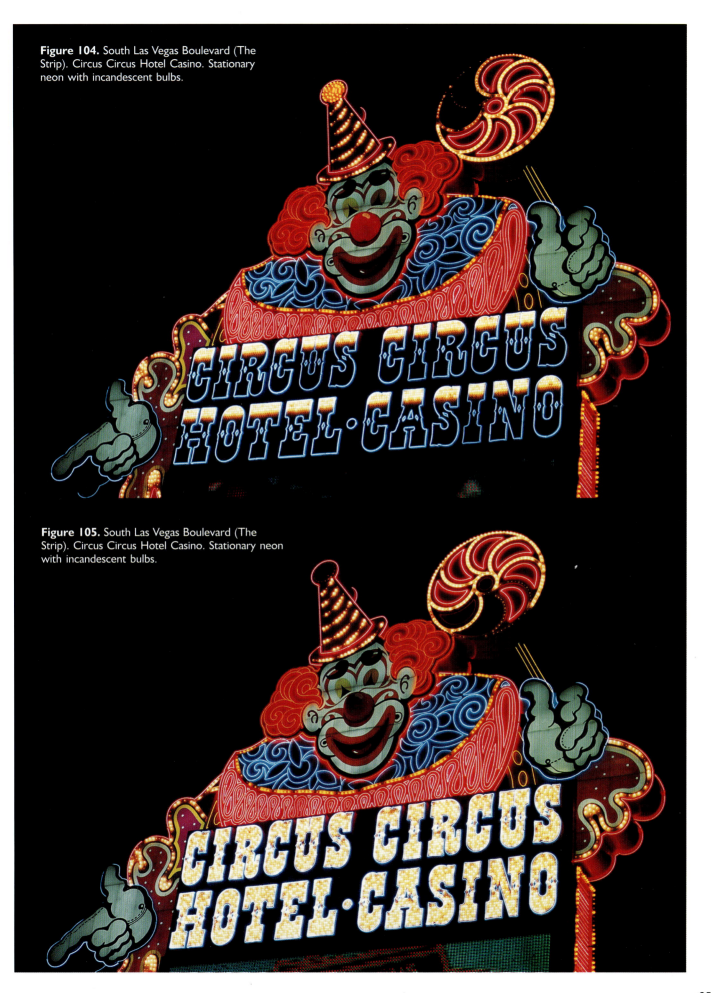

Figure 104. South Las Vegas Boulevard (The Strip). Circus Circus Hotel Casino. Stationary neon with incandescent bulbs.

Figure 105. South Las Vegas Boulevard (The Strip). Circus Circus Hotel Casino. Stationary neon with incandescent bulbs.

Figure 107. South Las Vegas Boulevard (The Strip). Mirage Hotel Casino. Marquee at night. Neon, glittering incandescent bulbs, and fluorescent backlight.

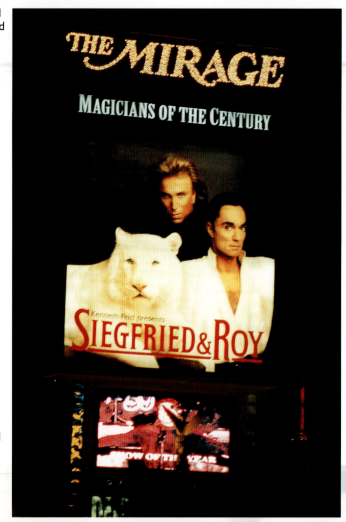

Figure 106. South Las Vegas Boulevard (The Strip). Mirage Hotel Casino. Marquee. Daylight.

Figure 109. South Las Vegas Boulevard (The Strip). MGM Casino Hotel.

Figure 110-111. South Las Vegas Boulevard (The Strip). MGM Hotel Casino. Lion and frontage. Incandescent (changing colors) bulbs.

Figure 108. South Las Vegas Boulevard (The Strip). MGM Casino Hotel. Daylight.

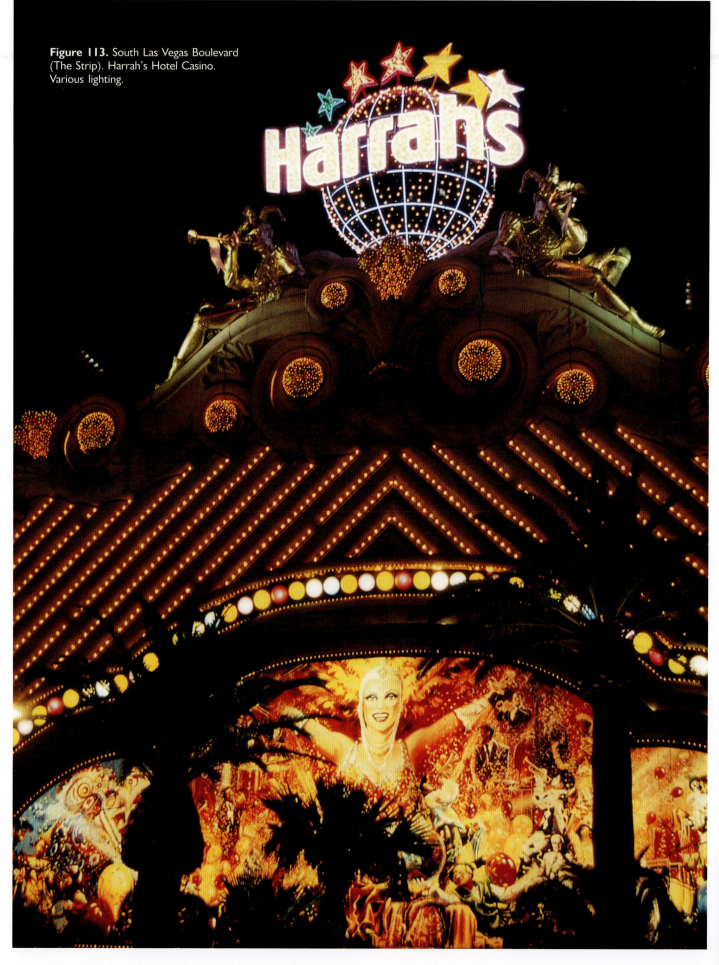

Figure 113. South Las Vegas Boulevard (The Strip). Harrah's Hotel Casino. Various lighting.

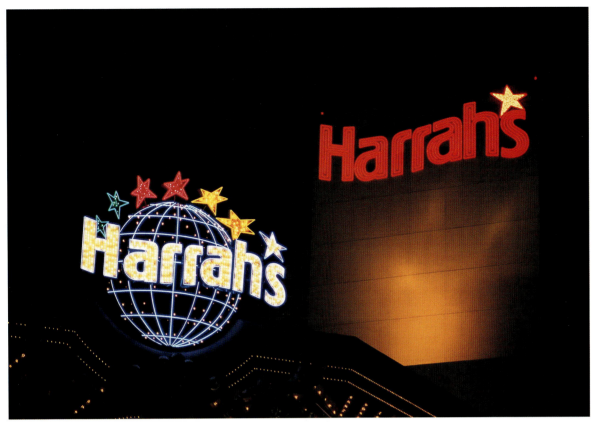

Figure 112. South Las Vegas Boulevard (The Strip). Harrah's Hotel Casino. Neon and flickering incandescent bulbs.

Figure 114. South Las Vegas Boulevard (The Strip). Harrah's Hotel Casino. Restaurant. Various lighting.

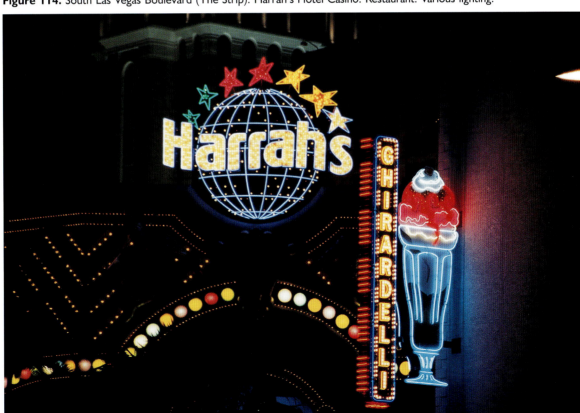

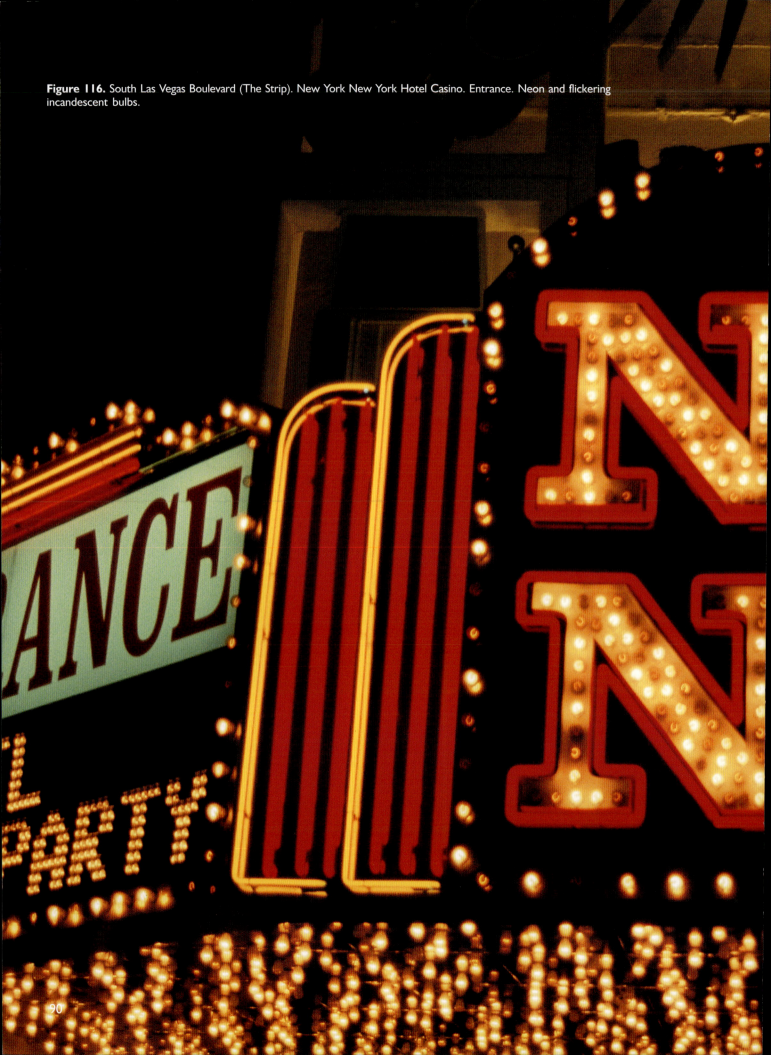

Figure 116. South Las Vegas Boulevard (The Strip). New York New York Hotel Casino. Entrance. Neon and flickering incandescent bulbs.

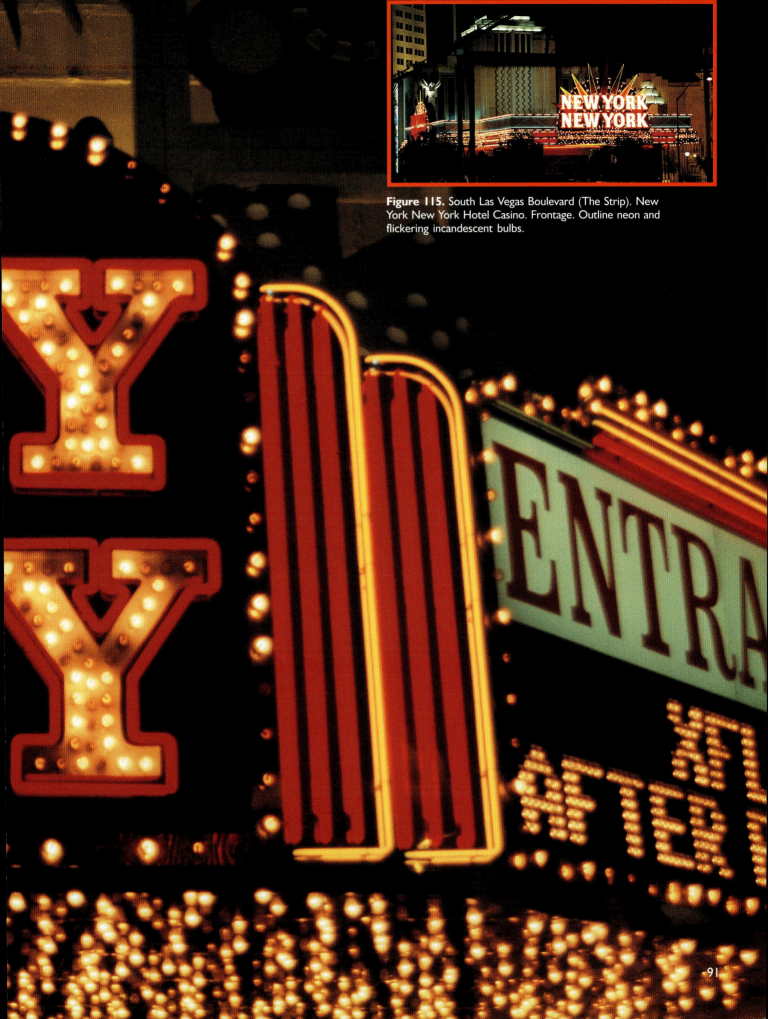

Figure 115. South Las Vegas Boulevard (The Strip). New York New York Hotel Casino. Frontage. Outline neon and flickering incandescent bulbs.

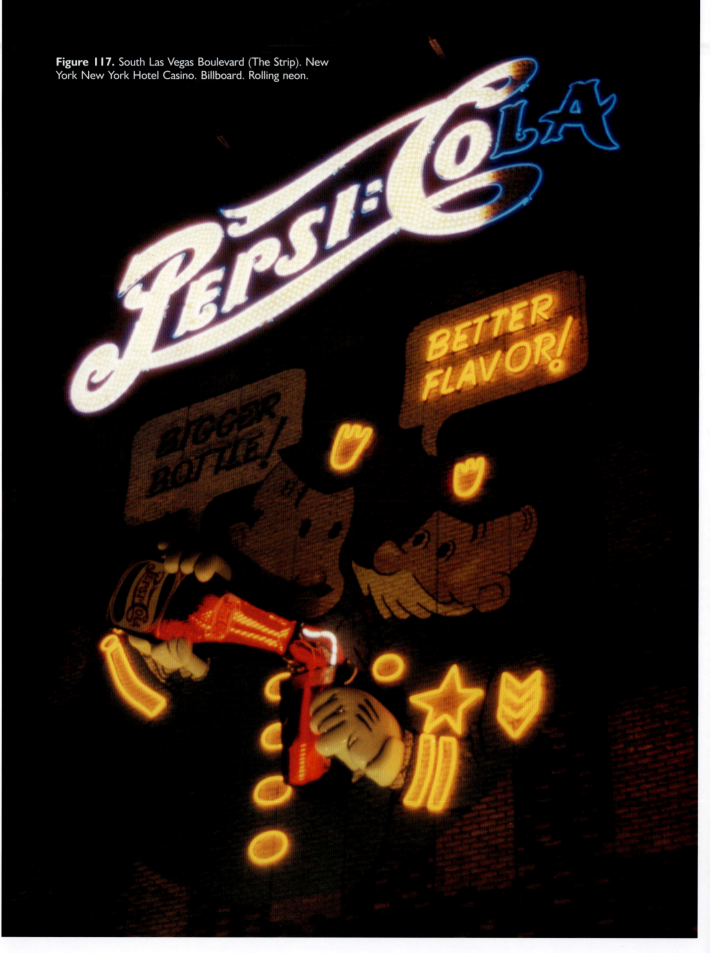

Figure 117. South Las Vegas Boulevard (The Strip). New York New York Hotel Casino. Billboard. Rolling neon.

Figure 118. South Las Vegas Boulevard (The Strip). Excalibur Hotel Casino. Marquee. Neon with glittering and stationary incandescent bulbs.

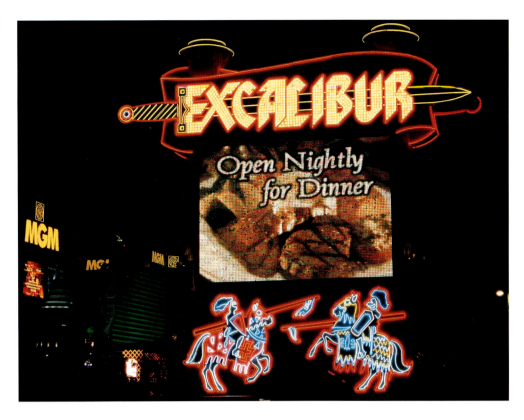

Figure 119. South Las Vegas Boulevard (The Strip). Excalibur Hotel Casino. Close-up of Figure 116.

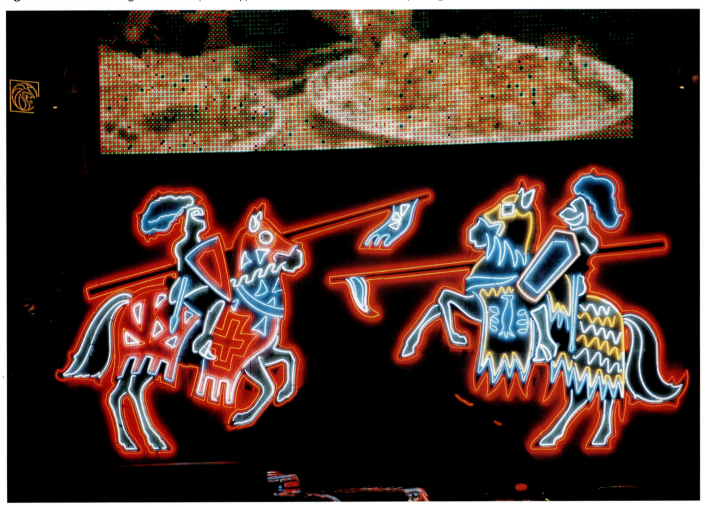

Figure 120. South Las Vegas Boulevard (The Strip). Caesar's Palace Hotel Casino. Entrance. Neon and incandescent bulbs.

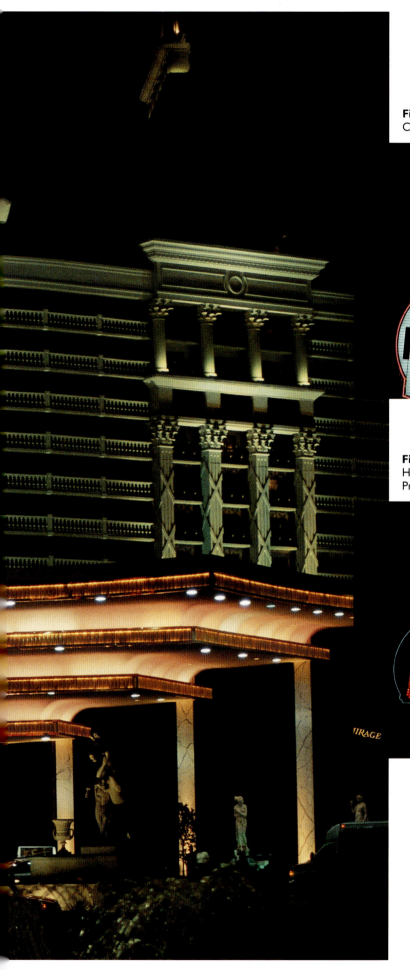

Figure 121. South Las Vegas Boulevard (The Strip). Caesar's Palace Hotel Casino. Marquee. Neon.

Figure 122. South Las Vegas Boulevard (The Strip). Caesar's Palace Hotel Casino (Mirage Hotel Casino in background). Marquee. Programmed incandescent bulbs.

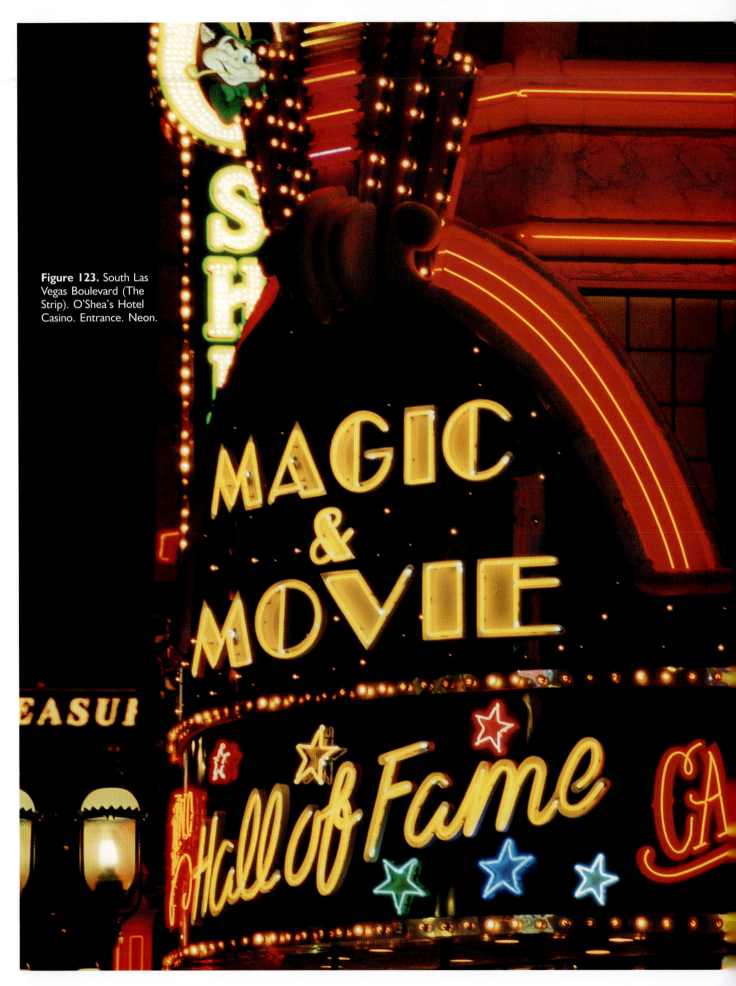

Figure 123. South Las Vegas Boulevard (The Strip). O'Shea's Hotel Casino. Entrance. Neon.

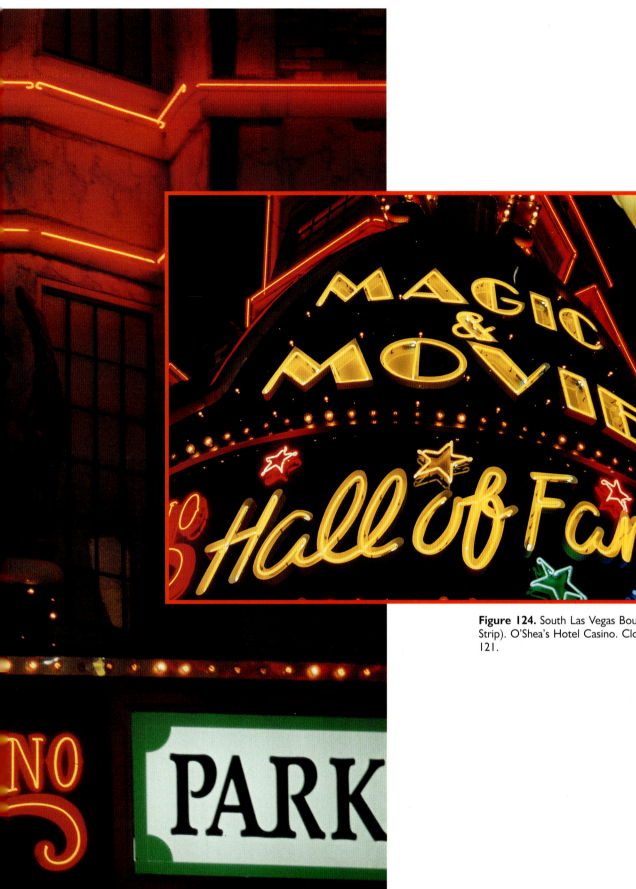

Figure 124. South Las Vegas Boulevard (The Strip). O'Shea's Hotel Casino. Close-up of Figure 121.

Figure 126. South Las Vegas Boulevard (The Strip). Panoramic shot down The Strip (Imperial Palace Hotel Casino in foreground).

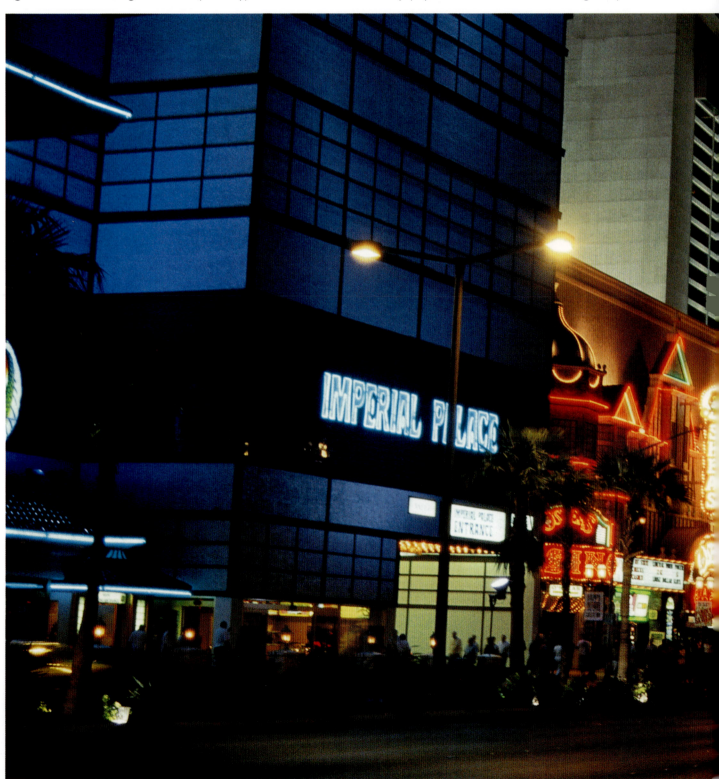

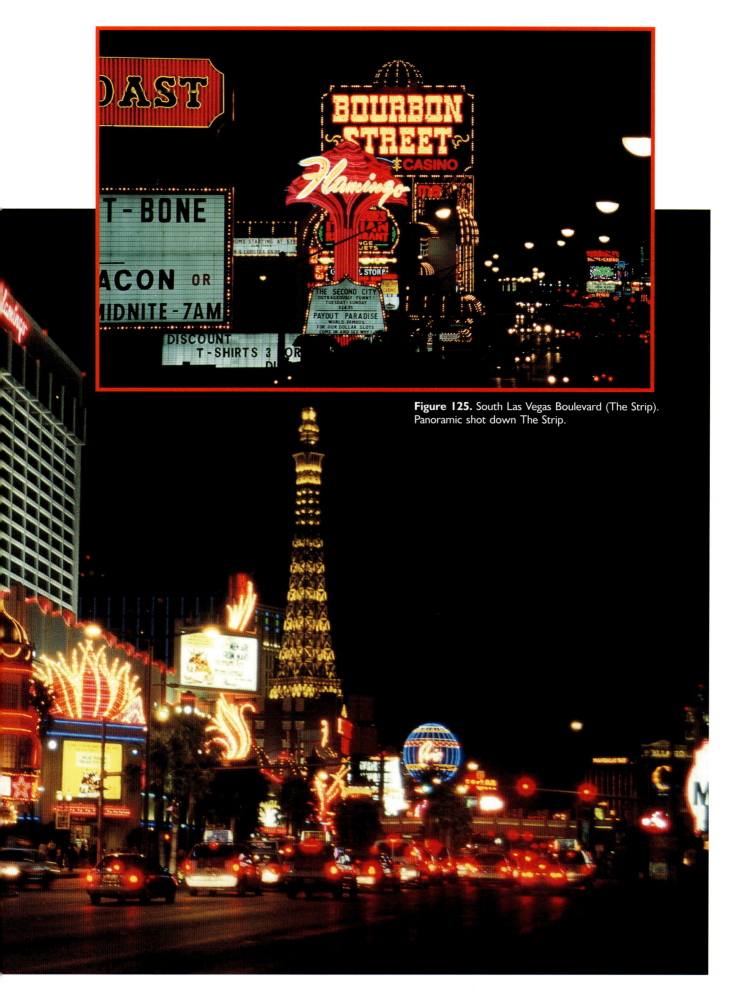

Figure 125. South Las Vegas Boulevard (The Strip). Panoramic shot down The Strip.

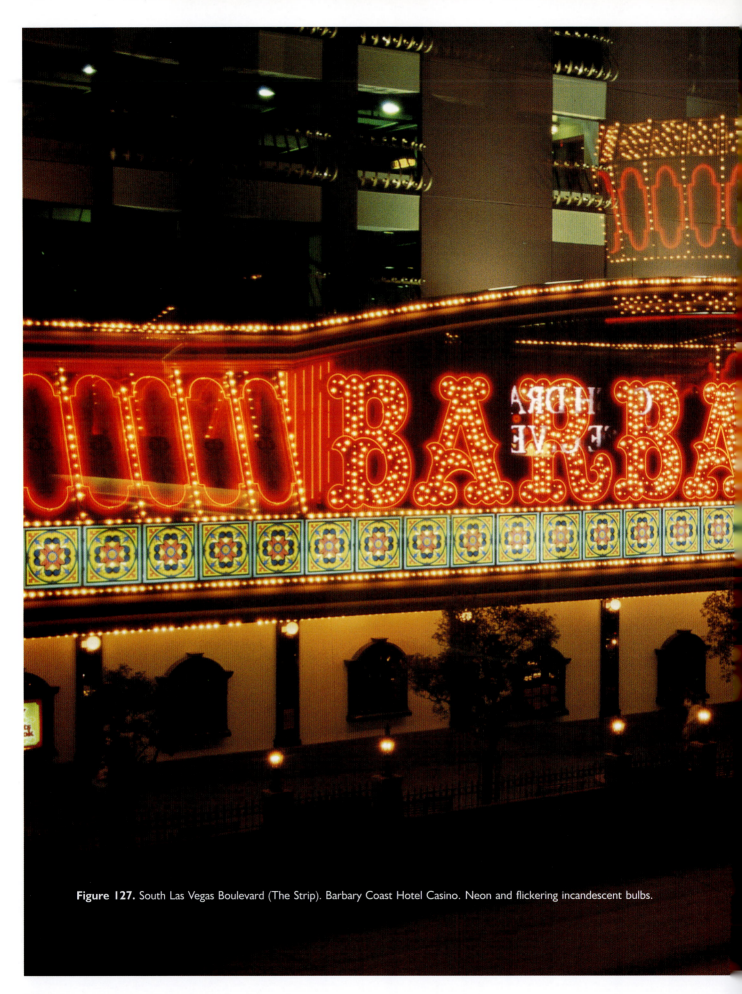

Figure 127. South Las Vegas Boulevard (The Strip). Barbary Coast Hotel Casino. Neon and flickering incandescent bulbs.

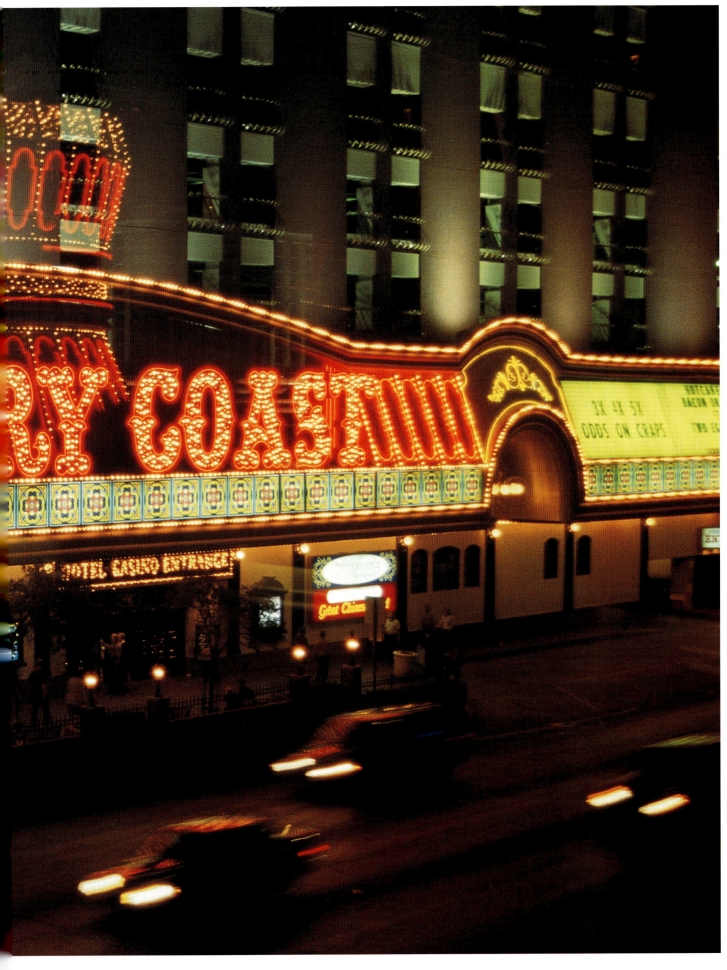

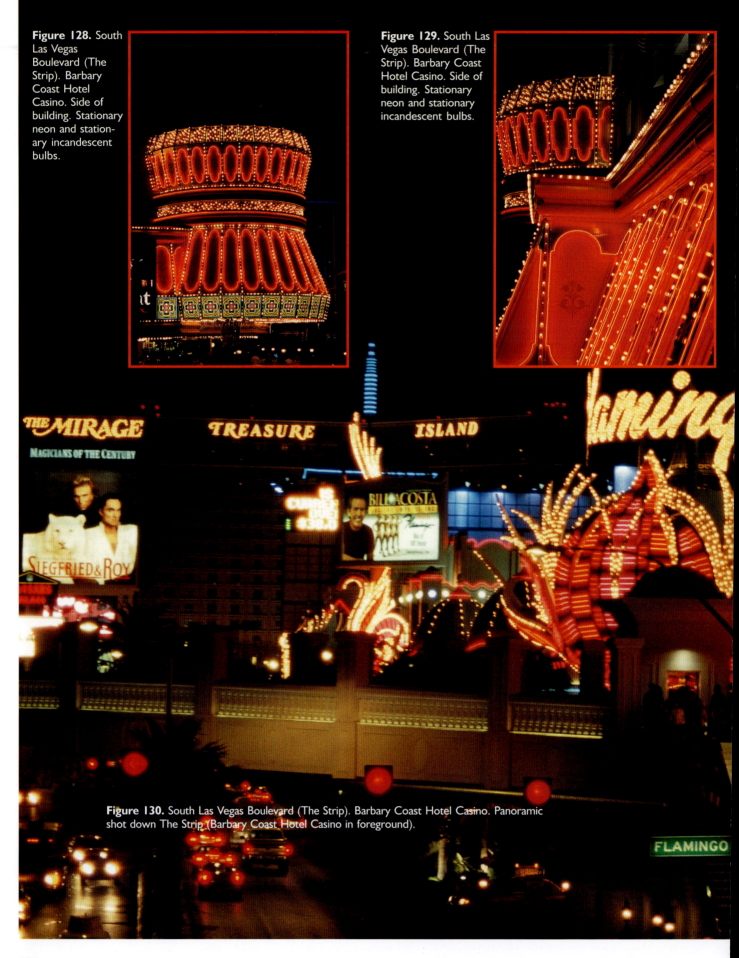

Figure 128. South Las Vegas Boulevard (The Strip). Barbary Coast Hotel Casino. Side of building. Stationary neon and stationary incandescent bulbs.

Figure 129. South Las Vegas Boulevard (The Strip). Barbary Coast Hotel Casino. Side of building. Stationary neon and stationary incandescent bulbs.

Figure 130. South Las Vegas Boulevard (The Strip). Barbary Coast Hotel Casino. Panoramic shot down The Strip (Barbary Coast Hotel Casino in foreground).

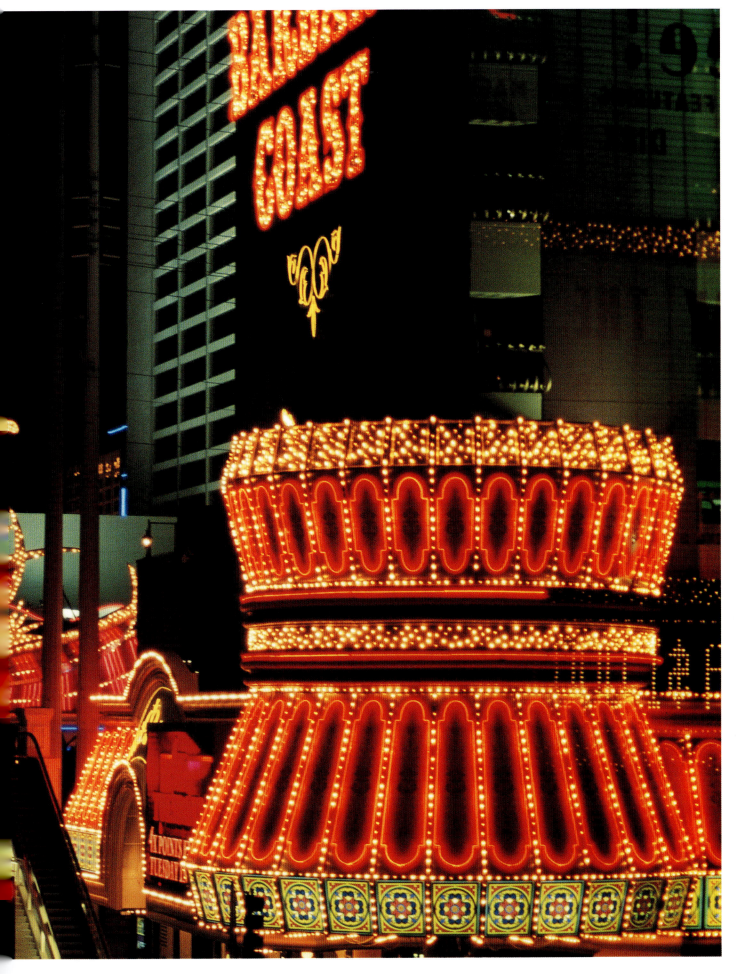

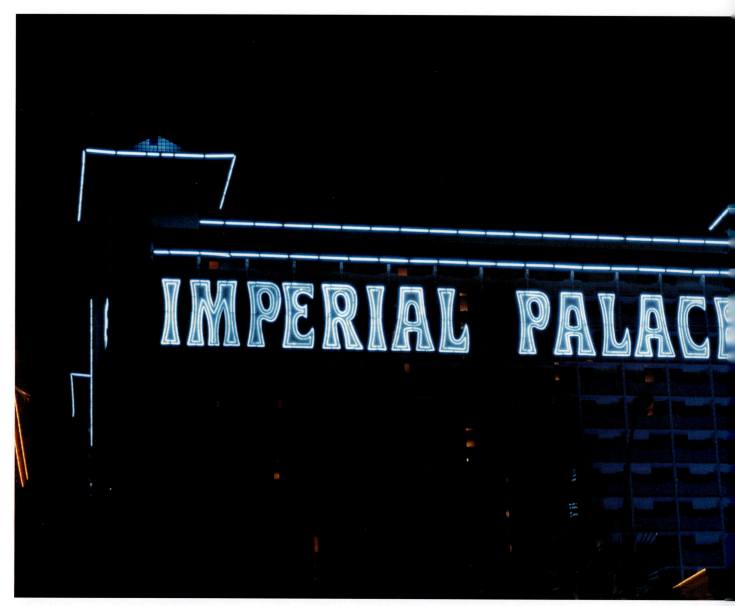

Figure 131. South Las Vegas Boulevard (The Strip). Imperial Palace Hotel Casino. Side of building. Stationary neon.

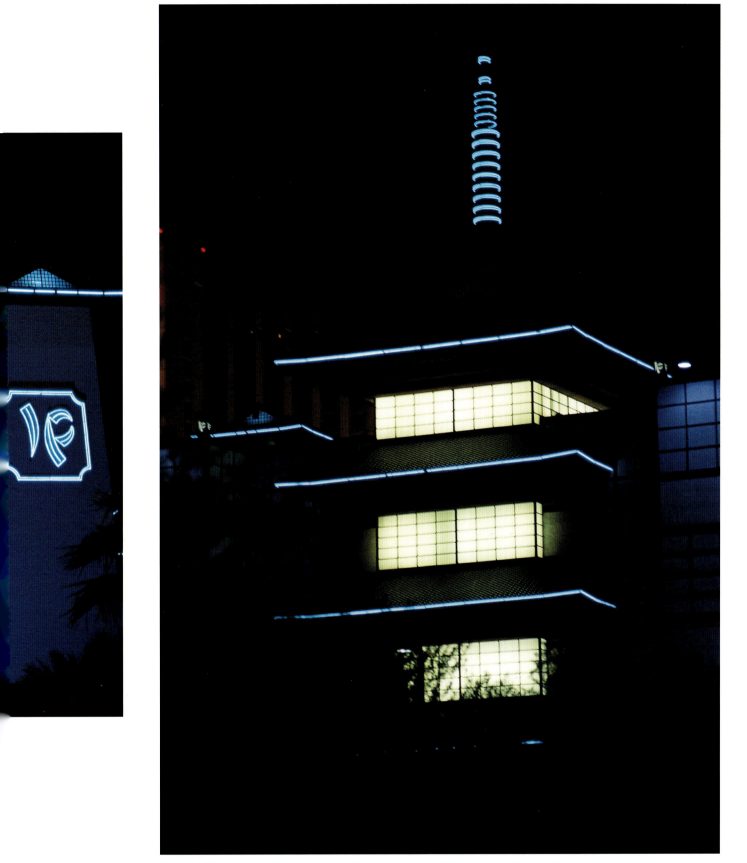

Figure 132. South Las Vegas Boulevard (The Strip). Imperial Palace Hotel Casino. Front of building. Stationary neon.

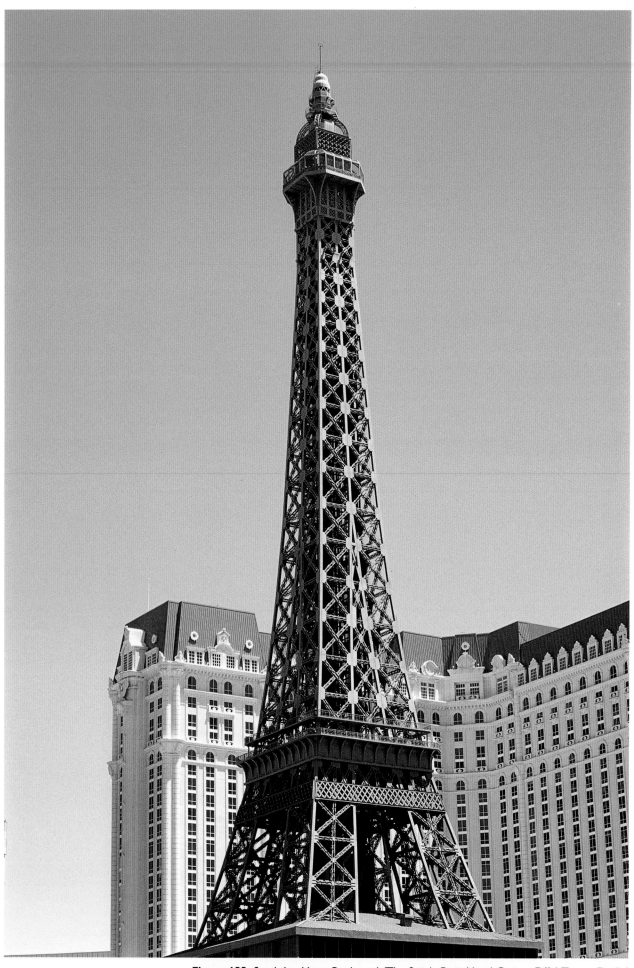

Figure 133. South Las Vegas Boulevard (The Strip). Paris Hotel Casino. Eiffel Tower. Daylight.

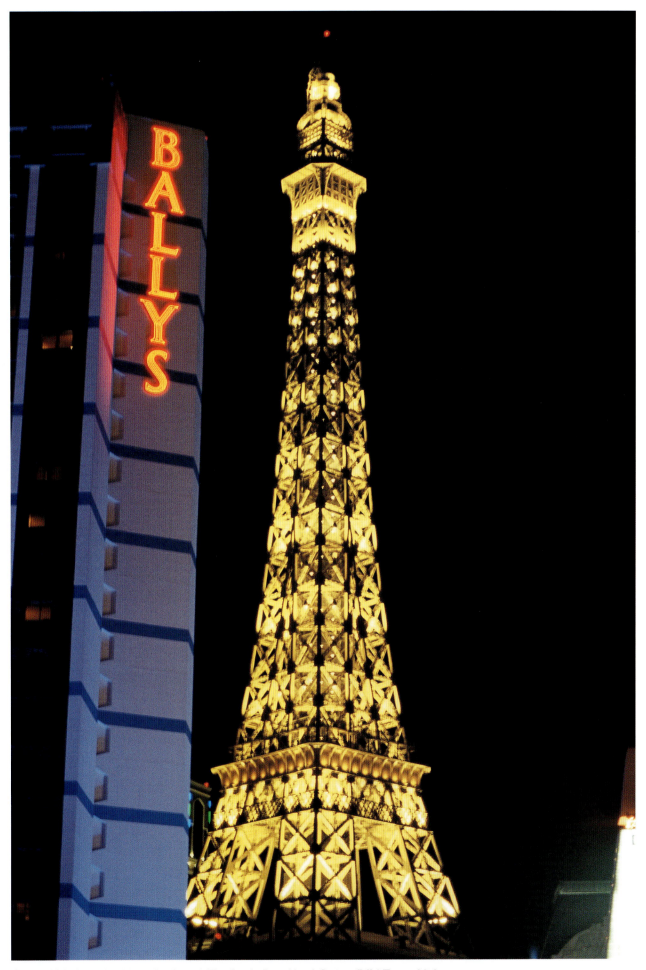

Figure 134. South Las Vegas Boulevard (The Strip). Paris Hotel Casino. Eiffel Tower. Night.

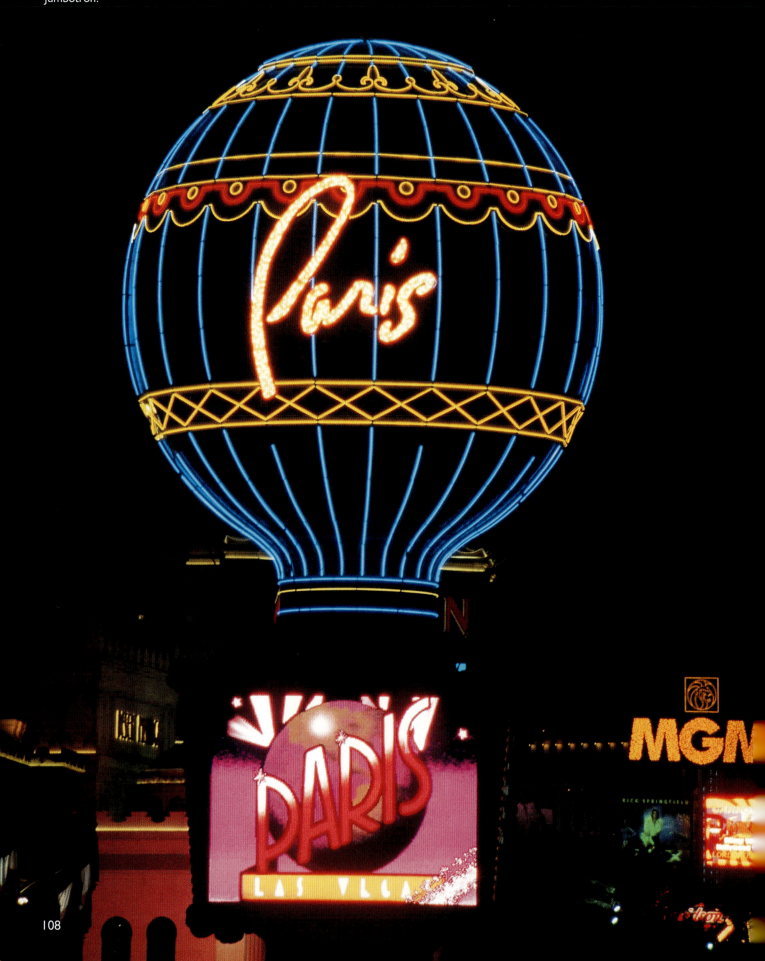

Figure 136. South Las Vegas Boulevard (The Strip). Paris Hotel Casino. Gondolfier's Balloon. Night. Stationary neon, glittering incandescent bulbs, and Jumbotron.

Figure 137. South Las Vegas Boulevard (The Strip). Treasure Island Hotel Casino. Marquee. Daylight.

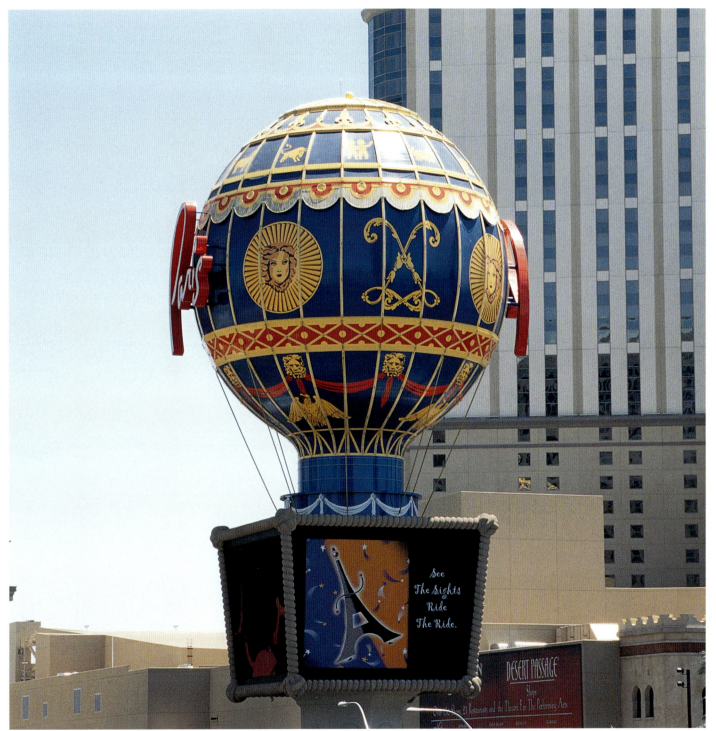

Figure 135. South Las Vegas Boulevard (The Strip). Paris Hotel Casino. Gondolfier's Balloon. Daylight.

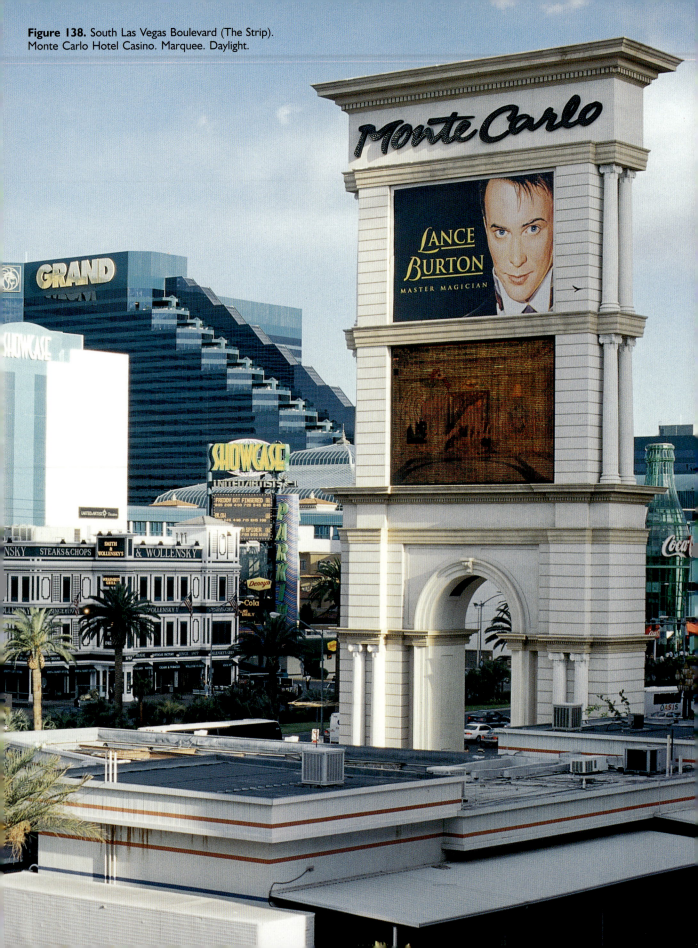

Figure 138. South Las Vegas Boulevard (The Strip). Monte Carlo Hotel Casino. Marquee. Daylight.

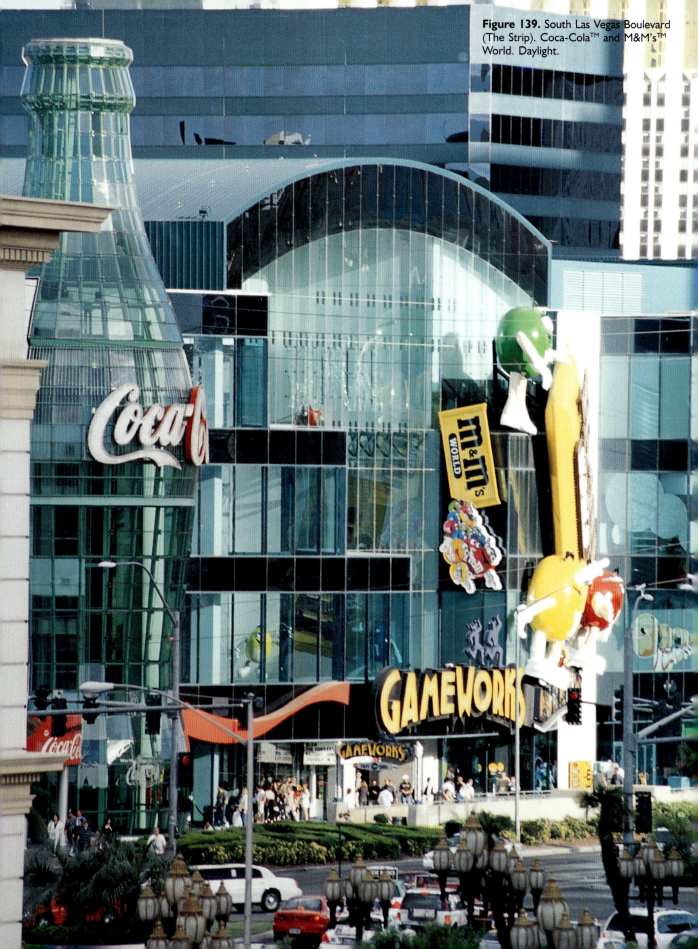

Figure 139. South Las Vegas Boulevard (The Strip). Coca-Cola™ and M&M's™ World. Daylight.

Figure 140. South Las Vegas Boulevard (The Strip). Fashion Show Mall. Daylight.

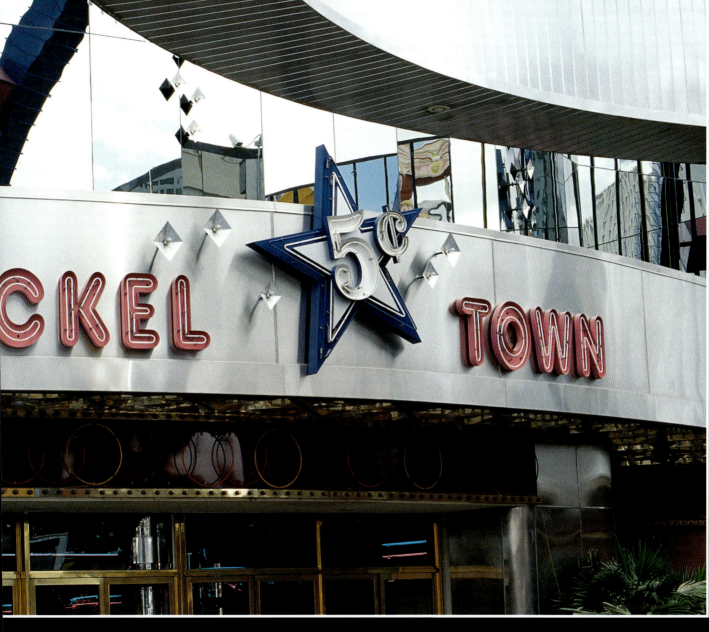
Figure 141. South Las Vegas Boulevard (The Strip). Riviera Hotel Casino. Nickel Town. Dayligh

Off-Strip

Figure 142. Off-Strip. Orleans Hotel Casino. Marquee. Neon and incandescent bulbs.

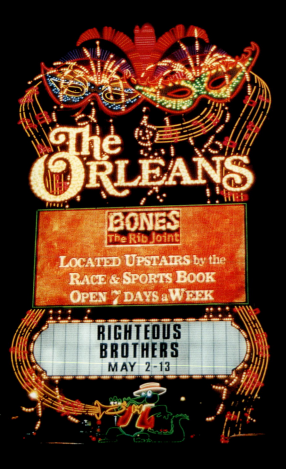

Figure 144. Off-Strip. Orleans Hotel Casino. Close-up of Figure 142.

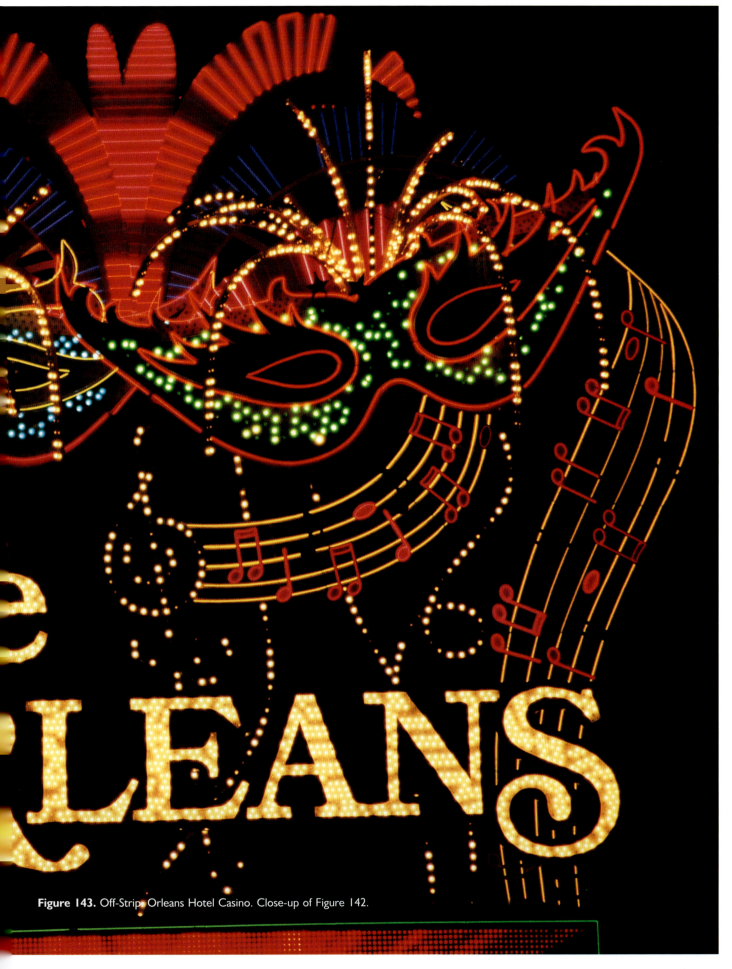
Figure 143. Off-Strip Orleans Hotel Casino. Close-up of Figure 142.

Figure 145. Off-Strip. Casino Royale Hotel Casino. Outline neon and flickering incandescent bulbs.

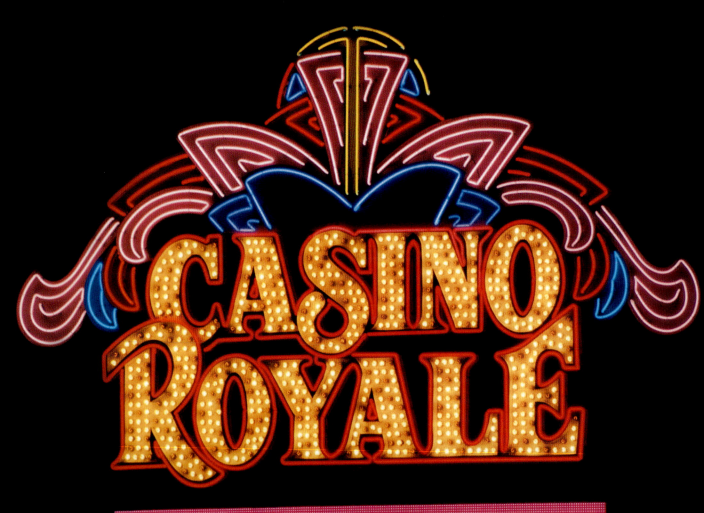

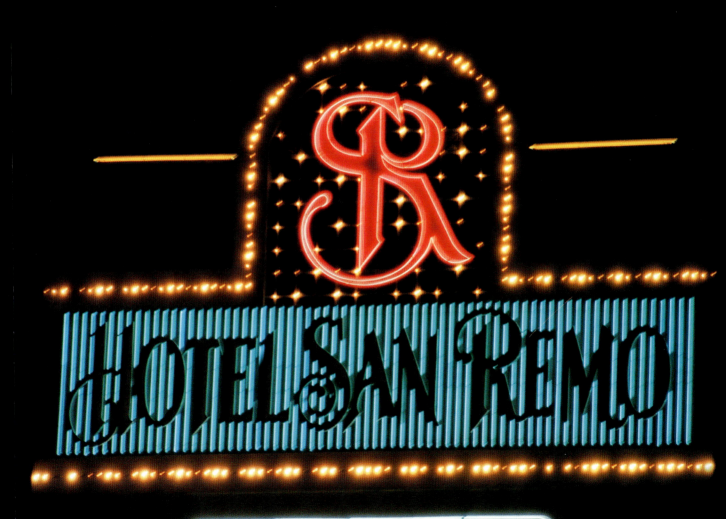

Figure 146. Off-Strip. Hotel San Remo Casino and Resort. Neon and rolling incandescent bulbs.

Figure 147. Off-Strip. Terrible's Hotel Casino. Neon and flickering incandescent bulbs.

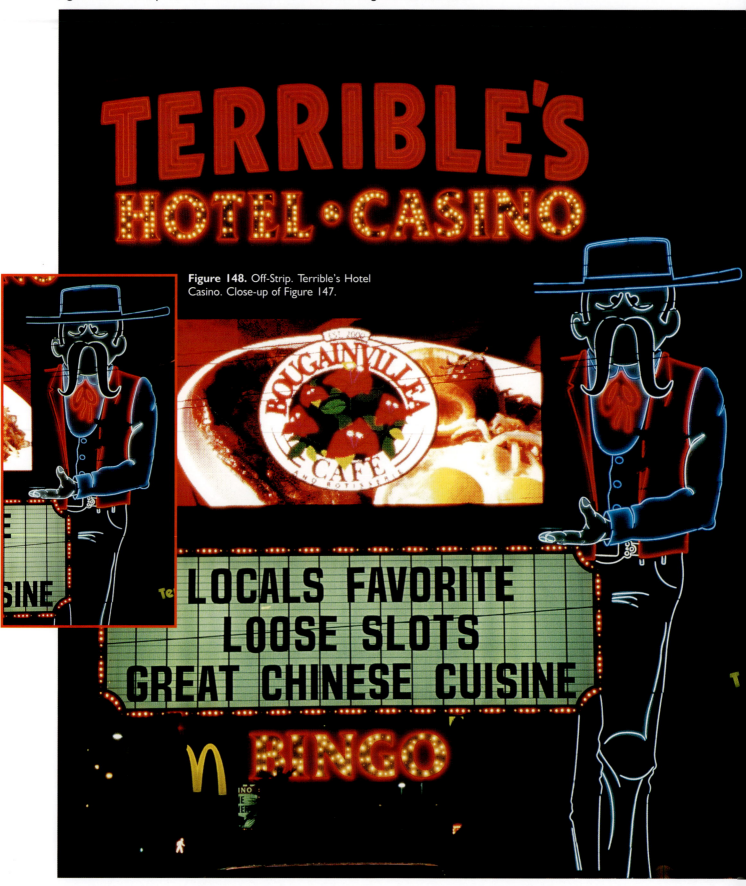

Figure 148. Off-Strip. Terrible's Hotel Casino. Close-up of Figure 147.

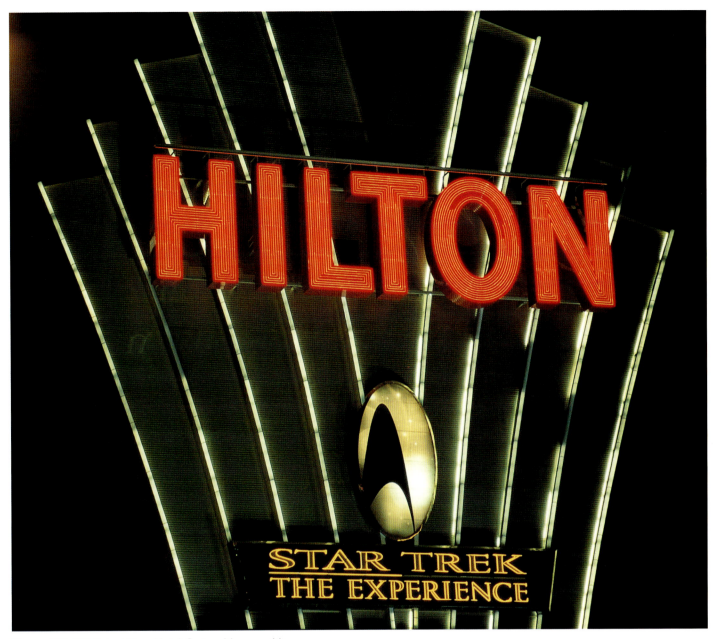

Figure 149. Off-Strip. Hilton Hotel Casino. Marquee. Neon.

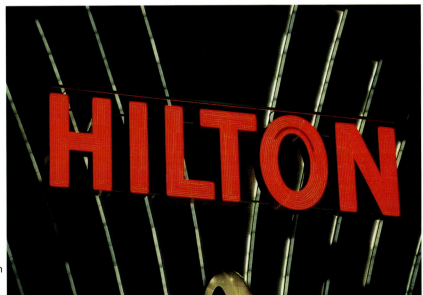

Figure 150. Off-Strip. Hilton Hotel Casino. Close-up of Figure 149.

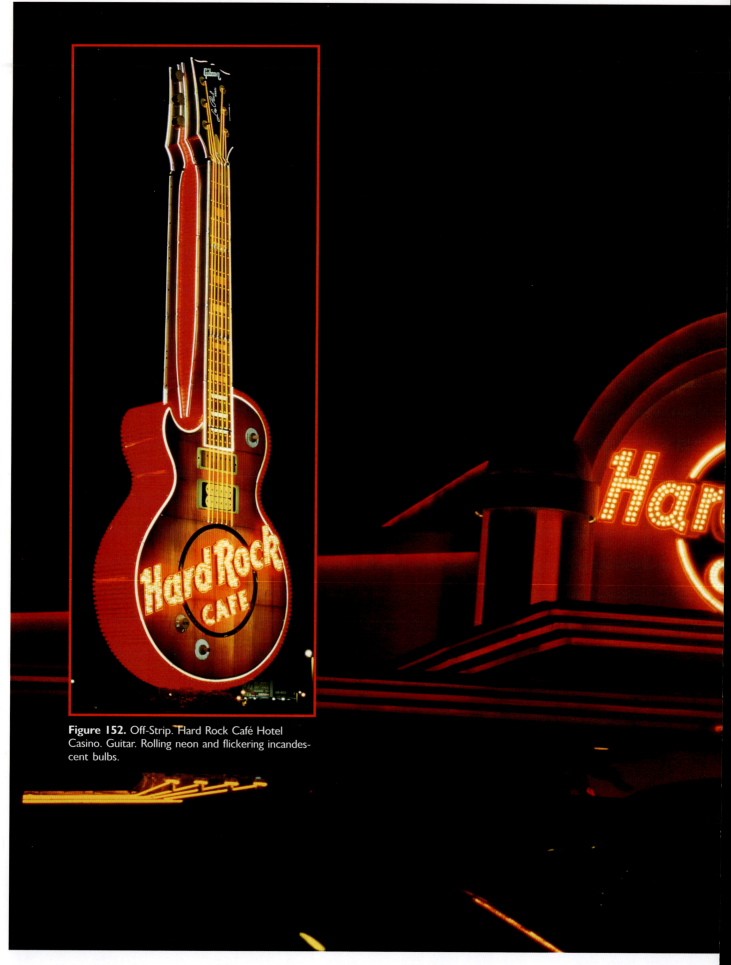

Figure 152. Off-Strip. Hard Rock Café Hotel Casino. Guitar. Rolling neon and flickering incandescent bulbs.

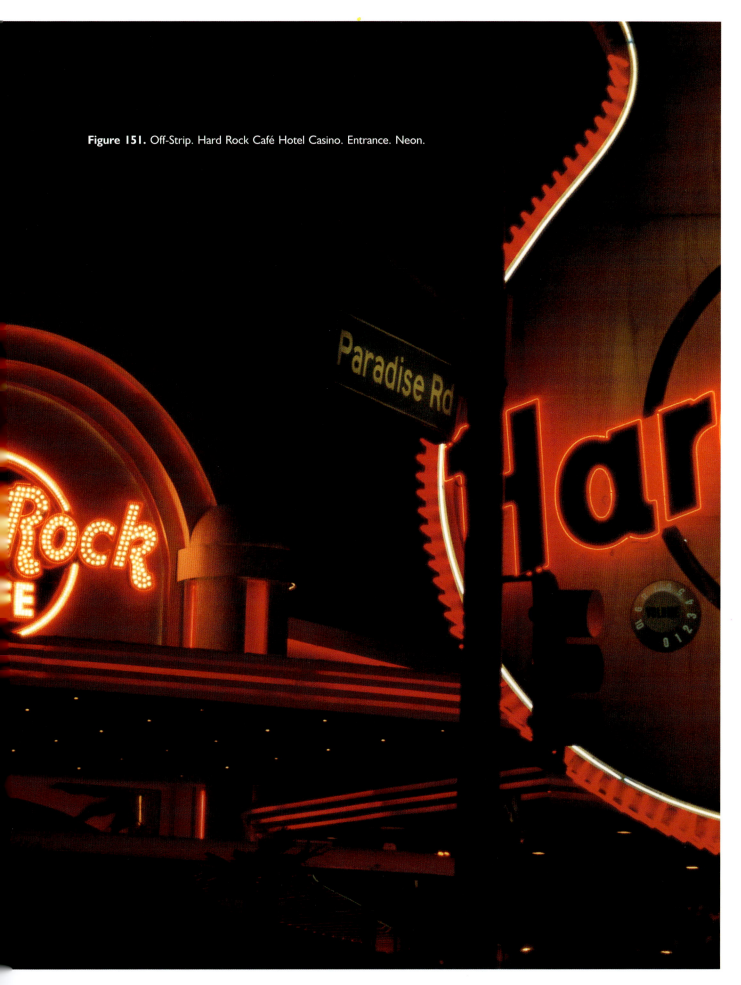

Figure 151. Off-Strip. Hard Rock Café Hotel Casino. Entrance. Neon.

Figure 154. Off-Strip. Sam's Town Hotel & Gambling Hall. Daylight.

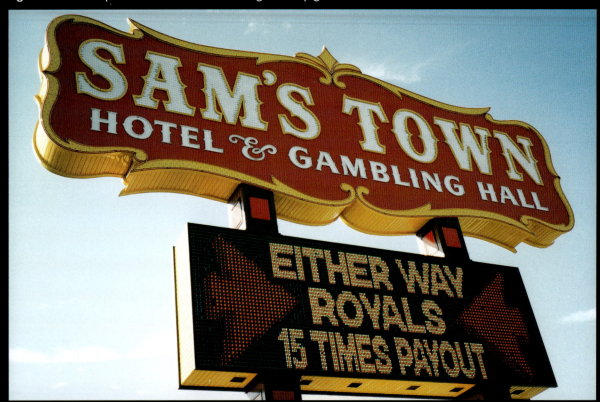

Figure 153. Off-Strip. Budget Suites Motel.

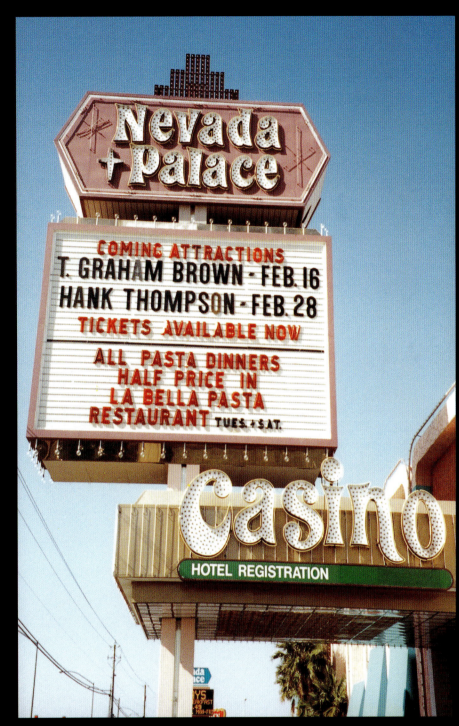

Figure 155. Off-Strip. Nevada Palace. Daylight.

Around Town

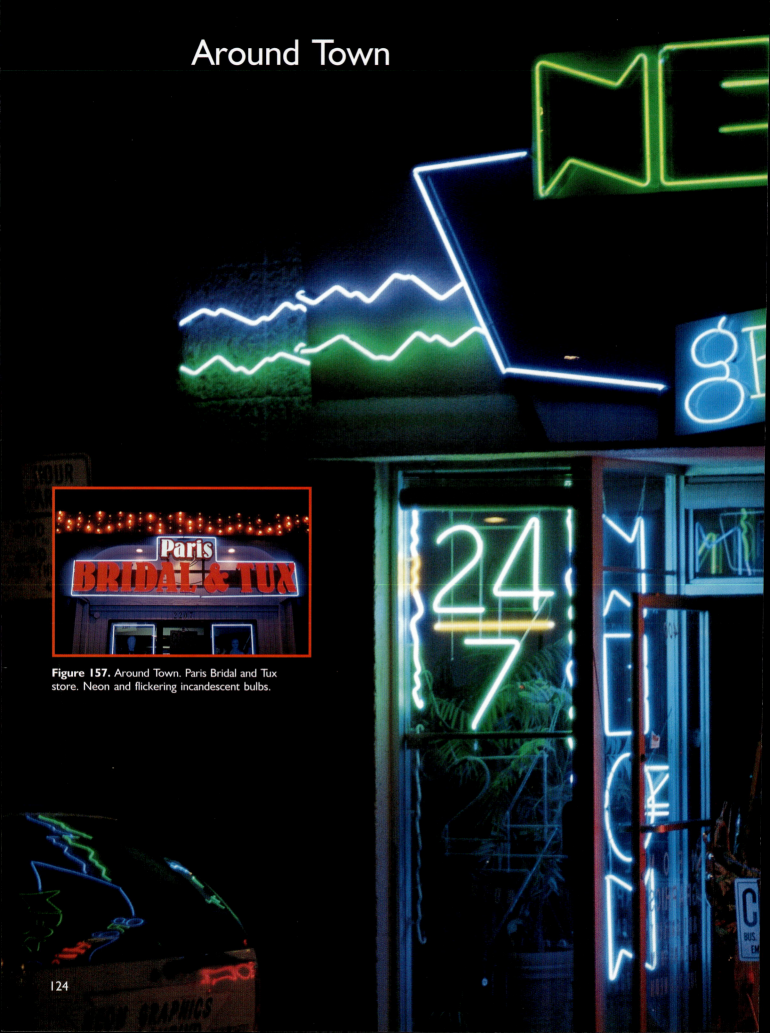

Figure 157. Around Town. Paris Bridal and Tux store. Neon and flickering incandescent bulbs.

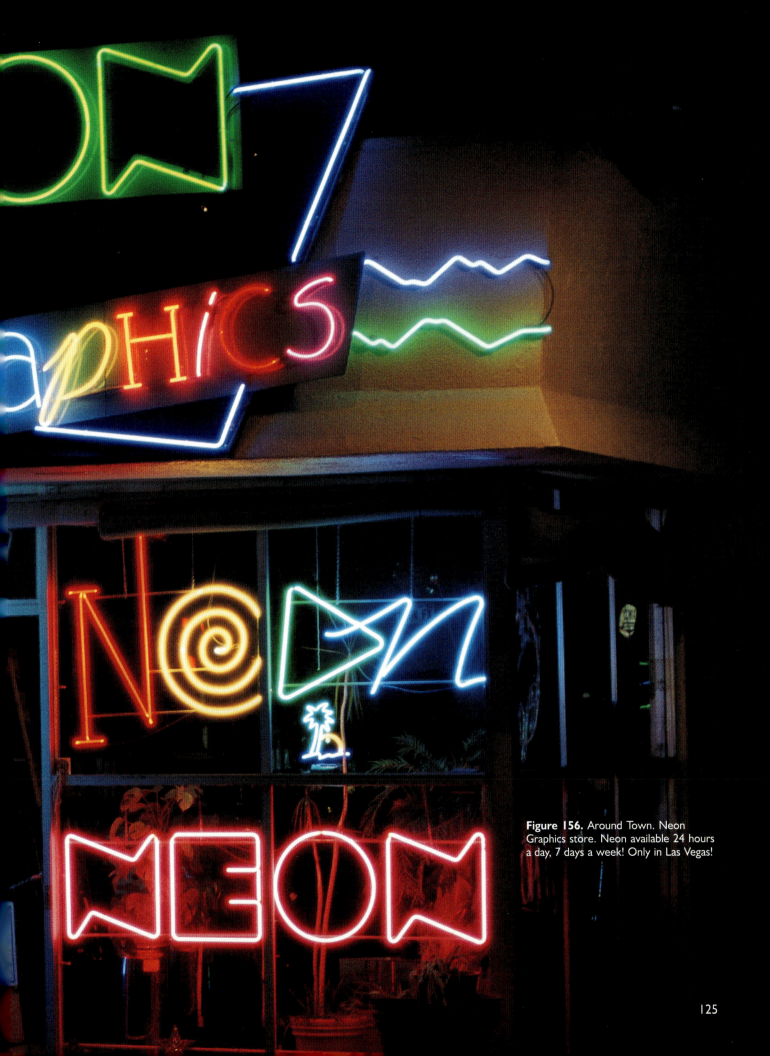

Figure 156. Around Town. Neon Graphics store. Neon available 24 hours a day, 7 days a week! Only in Las Vegas!

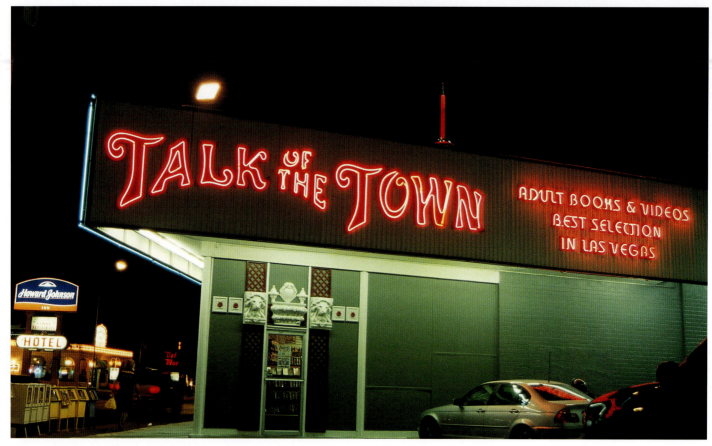

Figure 158. Around Town. Talk of the Town Adult store. Stationary neon.

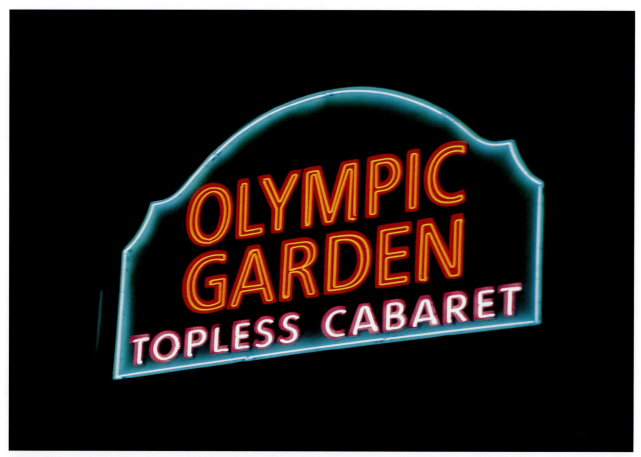

Figure 159. Around Town. Olympic Garden Topless Cabaret. Stationary neon.

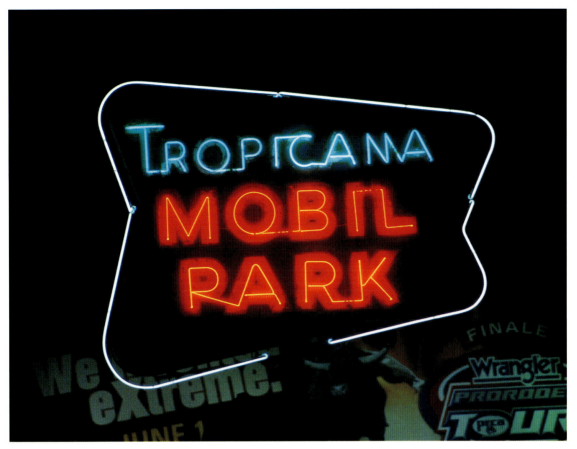

Figure 160. Around Town. Tropicana Mobile Park. Stationary neon.

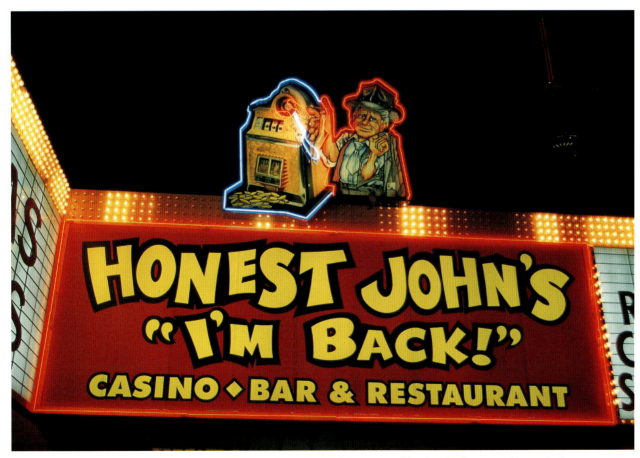

Figure 161. Around Town. Honest John's "I'm Back!" Casino Bar and Restaurant. Neon and rolling incandescent bulbs.

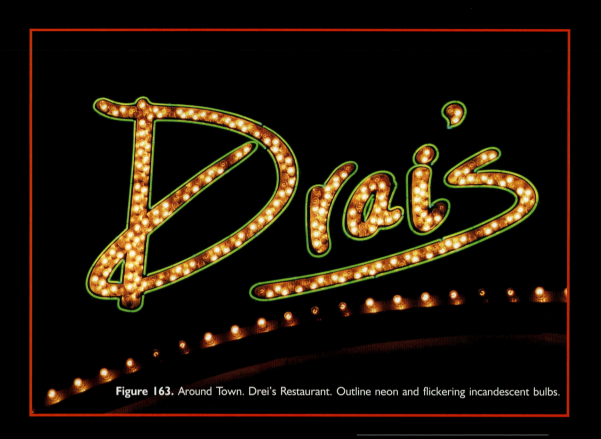

Figure 163. Around Town. Drei's Restaurant. Outline neon and flickering incandescent bulbs.

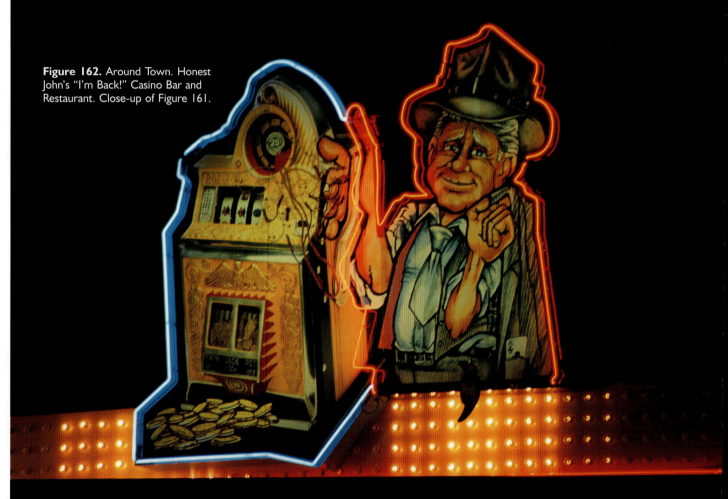

Figure 162. Around Town. Honest John's "I'm Back!" Casino Bar and Restaurant. Close-up of Figure 161.

Figure 165. Around Town. The Beach club. Outline neon and flickering incandescent bulbs.

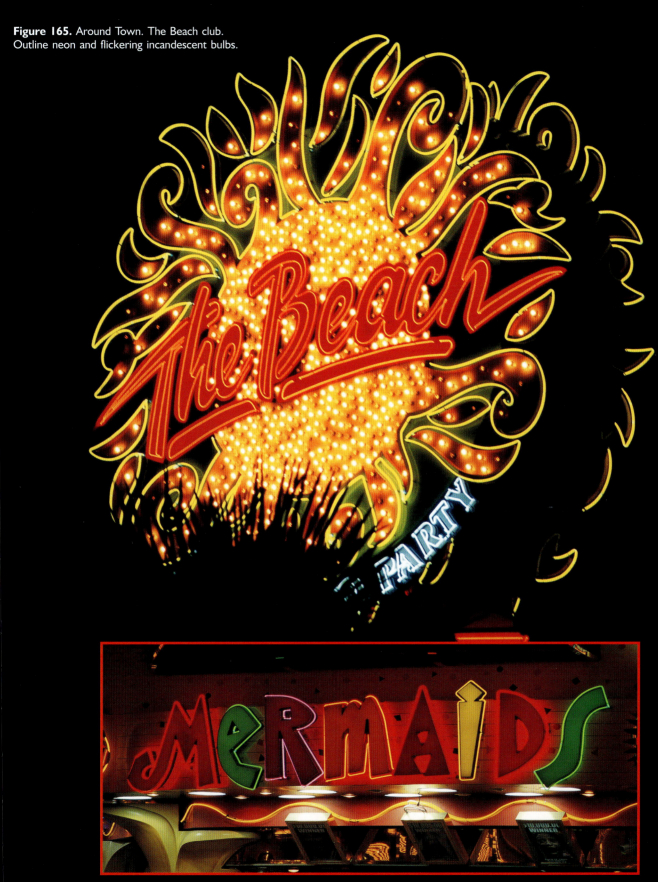

Figure 164. Around Town. Mermaid's. Entrance sign. Outline neon.

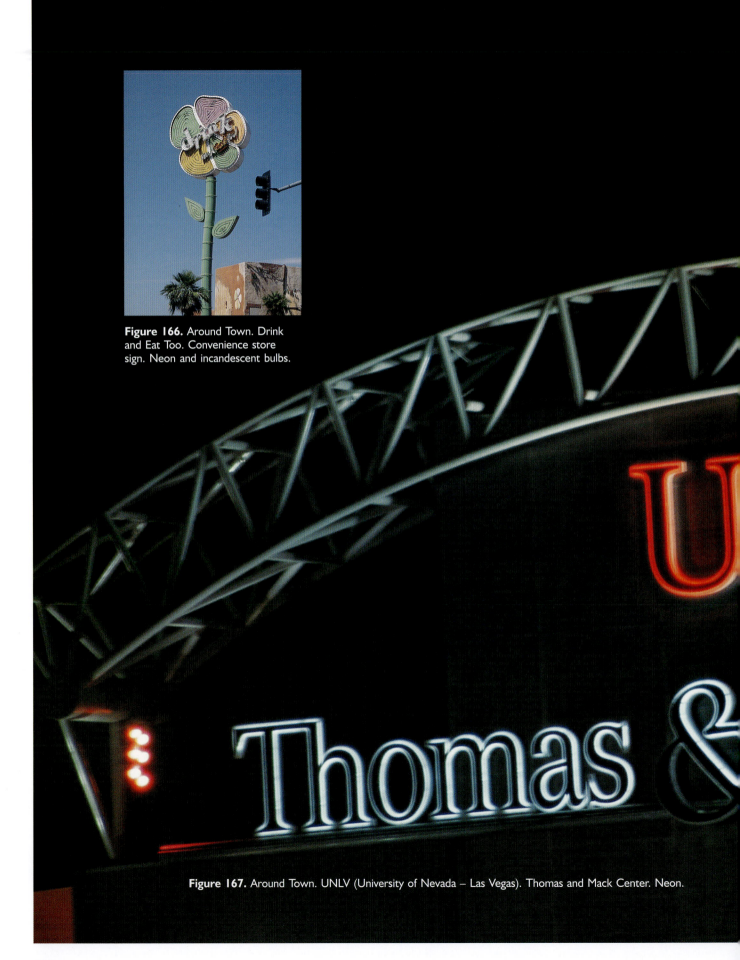

Figure 166. Around Town. Drink and Eat Too. Convenience store sign. Neon and incandescent bulbs.

Figure 167. Around Town. UNLV (University of Nevada – Las Vegas). Thomas and Mack Center. Neon.

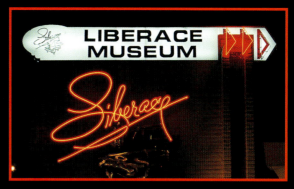

Figure 168. Around Town. Liberace Museum. Neon.

Figure 169. Around Town. Liberace Museum. Daylight.

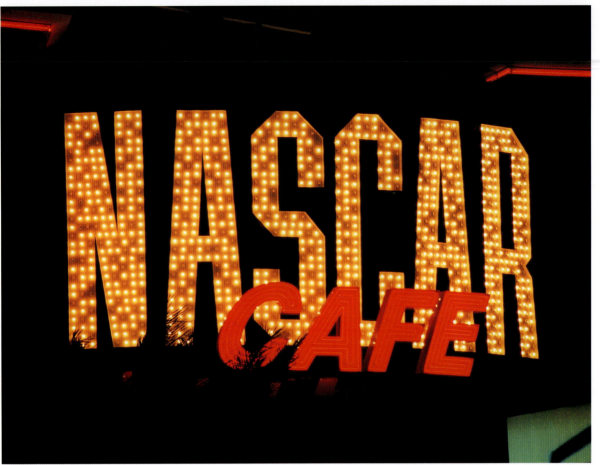

Figure 171. Around Town. Nascar Café. Neon and incandescent bulbs.

Figure 170. Around Town. Coffee Mani@ internet café. Neon and incandescent bulbs.

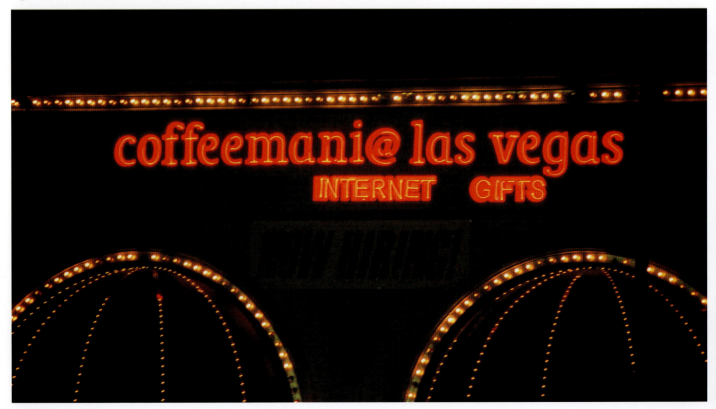

Figure 173. Around Town. Grand Canyon Experience. Neon.

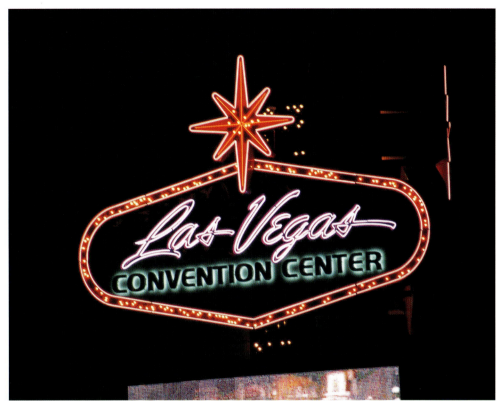

Figure 172. Around Town. Las Vegas Convention Center. Neon and incandescent bulbs.

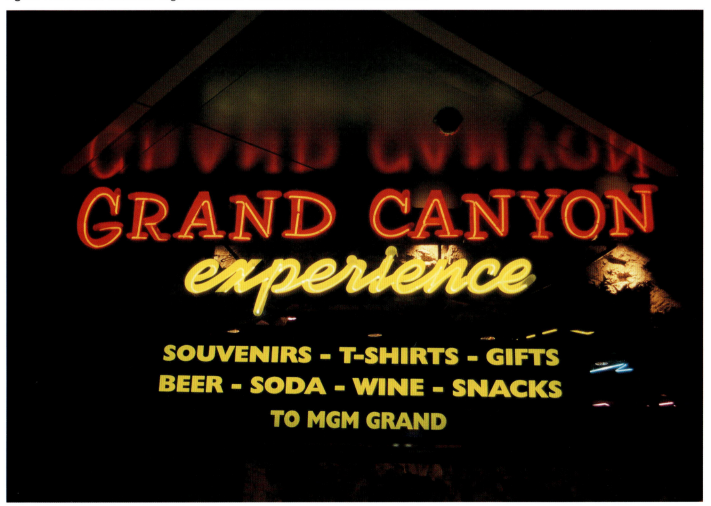

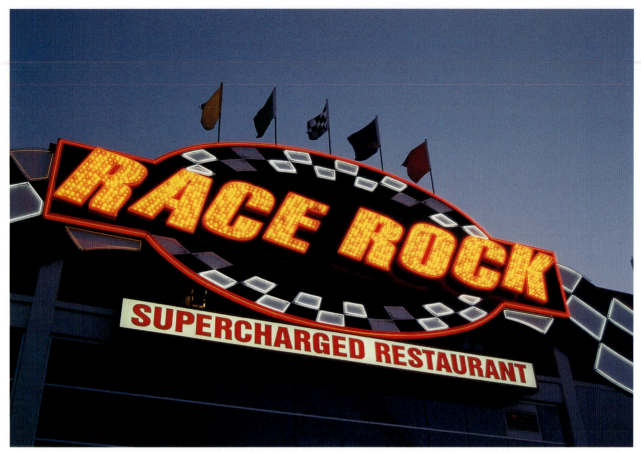

Figure 174. Around Town. Race Rock Super Charged Restaurant. Outline neon and flickering incandescent bulbs.

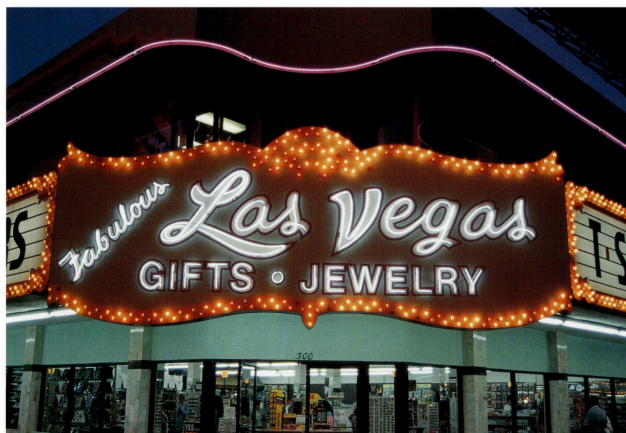

Figure 175. Around Town. Fabulous Las Vegas Gifts. Dusk. Neon and incandescent bulbs.

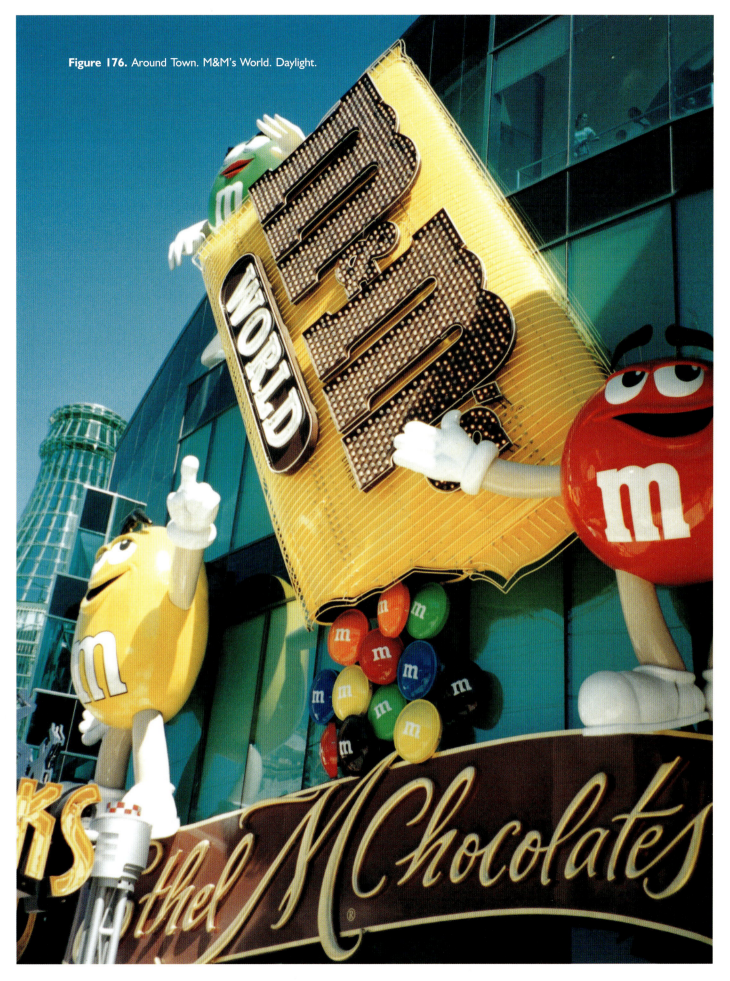

Figure 176. Around Town. M&M's World. Daylight.

Figure 179. Around Town. M&M's World. Flickering incandescent bulbs.

Figure 177. Around Town. M&M's World. Neon.

Figure 178. Around Town. M&M's World. Neon and incandescent bulbs.

Figure 180. Around Town. Las Vegas Executive Airport. Neon.

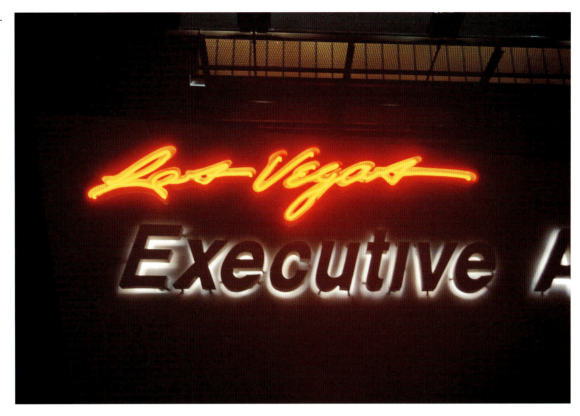

Figure 181. Around Town. Bonanza Gift and Souvenir Shops. Neon.

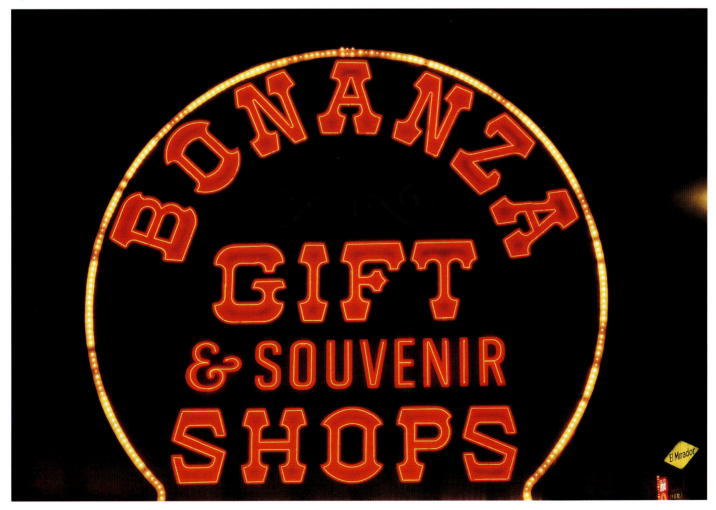

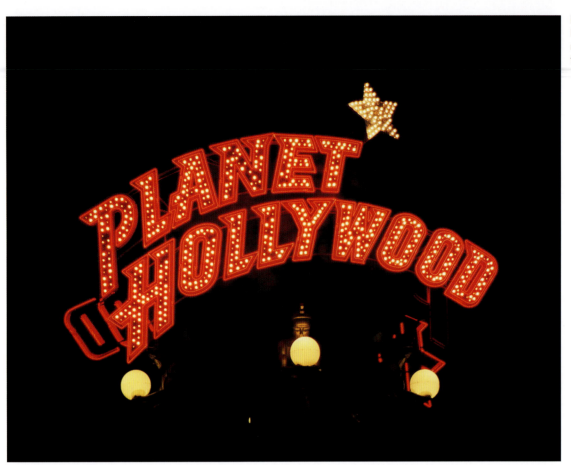

Figure 183. Around Town. Planet Hollywood Restaurant. Outline neon and flickering incandescent bulbs.

Figure 182. Around Town. Bonanza General Store. Frontage. Neon and incandescent bulbs.

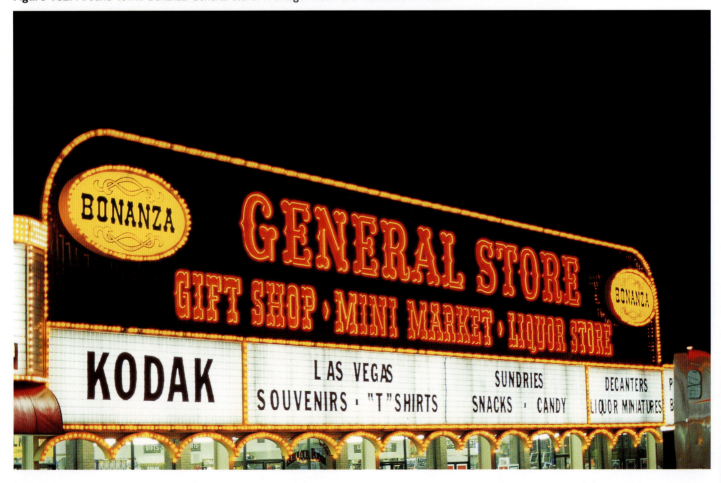

Figure 184. Around Town. Mega Jackpot World. Neon and incandescent bulbs.

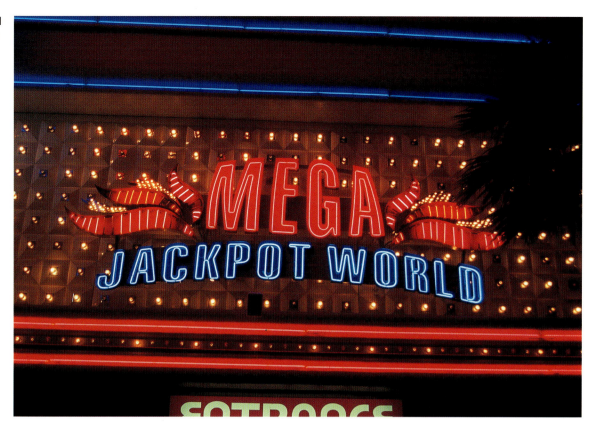

Figure 185. Around Town. Casino entrance sign. Neon and incandescent bulbs.

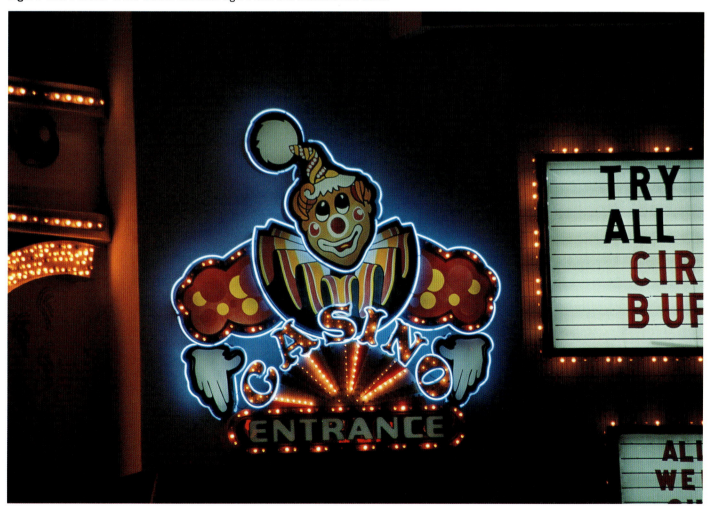

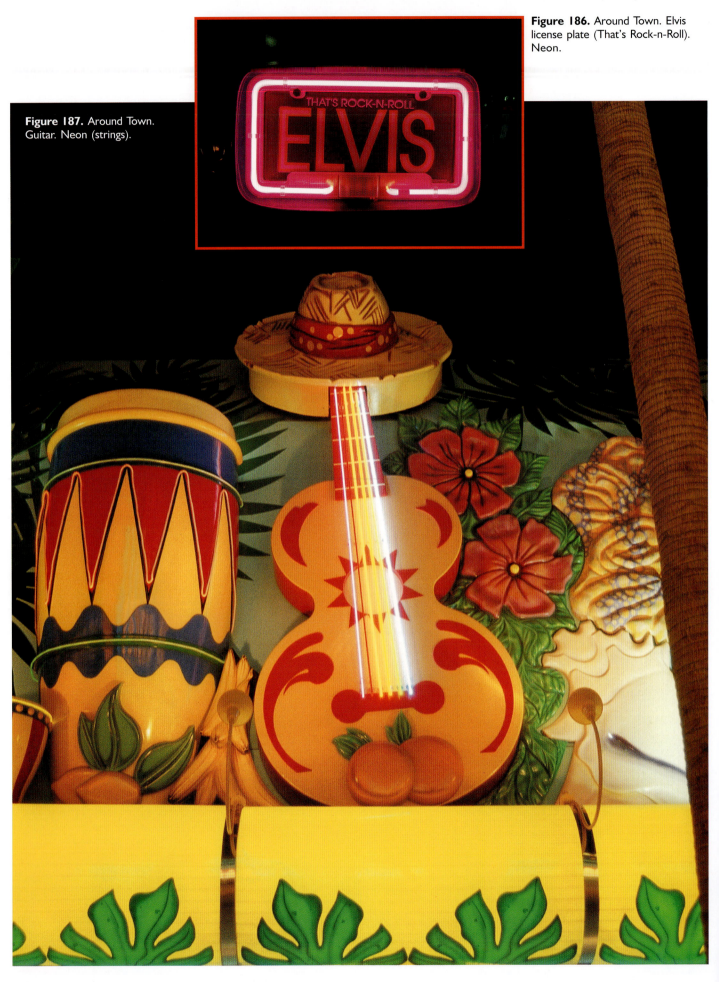

Figure 186. Around Town. Elvis license plate (That's Rock-n-Roll). Neon.

Figure 187. Around Town. Guitar. Neon (strings).

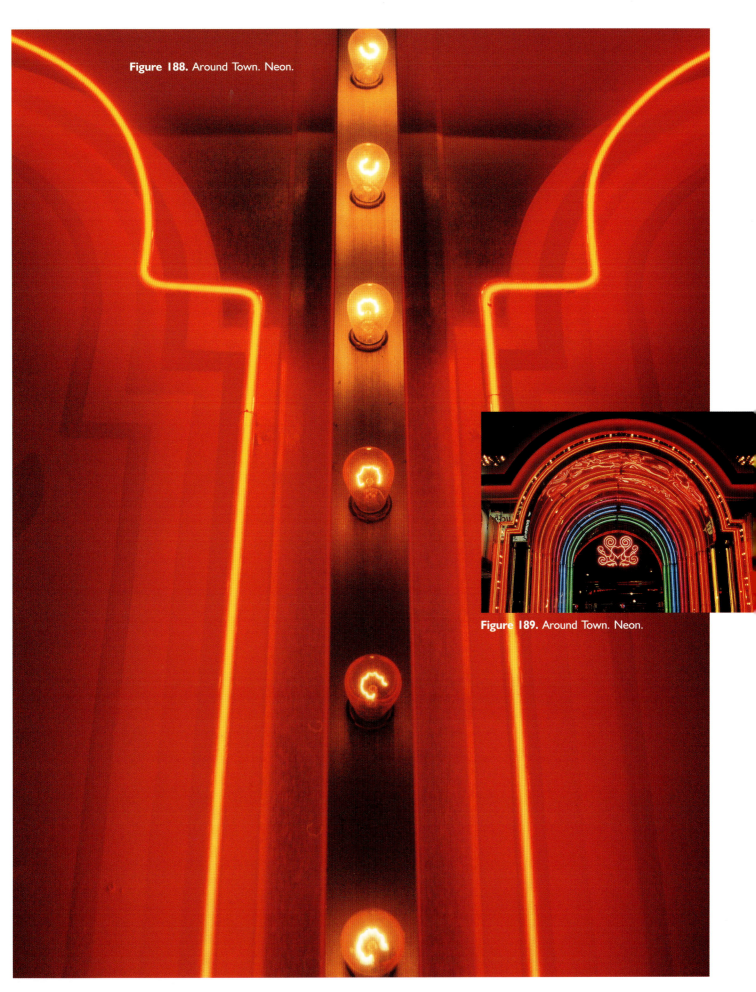

Figure 188. Around Town. Neon.

Figure 189. Around Town. Neon.

Inside Signage

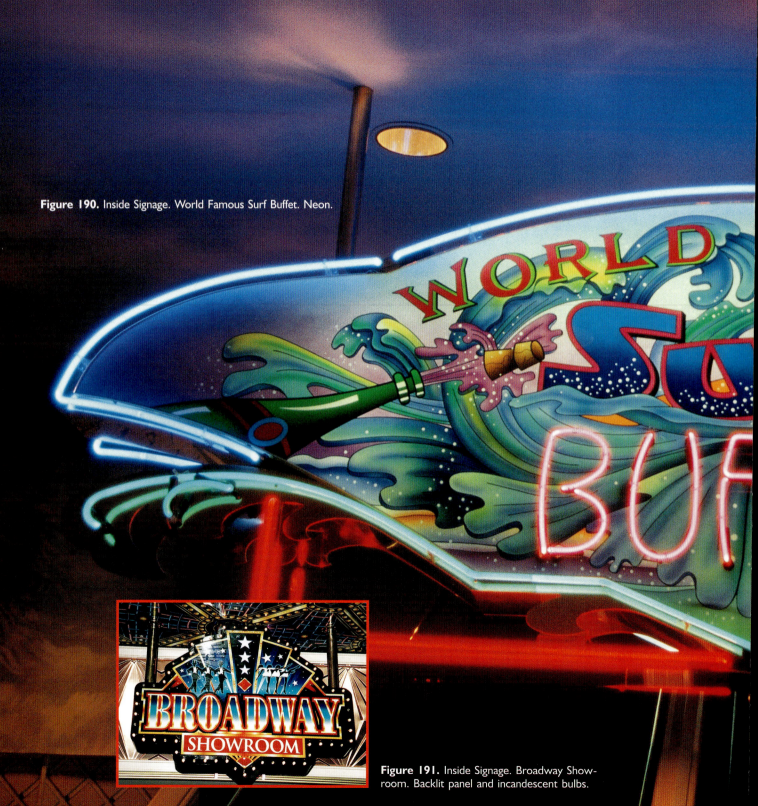

Figure 190. Inside Signage. World Famous Surf Buffet. Neon.

Figure 191. Inside Signage. Broadway Showroom. Backlit panel and incandescent bulbs.

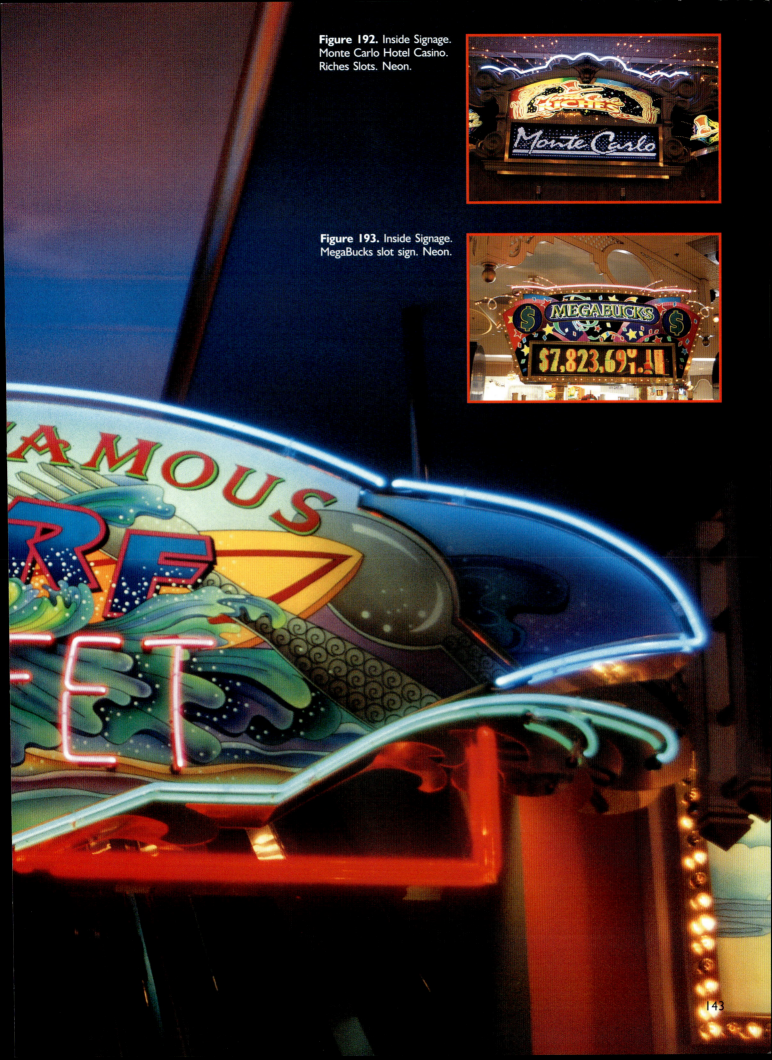

Figure 192. Inside Signage. Monte Carlo Hotel Casino. Riches Slots. Neon.

Figure 193. Inside Signage. MegaBucks slot sign. Neon.

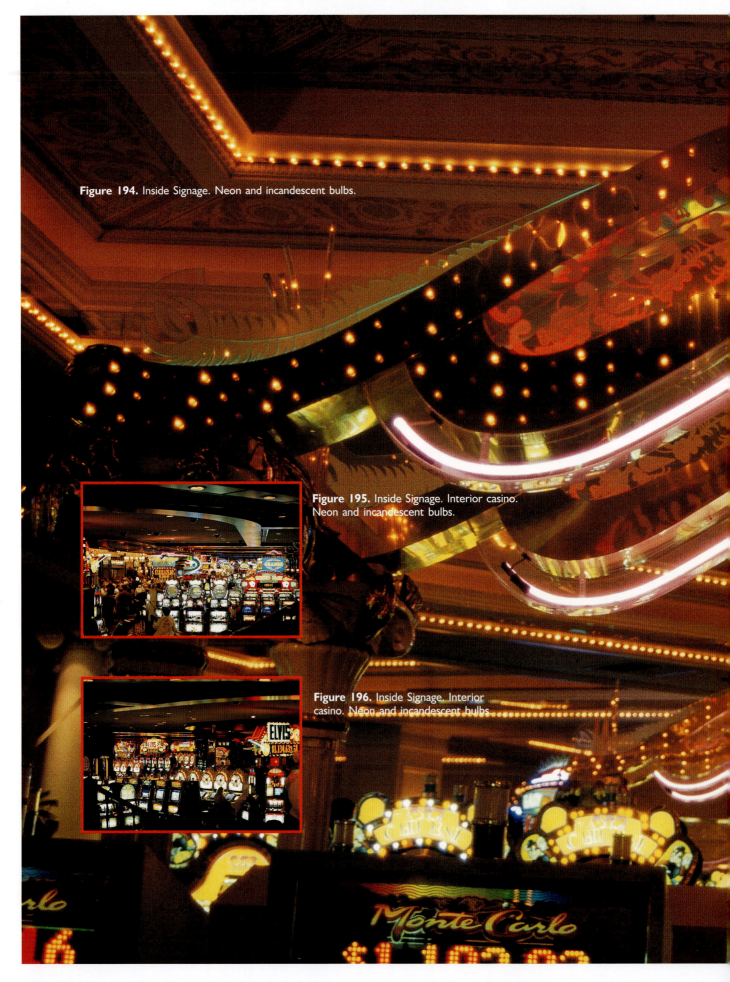

Figure 194. Inside Signage. Neon and incandescent bulbs.

Figure 195. Inside Signage. Interior casino. Neon and incandescent bulbs.

Figure 196. Inside Signage. Interior casino. Neon and incandescent bulbs.

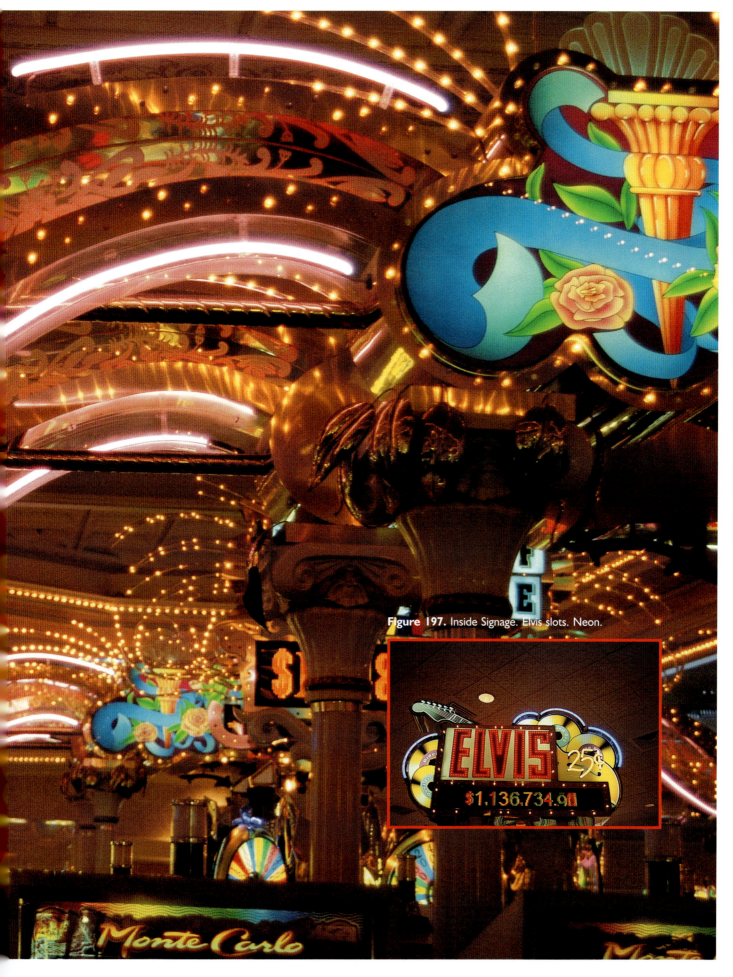

Figure 197. Inside Signage. Elvis slots. Neon.

Word Signs

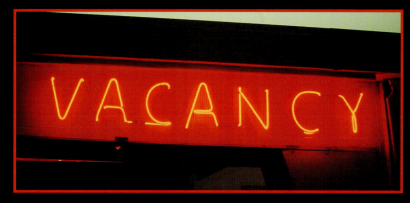

Figure 198. Word Sign. Vacancy. Neon.

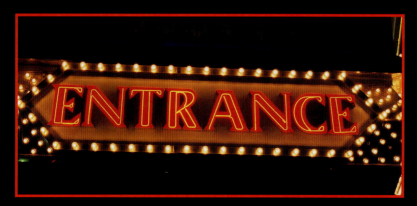

Figure 199. Word Sign. Entrance. Neon and incandescent bulbs.

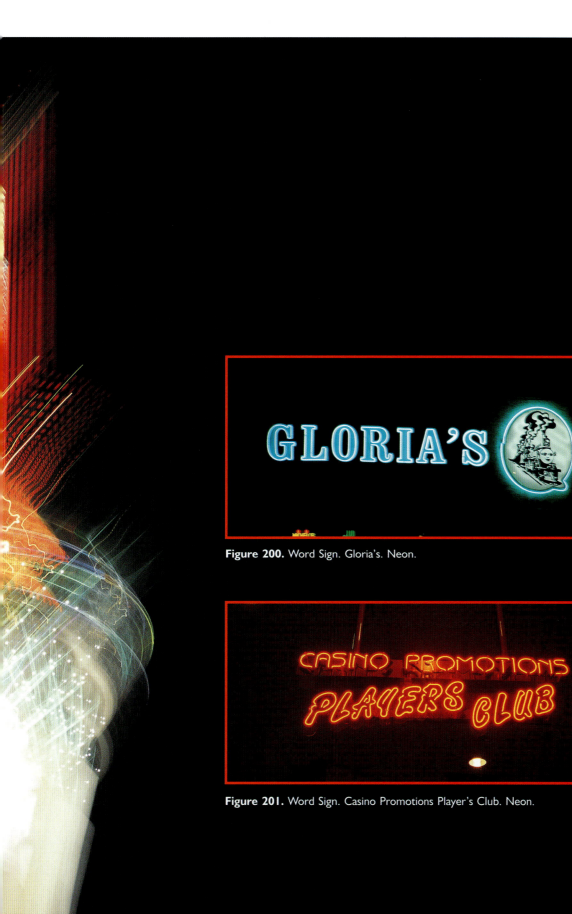

Figure 200. Word Sign. Gloria's. Neon.

Figure 201. Word Sign. Casino Promotions Player's Club. Neon.

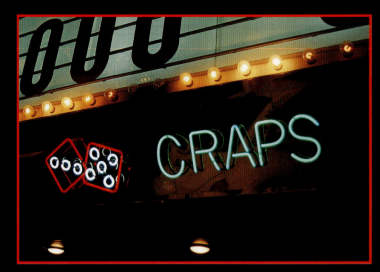

Figure 202. Word Sign. Craps (with dice). Neon.

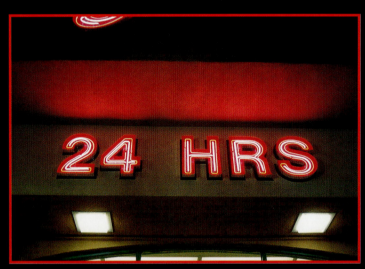

Figure 203. Word Sign. 24 HRS. Neon.

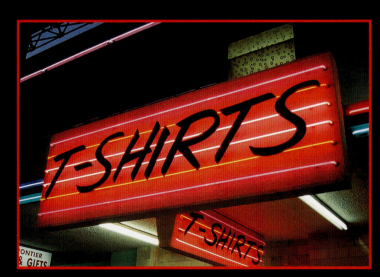

Figure 204. Word Sign. T-Shirts. Neon.

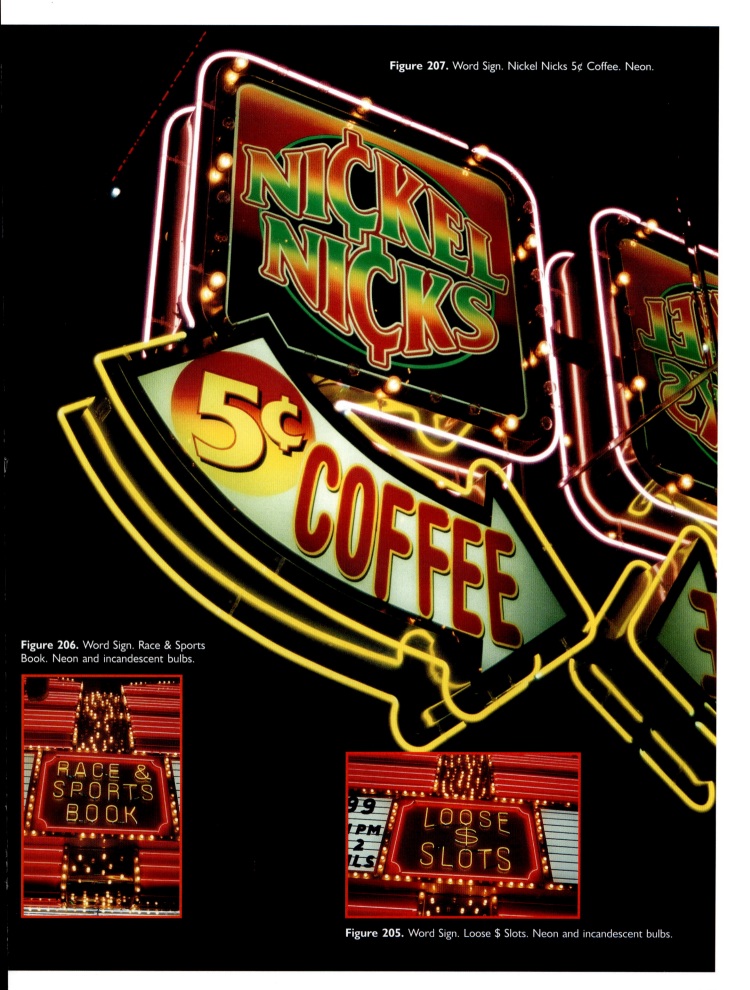

Figure 207. Word Sign. Nickel Nicks 5¢ Coffee. Neon.

Figure 206. Word Sign. Race & Sports Book. Neon and incandescent bulbs.

Figure 205. Word Sign. Loose $ Slots. Neon and incandescent bulbs.

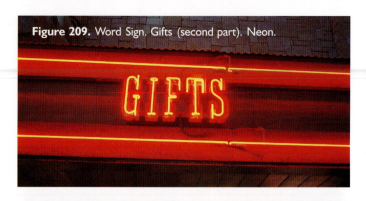

Figure 209. Word Sign. Gifts (second part). Neon.

Figure 210. Word Sign. T-Shirts (third part). Neon.

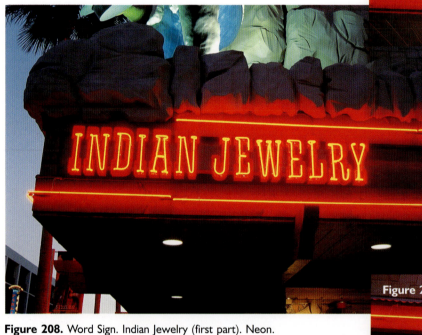

Figure 208. Word Sign. Indian Jewelry (first part). Neon.

Figure 211. Word Sign. Souvenirs (fourth part). Neon.

Figure 212. Word Sign. Western Stuff (fifth part). Neon.

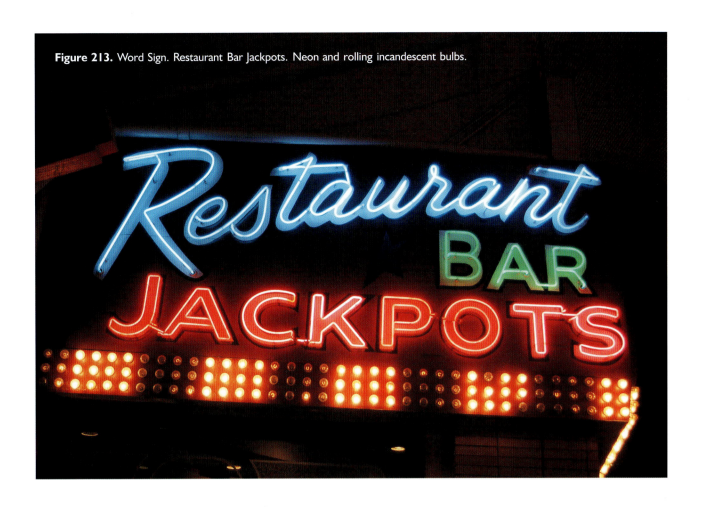

Figure 213. Word Sign. Restaurant Bar Jackpots. Neon and rolling incandescent bulbs.

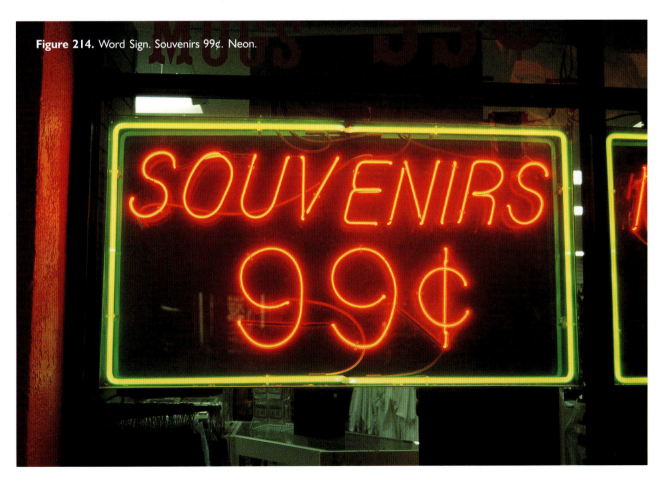

Figure 214. Word Sign. Souvenirs 99¢. Neon.

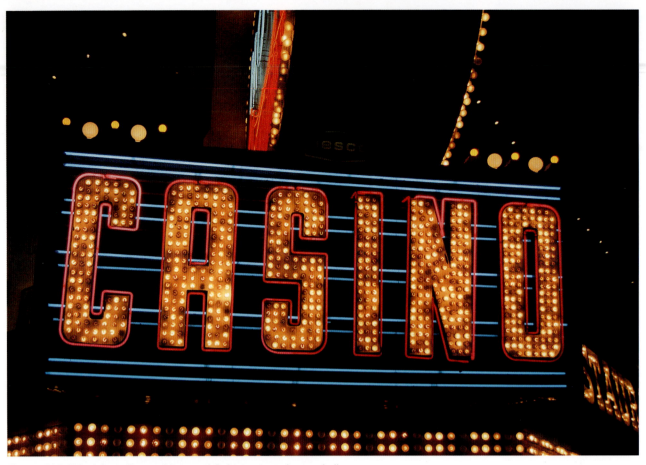

Figure 215. Word Sign. Casino. Neon and flickering incandescent bulbs.

Figure 216. Word Sign. Casino. Neon and flickering incandescent bulbs.

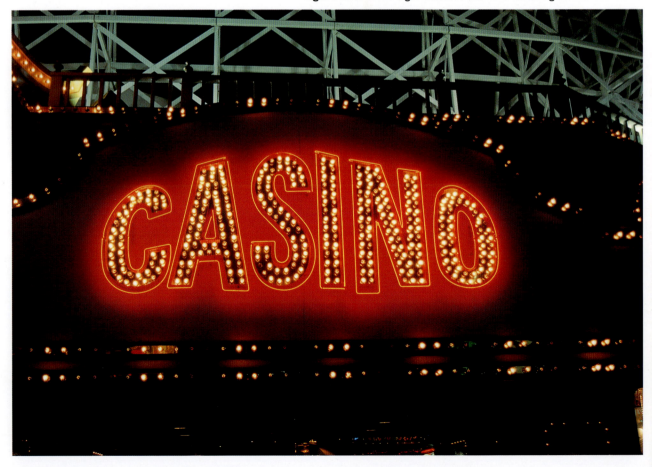

Commercial Retail

Figure 217. Commercial Retail. Arby's and Guinness World of Records Museum. Neon and flickering incandescent bulbs.

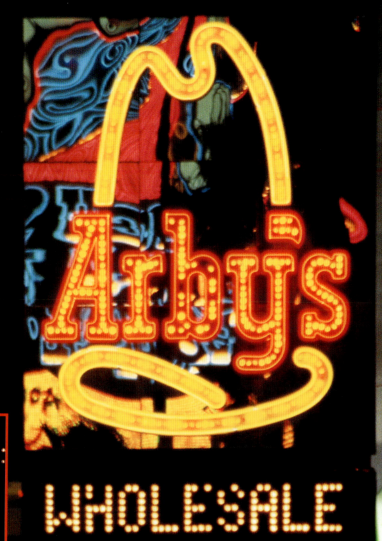

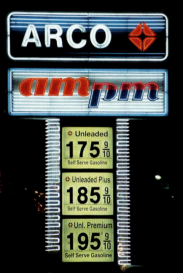

Figure 218. Commercial Retail. Arco and AM/PM. Rolling neon.

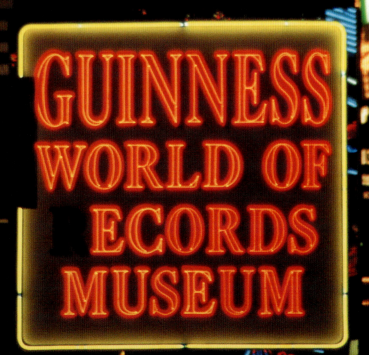

153

Figure 219. Commercial Retail. Denny's restaurant. Neon.

Figure 221. Commercial Retail. Walgreen's pharmacy. Neon.

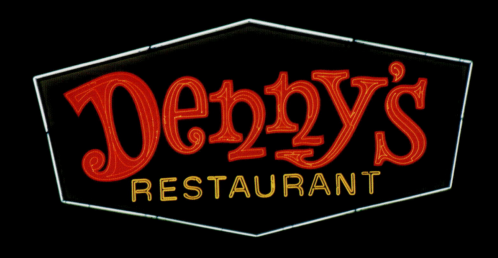

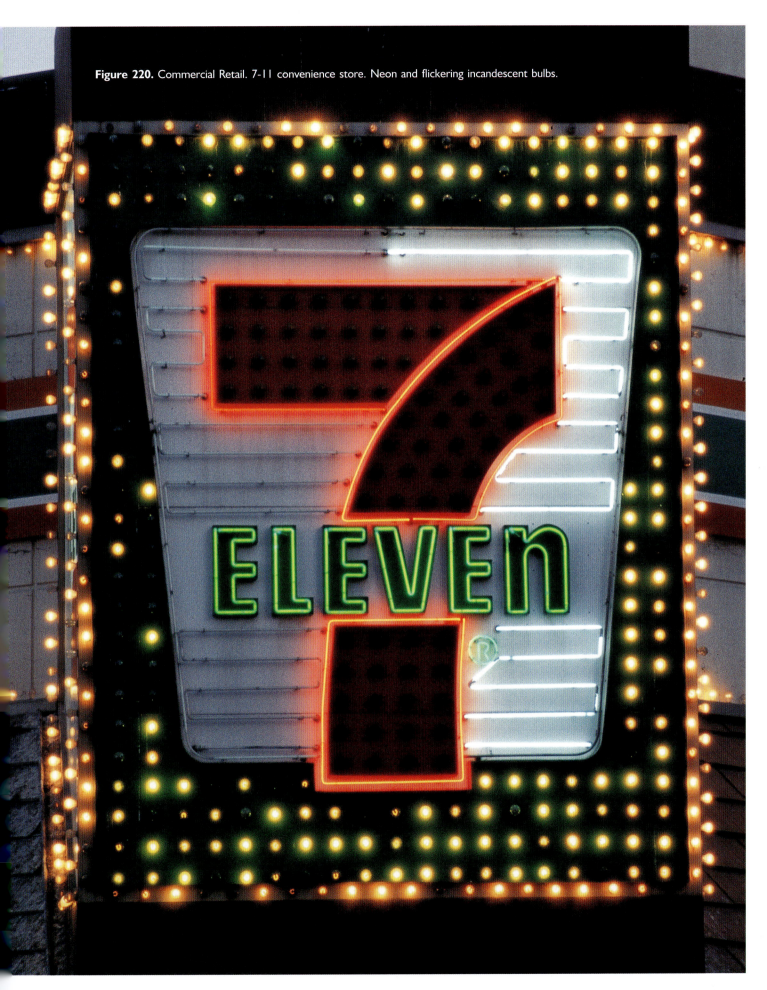

Figure 220. Commercial Retail. 7-11 convenience store. Neon and flickering incandescent bulbs.

Figure 223. Commercial Retail. McDonald's restaurant. Neon and flickering incandescent bulbs.

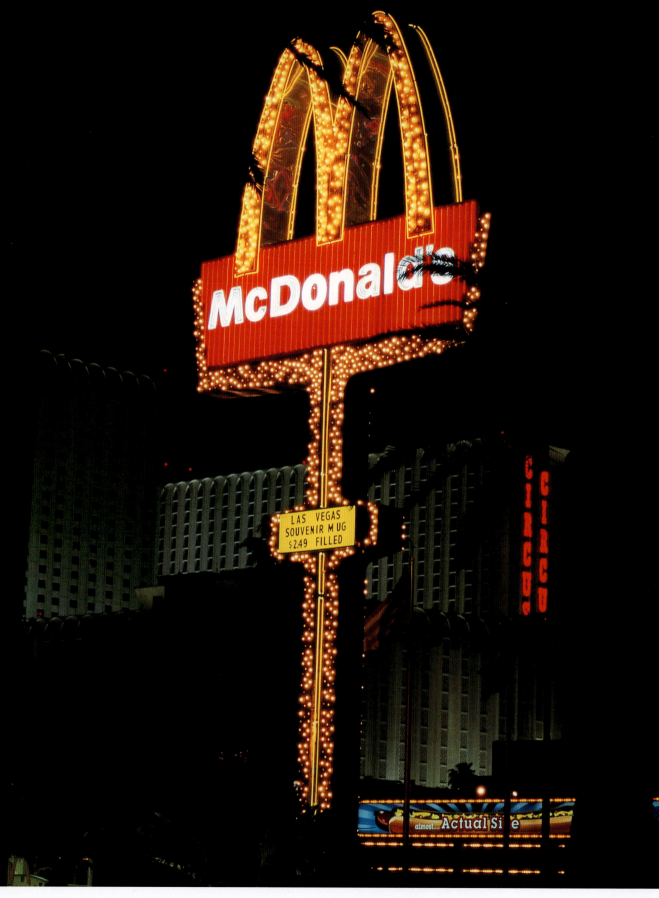

Figure 222. Commercial Retail. Fuji Film. Neon.

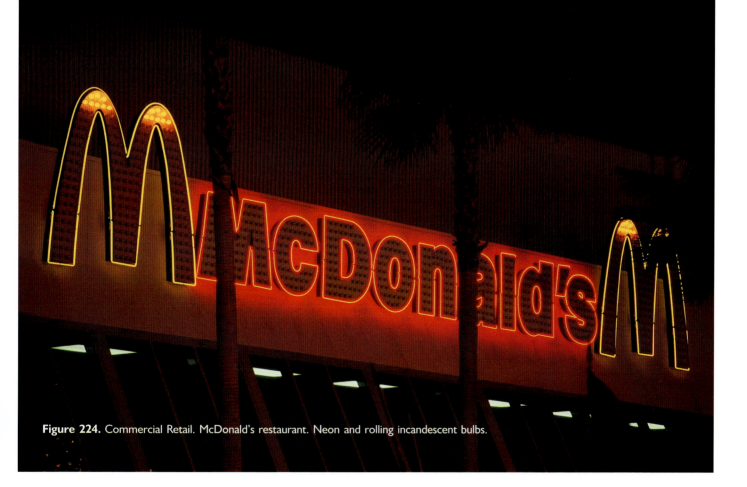

Figure 224. Commercial Retail. McDonald's restaurant. Neon and rolling incandescent bulbs.

Chapels

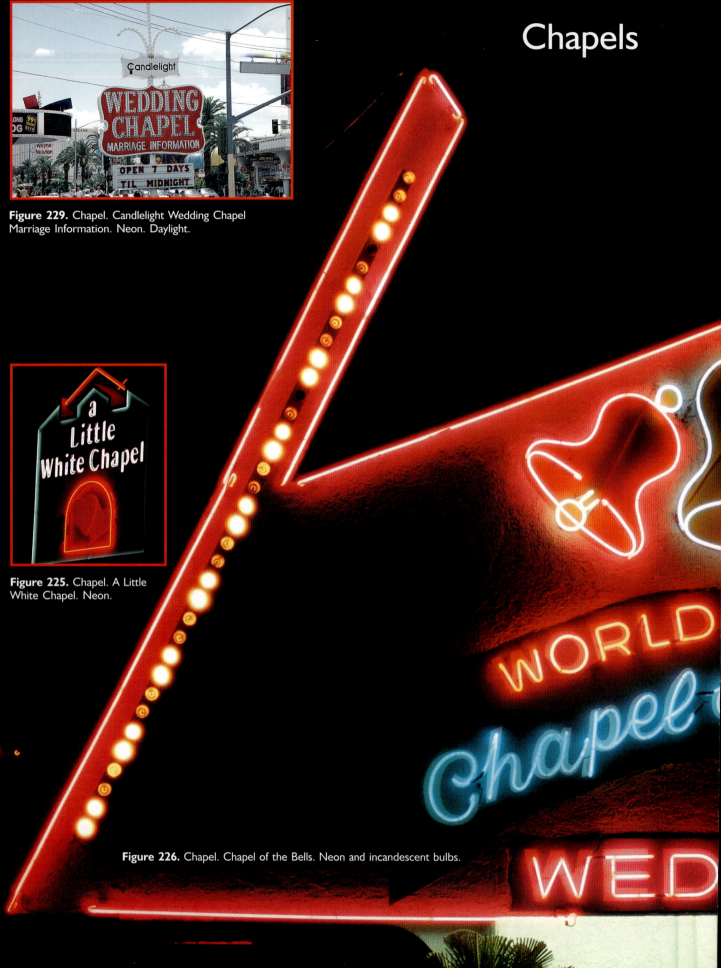

Figure 229. Chapel. Candlelight Wedding Chapel Marriage Information. Neon. Daylight.

Figure 225. Chapel. A Little White Chapel. Neon.

Figure 226. Chapel. Chapel of the Bells. Neon and incandescent bulbs.

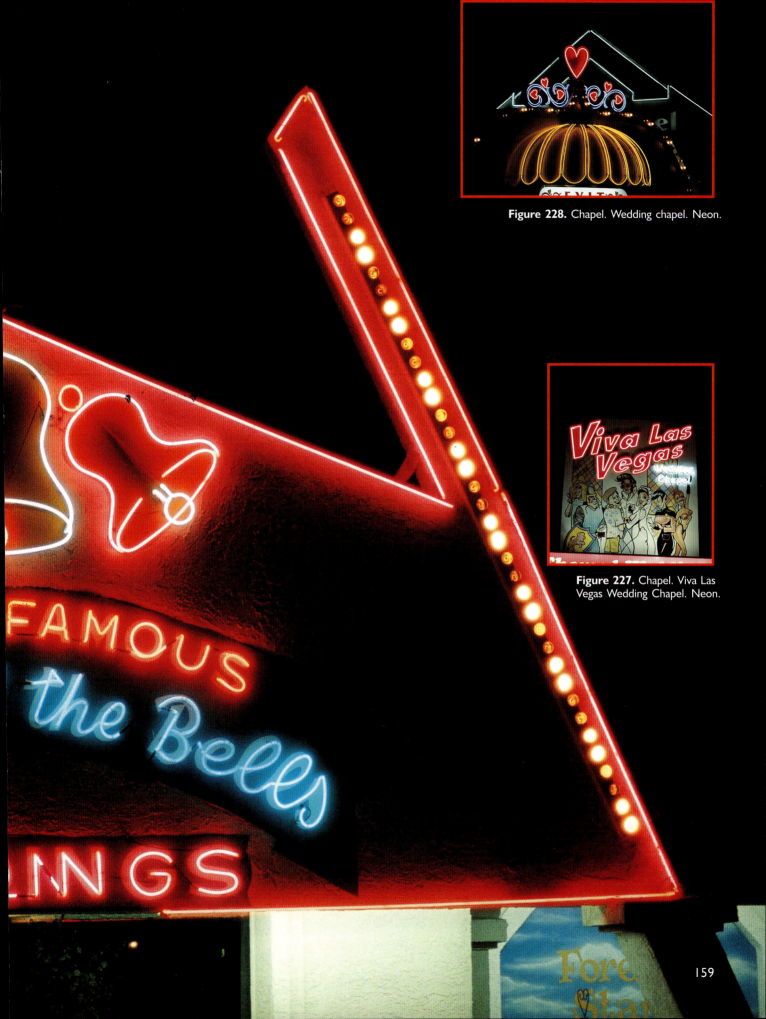

Figure 228. Chapel. Wedding chapel. Neon.

Figure 227. Chapel. Viva Las Vegas Wedding Chapel. Neon.

Selected Bibliography

Ballast, David Kent. *Neon Lighting in Architecture and Interiors.* Monticello, IL: Vance Bibliographies, 1987.

Callahan, Mary (ed.). *Fodor's Las Vegas 2001.* New York: Fodor's Travel Publications, Inc., 2001.

Dailey, Donna. *Southwest USA and Las Vegas.* London: Dorling Kindersley Publishing, Inc., 2001.

Denton, Sally, and Roger Morris. *Money and Power: The Making of Las Vegas and Its Hold On America, 1947-2000.* New York: Alfred A. Knopf, 2001.

Earley, Peter. *Super Casino: Inside the "New" Las Vegas.* New York: Bantam Books, Inc., 2000.

Herczog, Mary. *Frommer's Las Vegas.* New York: Hungry Minds, Inc., 2001.

Http://www.chemicalelements.com. World Wide Web, 2002.

Http://www.inventors.about.com. World Wide Web, 2001.

Http://www.neonshop.com. World Wide Web, 2001.

Http://es.rice.edu/ES/humsoc/Galileo. World Wide Web, 2001.

Http://www.ucl.ac.uk. World Wide Web, 2002.

Http://www.webelements.com. World Wide Web, 2002.

Martinez, Andres. *Living It Up and Doubling Down in the New Las Vegas.* New York: Dell Publishing, Inc., 2000.

Odessky, Richard. *Fly on the Wall: Recollections of Las Vegas' Good Old, Bad Old Days.* Las Vegas, NV: Huntington Press, 2000.

Rich, Jason. *The Everything Guide to Las Vegas: Hotels, Casinos, Restaurants, Major Family Attractions and More.* Avon, MA: Adams Media Corporation, 2000.

Sehlinger, Robert, and Deke Castleman. *The Unofficial Guide to Las Vegas.* New York: Hungry Minds, Inc., 2001.

Smith, John L. *Running Scared: The Life and Treacherous Times of Casino King Steve Wynn.* New York: Four Walls Eight Windows, 2001.

Stern, Rudi. *Contemporary Neon: Architecture-Graphics-Products-Sculpture.* Retail Rep., 1990.

Strattman, Wayne (ed.). *Neon Techniques: Handbook of Neon Sign and Cold Cathode Lighting.* Cincinnati, OH: ST Publications, 1997.

Webb, Michael. *Magic of Neon: The Rebirth of Light.* Layton, UT: Gibbs Smith, 1983.